Scenic Highways

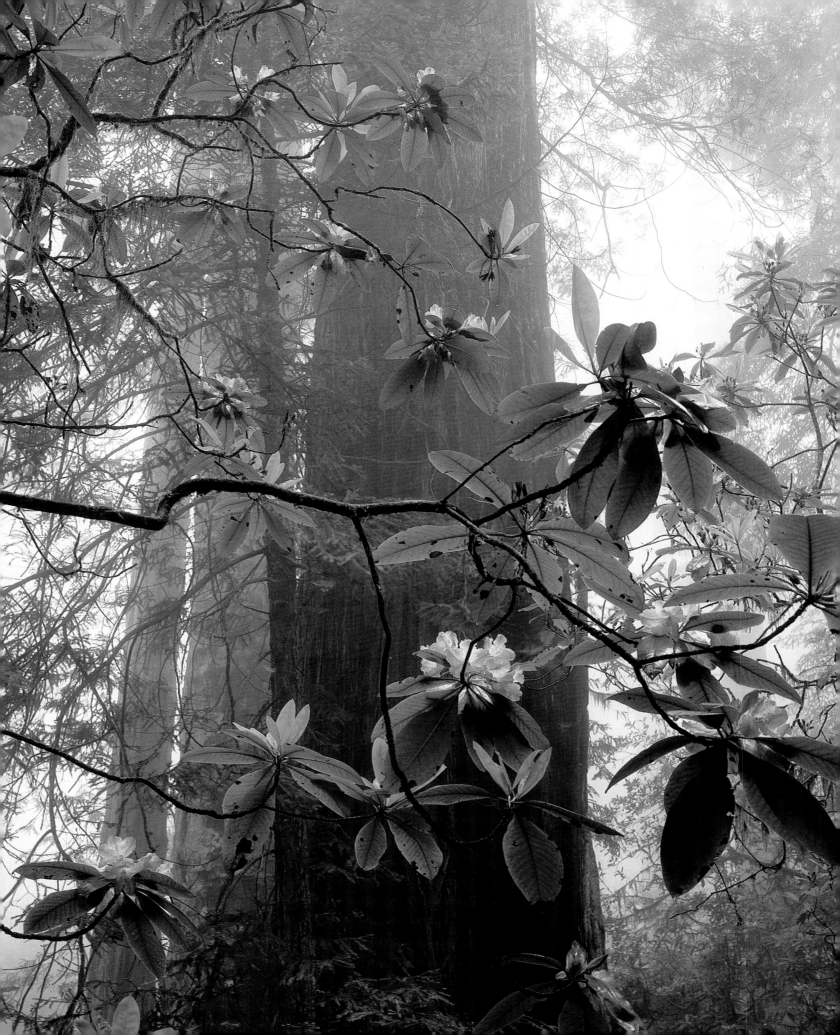

EXPLORE AMERICA

Scenic Highways

Reader's Digest

THE READER'S DIGEST ASSOCIATION, INC.
Pleasantville, New York / Montreal

SCENIC HIGHWAYS was created and produced by ST. REMY MULTIMEDIA INC.

STAFF FOR SCENIC HIGHWAYS
Series Editor: Elizabeth Cameron
Art Director: Solange Laberge
Editor: Elizabeth Warrington Lewis
Assistant Editor: Neale McDevitt
Photo Researcher: Linda Castle
Cartography: Hélène Dion, David Widgington
Designer: Anne-Marie Lemay
Research Editor: Robert B. Ronald
Contributing Researcher: Olga Dzatko
Copy Editors: Joan Page McKenna, Judy Yelon
Index: Linda Cardella Cournoyer
Production Coordinator: Dominique Gagné
System Coordinator: Éric Beaulieu
Technical Support: Mathieu Raymond-Beaubien, Jean Sirois
Scanner Operators: Martin Francoeur, Sara Grynspan

ST. REMY STAFF
PRESIDENT, CHIEF EXECUTIVE OFFICER: Fernand Lecoq
PRESIDENT, CHIEF OPERATING OFFICER: Pierre Léveillé
VICE PRESIDENT, FINANCE: Natalie Watanabe
MANAGING EDITOR: Carolyn Jackson
MANAGING ART DIRECTOR: Diane Denoncourt
PRODUCTION MANAGER: Michelle Turbide

Writers: Rita Ariyoshi—Road to the Crater
Lori Erickson—The Great Platte River Road
Rod Gragg—The Beartooth Highway, Coastal Route
Kim Heacox—George Parks Highway
Jim Henderson—Natchez Trace Parkway
Pierre Home-Douglas—Skyline Drive
K. M. Kostyal—Roadside Vermont
Steven Krolak—Sawtooth Drive, The Sunset Coast

Contributing Writers: Adriana Barton, Katy McDevitt, Patricia McDevitt, Ned Meredith

Address any comments about *Scenic Highways*
to U.S. Editor, General Books, c/o Customer Service,
Reader's Digest, Pleasantville, NY 10570

READER'S DIGEST STAFF
Editor: Kathryn Bonomi
Art Editor: Eleanor Kostyk
Production Supervisor: Mike Gallo
Editorial Assistant: Mary Jo McLean

READER'S DIGEST GENERAL BOOKS
**Editor-in-Chief, Books and
Home Entertainment:** Barbara J. Morgan
Editor, U.S. General Books: David Palmer
Executive Editor: Gayla Visalli
Managing Editor: Christopher Cavanaugh

Opening photographs
Cover: Farm near Marietta, Ohio, in Washington County
Back Cover: Heceta Head Lighthouse, Devil's Elbow State Park, Oregon
Page 2: Redwood National Park, California
Page 5: Coconino National Forest, Arizona

Library of Congress Cataloging in Publication Data

Scenic highways.
 p. cm.—(Explore America)
 Includes index.
 ISBN 0-89577-906-4
 1. United States—Tours. 2. Automobile travel—United States—
Guidebooks. 3. Roads—United States—Guidebooks. 4. Scenic
byways—United States—Guidebooks. I. Reader's Digest Association.
II. Series.
 E158.S3 1997
 917.304'929—dc21 97-14290

CONTENTS

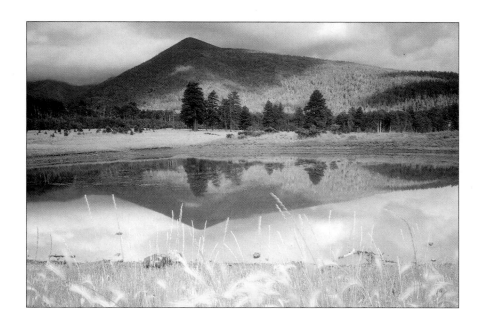

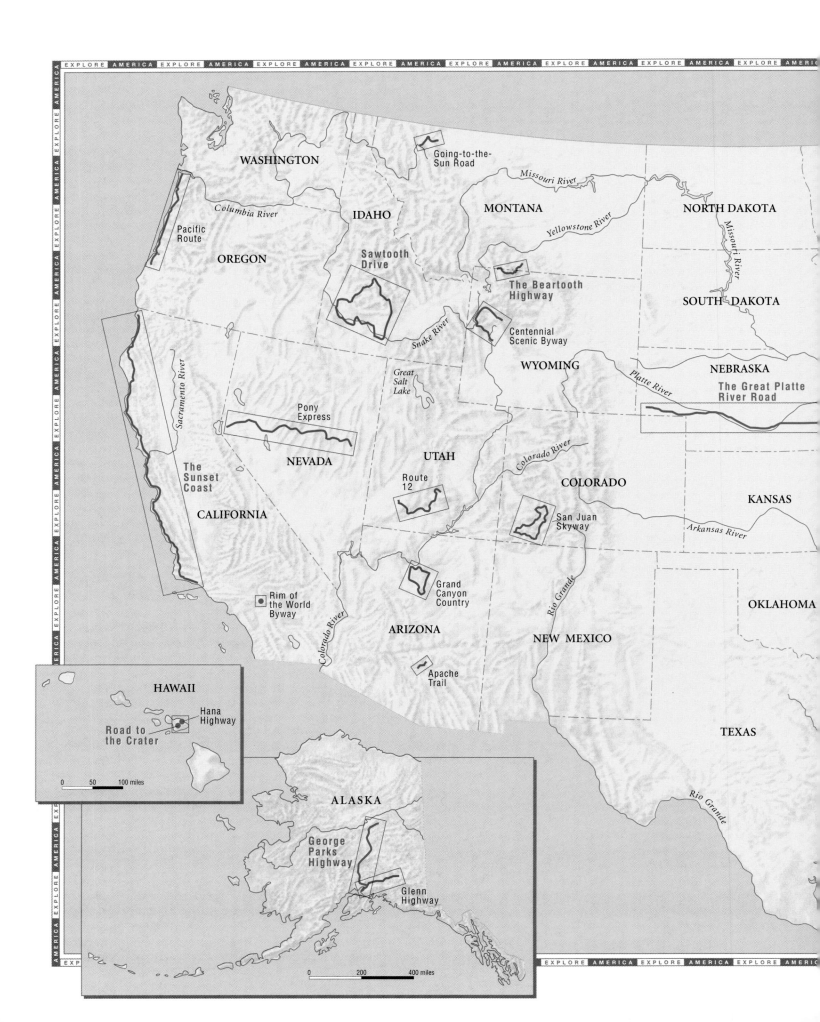

SCENIC HIGHWAYS

Lake Superior

MAINE

VERMONT

Lake Champlain Islands

Seaway Trail

NEW HAMPSHIRE

MASSACHUSETTS

Lake Huron

Roadside Vermont

Lake Ontario

NEW YORK

Old King's Highway

RHODE ISLAND

CONNECTICUT

Lake Michigan

Lakeside Drive

WISCONSIN

MICHIGAN

Lake Erie

PENNSYLVANIA

Through the Marshlands

NEW JERSEY

MINNESOTA

Kettle Moraine Scenic Drive

Mississippi River

OHIO

Old National Highway

D. C.

DELAWARE

MARYLAND

IOWA

INDIANA

Covered Bridge Scenic Byway

Skyline Drive

George Washington Memorial Parkway

ILLINOIS

Ohio River Scenic Route

WEST VIRGINIA

Missouri River

Ohio River

VIRGINIA

MISSOURI

Bluegrass Route

KENTUCKY

NORTH CAROLINA

TENNESSEE

Route 7

Mississippi River

SOUTH CAROLINA

Coastal Route

ARKANSAS

Highway 176

Talimena Scenic Byway

GEORGIA

ALABAMA

Natchez Trace Parkway

LOUISIANA

MISSISSIPPI

Creole Trail

FLORIDA

0 100 200 300 miles

The Keys

READER'S GUIDE

"Great beautiful clouds floated overhead, valley clouds that made you feel the vastness of . . . America from mouth to mouth and from tip to tip," wrote Jack Kerouac in his famous novel On The Road. America's network of highways makes it easy for motorists to explore the diversity of the nation. Part I presents 10 scenic drives—from the rolling hills and valleys of Vermont's Route 100 to the breathtaking mountain vistas of Wyoming's Beartooth Highway (in green on this map). Part II, the Gazetteer, provides photographs, maps, and descriptions of 27 others. A legend explaining the symbols for facilities and map features can be found on the front inside cover.

VIRGIN ISLANDS

PUERTO RICO

0 50 100 miles

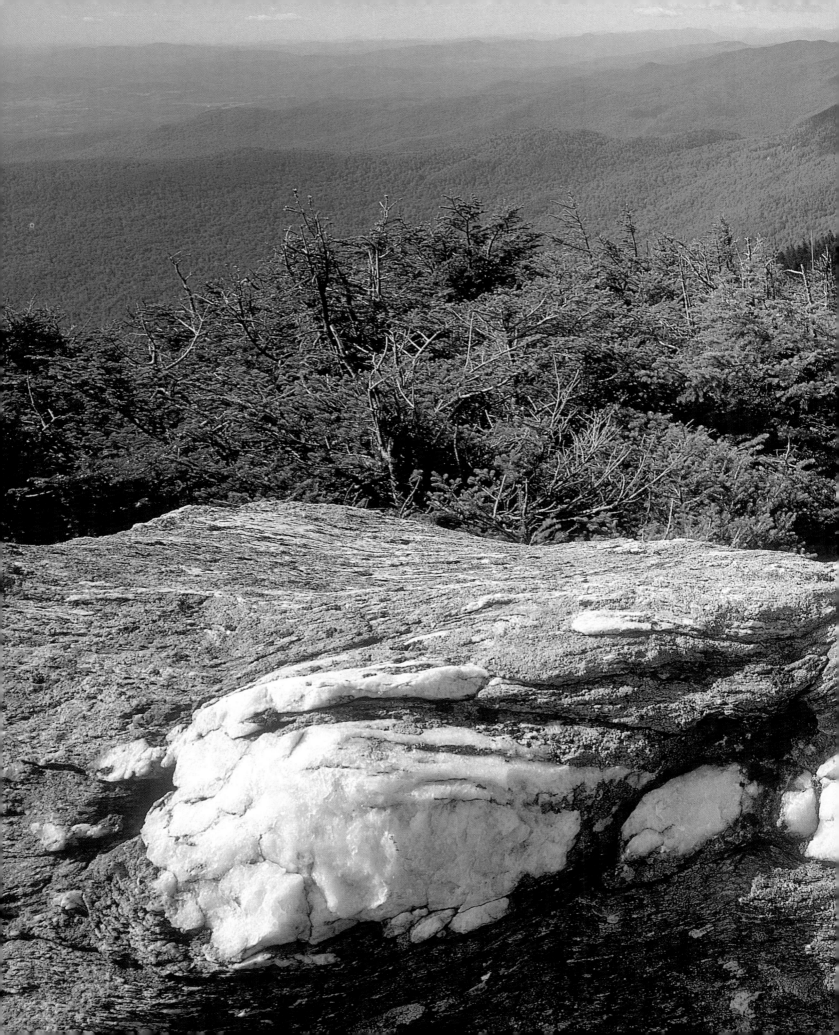

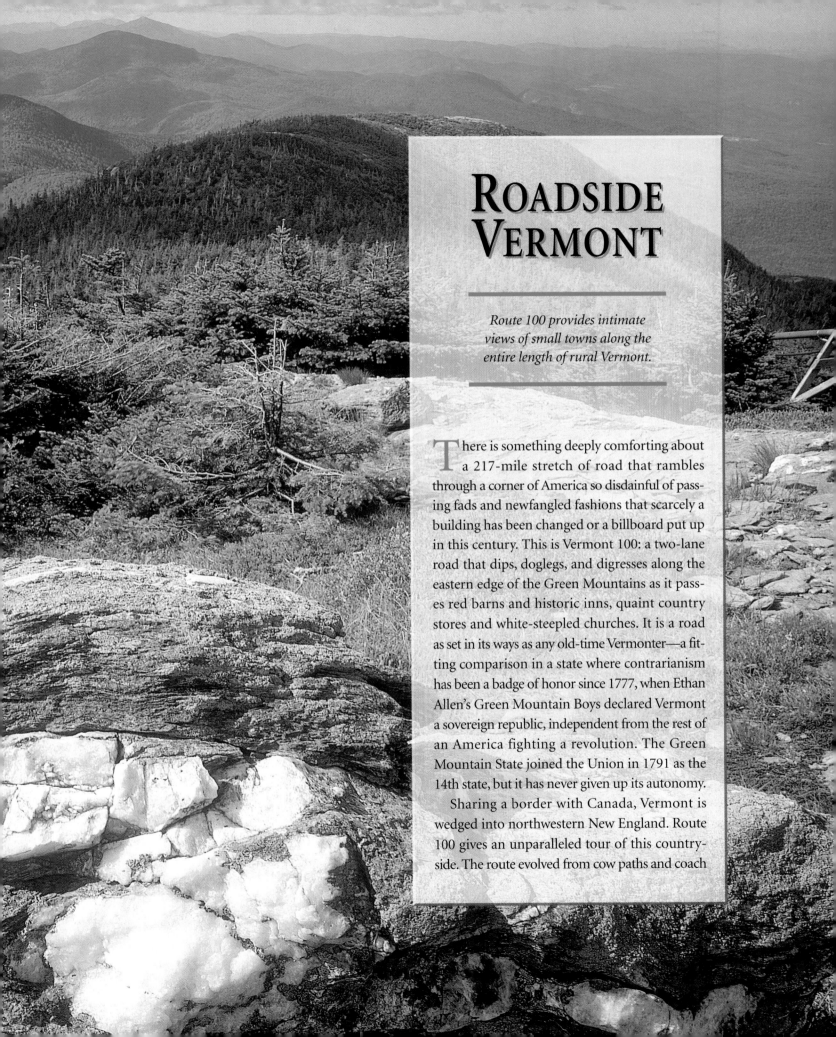

ROADSIDE VERMONT

Route 100 provides intimate views of small towns along the entire length of rural Vermont.

There is something deeply comforting about a 217-mile stretch of road that rambles through a corner of America so disdainful of passing fads and newfangled fashions that scarcely a building has been changed or a billboard put up in this century. This is Vermont 100: a two-lane road that dips, doglegs, and digresses along the eastern edge of the Green Mountains as it passes red barns and historic inns, quaint country stores and white-steepled churches. It is a road as set in its ways as any old-time Vermonter—a fitting comparison in a state where contrarianism has been a badge of honor since 1777, when Ethan Allen's Green Mountain Boys declared Vermont a sovereign republic, independent from the rest of an America fighting a revolution. The Green Mountain State joined the Union in 1791 as the 14th state, but it has never given up its autonomy.

Sharing a border with Canada, Vermont is wedged into northwestern New England. Route 100 gives an unparalleled tour of this countryside. The route evolved from cow paths and coach

ICE-AGE RELICS

Overleaf: Lichens and arcticlike plants grow on the rocky alpine summit of the Nose, Mount Mansfield's middle peak. The Green Mountain range, which runs the length of Vermont, includes the highest peaks in the state, with Mount Mansfield topping them all at 4,393 feet.

SNOWBOUND TREASURES

The valuable collection of the Noyes House Historical Museum in Morrisville, below, is displayed in the Federal-style home inhabited by the Noyes family from 1870 to 1950. Items include Toby jugs, old tavern signs, farming implements, and other artifacts of 19th-century Vermont life.

roads that once linked many of Vermont's 19th-century settlements. Today travelers feel an irresistible urge to set their pace to that of the villages they drive through—communities searching for creative ways to survive and still keep small-town traditions alive. Local businesses retain the old-fashioned values, and town historical museums offer glimpses into local lore and history. In the fall nature works its magic, recasting the luxuriant green forests in brilliant orange and red hues.

PROPHET'S BIRTHPLACE

The highway begins in the south by zigzagging in a seemingly haphazard way along the border of Massachusetts. It soon reaches Whitingham, birthplace of one of Vermont's most famous independent thinkers, Brigham Young. The Mormon leader was born on a farm here in 1801 to a poor basket maker. In 1847 he led his flock—members of the newly created Church of Jesus Christ of Latter-day Saints—from Nauvoo, Illinois, to Utah, where they founded Salt Lake City. A roadside marker describes Young as "a man of much courage and superb equipment," and a marble memorial to him has been set up in a park on Town Hill.

A couple of miles farther east is the town of Jacksonville, home of the North River Winery.

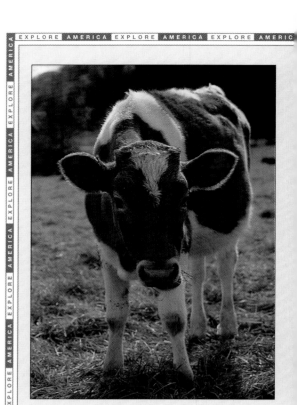

CURIOUS CALF

A heifer, above, poses for the camera and takes a break from munching on the thick grass that grows in western Vermont's rich pasturelands.

INFORMATION FOR VISITORS

Route 100 extends for about 217 miles from the towns of Stamford, in southern Vermont, to Newport, near the northern border with Canada. Access roads from the highway lead to many of Vermont's alpine and cross-country ski resorts. Visitors who wish to view the fall foliage at its height, in October, are advised to reserve accommodations well in advance. The largest commercial airport, which serves the region, is located in Burlington.
For more information: Vermont Division for Historic Preservation, 135 State St., Montpelier, VT 05633; 802-828-3226.
Vermont Travel Division, 134 State St., Montpelier, VT 05602; 802-828-3237 or 800-837-6668.

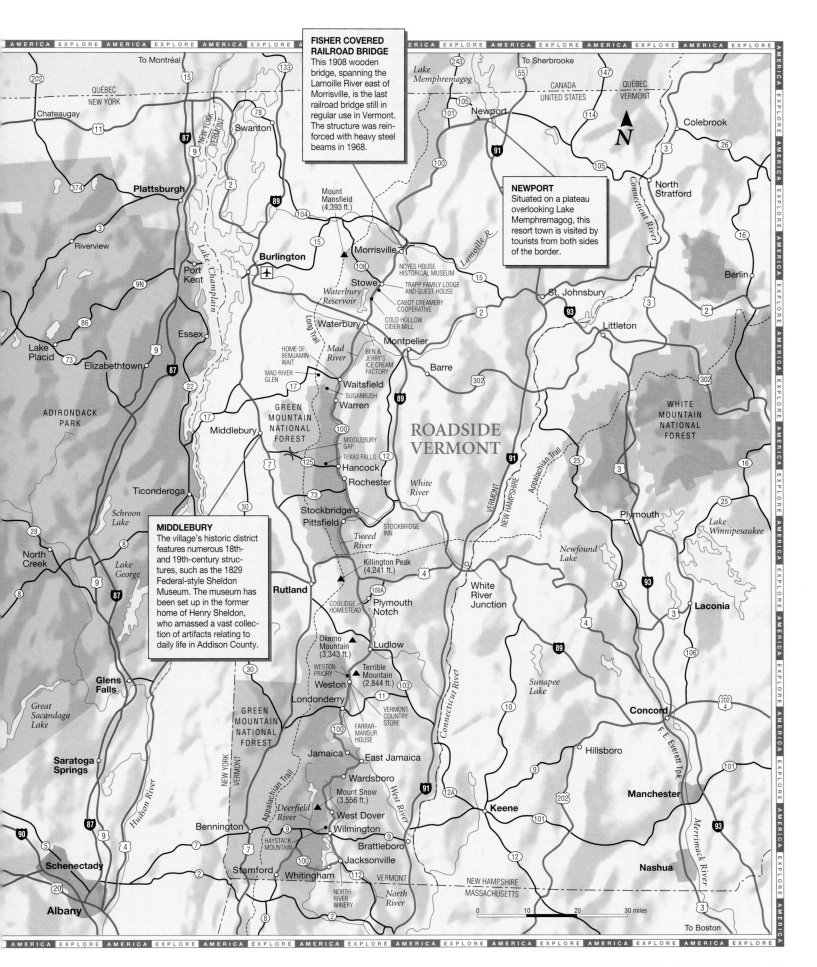

FISHER COVERED RAILROAD BRIDGE
This 1908 wooden bridge, spanning the Lamoille River east of Morrisville, is the last railroad bridge still in regular use in Vermont. The structure was reinforced with heavy steel beams in 1968.

NEWPORT
Situated on a plateau overlooking Lake Memphremagog, this resort town is visited by tourists from both sides of the border.

MIDDLEBURY
The village's historic district features numerous 18th- and 19th-century structures, such as the 1829 Federal-style Sheldon Museum. The museum has been set up in the former home of Henry Sheldon, who amassed a vast collection of artifacts relating to daily life in Addison County.

ROADSIDE VERMONT

To Montréal

QUÉBEC
NEW YORK

Chateaugay

Plattsburgh

Swanton

Riverview

Port Kent

Burlington

Essex

Lake Placid

Elizabethtown

ADIRONDACK PARK

Ticonderoga

Schroon Lake

North Creek

Lake George

Middlebury

GREEN MOUNTAIN NATIONAL FOREST

MIDDLEBURY GAP
TEXAS FALLS
Hancock
Rochester

Stockbridge
Pittsfield
Tweed River

Rutland

COOLIDGE HOMESTEAD
Plymouth Notch

Okemo Mountain (3,343 ft.)
Ludlow

WESTON PRIORY
Weston
Terrible Mountain (2,844 ft.)
Londonderry

Glens Falls

Saratoga Springs

Great Sacandaga Lake

GREEN MOUNTAIN NATIONAL FOREST

FARRAR-MANSUR HOUSE

Jamaica
East Jamaica

Wardsboro

Mount Snow (3,556 ft.)
Deerfield River
West Dover
Wilmington

Bennington

HAYSTACK MOUNTAIN

Stamford
Whitingham

NORTH RIVER WINERY
North River

Schenectady

Albany

Lake Memphremagog

To Sherbrooke

CANADA
UNITED STATES

QUÉBEC
VERMONT

Newport

Colebrook

North Stratford

Connecticut River

Berlin

St. Johnsbury

Littleton

Mount Mansfield (4,393 ft.)

Morrisville

NOYES HOUSE HISTORICAL MUSEUM

Stowe
TRAPP FAMILY LODGE AND GUEST HOUSE
CABOT CREAMERY COOPERATIVE
Waterbury Reservoir
COLD HOLLOW CIDER MILL

Waterbury

Long Trail

HOME OF BENJAMIN WAIT

MAD RIVER GLEN

Mad River

Waitsfield

SUGARBUSH
Warren

Montpelier

BEN & JERRY'S ICE CREAM FACTORY

Barre

ROADSIDE VERMONT

White River

WHITE MOUNTAIN NATIONAL FOREST

Appalachian Trail

Plymouth

Lake Winnipesaukee

Newfound Lake

Killington Peak (4,241 ft.)

STOCKBRIDGE INN

White River Junction

Laconia

VERMONT
NEW HAMPSHIRE

Sunapee Lake

Connecticut River

VERMONT COUNTRY STORE

West River

Concord

Hillsboro

Keene

Manchester

Merrimack River

Nashua

Brattleboro

Jacksonville

VERMONT
NEW HAMPSHIRE
MASSACHUSETTS

0 10 20 30 miles

To Boston

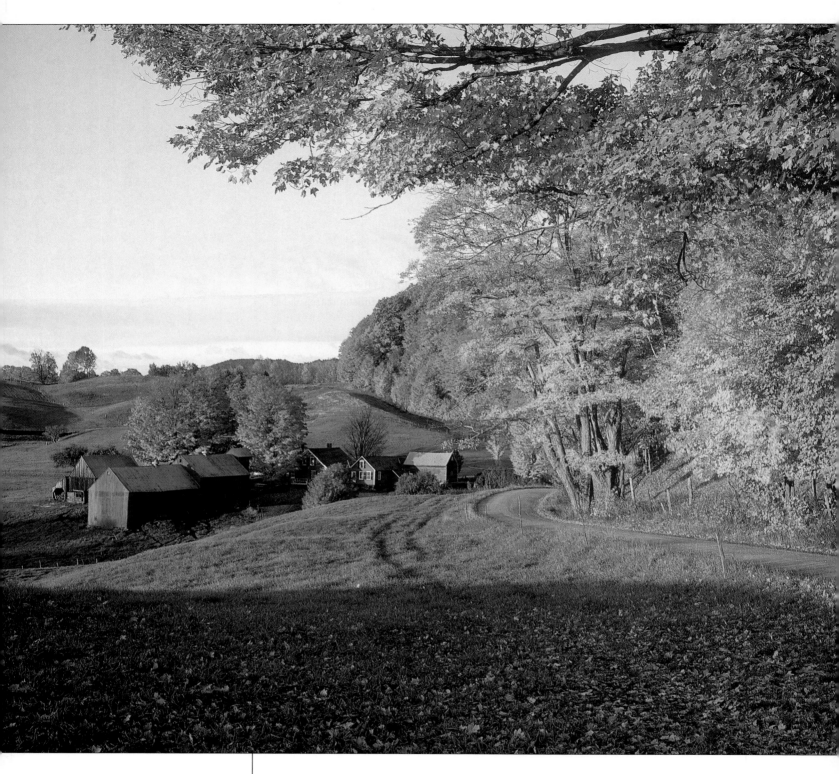

COLORFUL VERMONT
Rich gold and orange autumn foliage complements the red of farm buildings in the Woodstock area of Vermont, above.

Undeterred by the cold northern clime, the vineyard grows its grapes on riverside farmland. The owners offer tastings and tours of a back room that is lined with barrels of fermenting spirits.

As Route 100 leaves Jacksonville, it hits its stride and tunnels confidently northward through a cool, evergreen-scented forest. Swooping into the open swell of Deerfield Valley, it runs through the middle of Wilmington, the area's hub and a town with a colorful 300-year history of pioneering, millwork, and railroading. Unadorned 18th- and 19th-century buildings have been converted to

inns, restaurants, and shops that display and sell items made by Vermont potters, stained-glass workers, weavers, and other artisans.

GREEN MOUNTAIN SKI COUNTRY

Following the rills of the North River out of town, the road heads toward West Dover and the ski slopes of Green Mountain country. The ribboned sides of 3,556-foot Mount Snow loom into view, with Haystack Mountain nearby. One of the oldest ranges in the United States, this rugged spine

compared to those of many out-of-state tourist areas. The construction of ski resorts here in the 1950's spurred roadside development that began to clutter West Dover, and Vermonters decided to press for preservation action. In the late 1960's, the Vermont legislature passed a law that banned roadside billboards.

In less time than it takes to wait in a ski-lift line, Route 100 has left West Dover and started to bob and bend along the edge of the mountains, passing through Wardsboro, the Jamaicas, and the old mill town of Londonderry, which overlooks the West River. Never straying far from the water, the road soon becomes Main Street in the quintessential Vermont village of Weston. In the summer the village green and its Victorian bandstand are shaded by stalwart maples that, in autumn, shimmer vibrantly in the clear New England light.

The Farrar-Mansur House, built in 1797, looks onto the green. Once the local tavern, it now serves as the town museum. The Weston Mill Museum, on the river's edge, honors the days of old with displays of cooperage, farming, and milling tools. A classic example of that venerable Vermont institution, the country store, has attracted visitors to Weston for more than a half-century, ever since local writer Vrest Orton opened his business. The Vermont Country Store, in keeping with time-honored tradition, still stocks and sells everything from all-weather slickers and long underwear to gourmet cookware and local cheeses.

The Weston Priory, a few miles north of Weston just off Route 100, is an active monastery. The

up the middle of the state boasts close to 100 peaks that reach heights greater than 2,000 feet. In 1954 entrepreneur Walter Schoenknecht bought farmland and turned it into a schussers' paradise. Skiers still flock to Mount Snow every winter. And when the softness of summer light dapples the mountains, hikers and mountain bikers arrive, taking ski lifts up to a ridgeline trail with views that open up on the rolling, village-dotted terrain.

In West Dover the area's country charm temporarily gives way to motel signs offering hot tubs, cheap meals, and bargain rates—fairly discreet ads

ALL-AMERICAN HOMESTEAD
Plymouth Notch, below, the birthplace of Calvin Coolidge, is a tiny 19th-century hamlet. It features a community dance hall that served as the 1924 summer White House and the Coolidge Homestead. Vice-President Coolidge was visiting here on August 3, 1923, when he learned that President Harding had died. In his role as a notary public, Calvin's father, Col. John Coolidge, swore Calvin in as the 30th president in the family home.

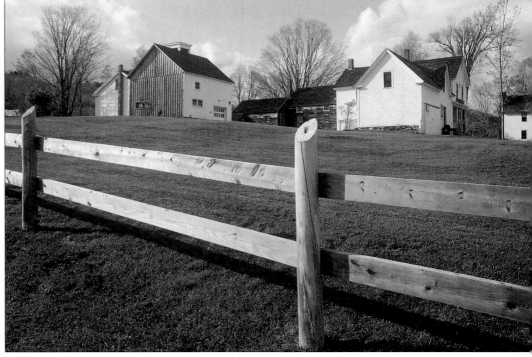

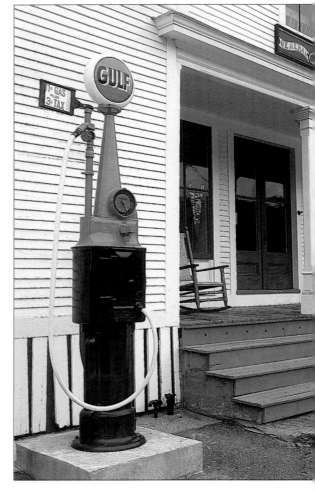

REMEMBER THE DAYS
An antique gas pump, right, sits in front of the General Store in Plymouth Notch. Calvin Coolidge's homestead is behind the store.

BORDER TO BORDER
The two units of Green Mountain National Forest include 355,000 acres of lakes, mountains, and streams, such as the one pictured below. One unit is situated in the middle of the state and the other is tucked into the southwestern corner.

Benedictine brothers welcome worshipers to daily celebrations of the Eucharist accompanied by original liturgical choral music. The monks began composing their music in the 1960's, and they released their first album in 1971. The priory also operates a shop that carries apples, maple syrup, and priory-made crafts.

Beyond Weston the road climbs up the forested slopes of 2,800-foot Terrible Mountain and descends into Ludlow, a town that lies in the shadow of another peak—3,343-foot Okemo Mountain. Now a bustling winter center attracting skiers from Okemo and elsewhere, this crossroads market town prospered during the Civil War period, when it began to manufacture a textile called shoddy, made from reworked wool.

North of Ludlow, a string of little lakes—Rescue, Echo, and Amherst—appears, each fringed by greenery that fires in autumn into burnished reds and golds. In winter ice-fishing shacks spring up on the frozen lakes, sheltering anglers from the cold and wind as they drop their fishing lines into the water through holes cut in the ice.

A short detour to the northeast along Vermont 100A leads to the Coolidge Homestead in Plymouth Notch. The man who would become the 30th president of the United States was born in 1872 in this white clapboard hamlet, a village reminiscent of a

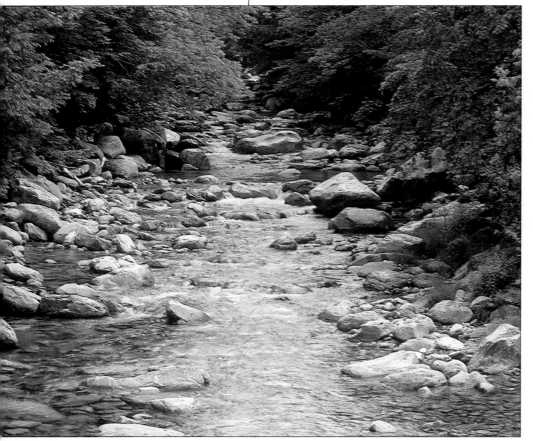

work by the 19th-century printmakers Currier & Ives. Down the lane stands a cheese factory built in 1890 by Calvin's father, John Coolidge, and reopened by Calvin's son, John, in the 1960's. Visitors are welcome to tour the modest operation and taste its delicious cheddars.

Before heading back to the main highway, visitors may wish to visit the Plymouth Cemetery around the corner from the factory, where six generations of Coolidges, including the president, his mother, father, and stepmother, are buried.

North of Plymouth lies Killington, the largest downhill ski resort in the East. When the snow has melted, the ski lift is commandeered by hikers and bikers, who fan out across the soaring 4,241-foot summit of Killington Peak and take one of 15 hiking trails into the forested backcountry. Long Trail edges across the face of Killington and intersects the Maine-to-Georgia Appalachian Trail.

The tempo along Vermont 100 slows to a steady rhythm as the road leaves the lively tourist ambience of Killington and heads north under a canopy of trees on the outskirts of the Green Mountain National Forest. Pittsfield is little more than a crossroad town, its quiet air broken by the bubbling of the Tweed, a fast-running river spanned by a covered bridge. Bending abruptly to the east, the highway reaches Stockbridge, where the verandaed

Stockbridge Inn has taken in guests since the 1860's. After Stockbridge comes Rochester, a village of 36,608 lovely acres and some 1,000 residents. A detour west along Route 125 at Hancock arrives at Texas Falls, whose gentle, icy cascade swirls and tumbles over bedrock worn smooth by the millennia. Two nature trails on the site plunge into an evergreen forest rife with ferns.

Moving steadily north, Route 100 reaches Warren, which is situated beside the cantankerous north-running Mad River. During winter a local inn offers sleigh rides through the snowy countryside followed by hot cider sipped leisurely in front of the farmhouse hearth—enticements that few winter travelers can ignore.

some of its original 1790's architectural features. In the early spring, when the melting season sets in, Waitsfield farmers take to the woods to tap the trees for their freshly running sap. Visitors are welcome to stop by one of the many sugarhouses that dot the area and watch as the clear sap of the maples is boiled into a sweet, light-amber elixir.

ICE CREAM EMPIRE

Leaving Waitsfield behind, the road travels through open farm country polka-dotted by grazing Holsteins. Just outside Waterbury, Interstate 89 goes through an underpass and emerges to find the barnlike building of ice cream moguls Ben Cohen and Jerry Greenfield.

Waitsfield, which is a few miles up the road, near Sugarbush and Mad River Glen, also draws skiers. But like other villages along this road, Waitsfield long predates the resort scene. Its historic district boasts genteel antique homes, including the dignified clapboard home of Gen. Benjamin Wait, a veteran of both the French and Indian War and the American Revolution who went on to found the village that bears his name. Although the Wait home has been remodeled extensively, it retains

Ben and Jerry got their start in 1977 when, as young transplants from Long Island, they wrote away for a $5 correspondence course on ice cream making. Within a year the partners had turned a gas station in Burlington into an ice cream parlor. Today the chunky, fruity, fabulous confections of Ben & Jerry's are sold all over the world. But here at their factory it quickly becomes clear what energetic entrepreneurialism spiced with whimsy can do for industry. Ben & Jerry's motto is "If it's not fun,

RIVERSIDE IDYLL
Hungry cattle roam the green pastures of a dairy farm, above, near the town of West Arlington in southern Vermont.

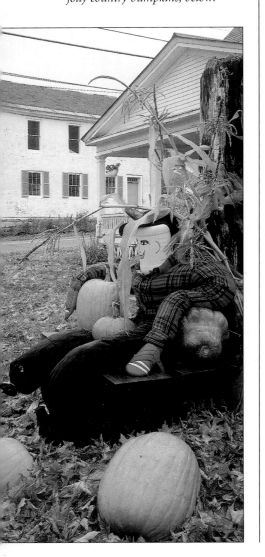

why do it?" Tours through the plant are both fun and interesting as guides describe the company's practice of responsible, caring capitalism and its commitment to the town of Burlington. On the floor of the factory production room, machines guzzle hundreds of gallons of Vermont milk. Factory tours end in the tasting room, where guests are invited to sample the flavor of the day.

Beyond the factory the terrain opens up on the way to Stowe. The businesses scattered along the road sell Vermont-made products, such as cider, maple syrup, cheeses, and crafts. At the Cold Hollow Cider Mill, the smell of apples wafts through big barnlike buildings where fruit is crushed into sweet cider as curious visitors look on. A little farther along, the Cabot Creamery Annex sells aged cheddar, Monterey Jack, and the famous flavored cheddars produced by Vermont's Cabot Creamery Cooperative.

Entering Stowe travelers will come upon the graceful Congregational Community Church, built in 1864. The church is a reminder that for all its popularity as a ski mecca, Stowe continues to adhere to New England traditions.

In 1933 the Depression-era Civilian Conservation Corps began cutting trails down the slopes of 4,393-foot Mount Mansfield for use by local skiers and hikers. Word of the mountain's ski potential got out and by 1940 Stowe claimed one of the first chairlifts in the country. Today many fine inns and lodges are found along the small roads that twist at the base of Mount Mansfield and Spruce Peak, including one owned by the von Trapp family of *The Sound of Music* fame. The von Trapps fled

Nazi-torn Austria at the beginning of World War II and eventually settled in the Stowe area because it reminded them of their native Alps. The family's timbered Tyrolean-style lodge has perched above the town since 1940 and flourished ever since their family saga was pictured on the silver screen. Guests enjoy a variety of activities including hiking, tennis, fishing, and, of course, skiing. In December 1980 a fire razed the original lodge, but three years later a new lodge began receiving guests.

In winter visitors to Stowe can take sleigh rides through the snow-blanketed landscape and ice skate at a local rink. Downhill runs and more than 60 miles of cross-country trails lace the mountains. In the summer hikers climb Mount Mansfield along the five-mile Stowe Recreation Path, which plunges through cornfields and meadows filled with a riot of wildflowers.

SIMPLE ENDING

From Stowe the route plows doggedly through northeastern Vermont, past cultivated fields and stony pastures. In the fall the region's lakes showcase reds, golds, and yellows, and local neighborhood groups throw harvest dinners for the leaf-peepers. But most of the time visitors are left to do as they please. As the highway nears the Canadian border, the car radio may pick up the sounds of *Québécois* French. About 40 miles from Stowe and just a few miles west of Lake Memphremagog, Vermont 100 meets Routes 101 and 105. It is, perhaps, a rather sudden end to the leisurely meandering that has taken travelers through the very heart of Vermont.

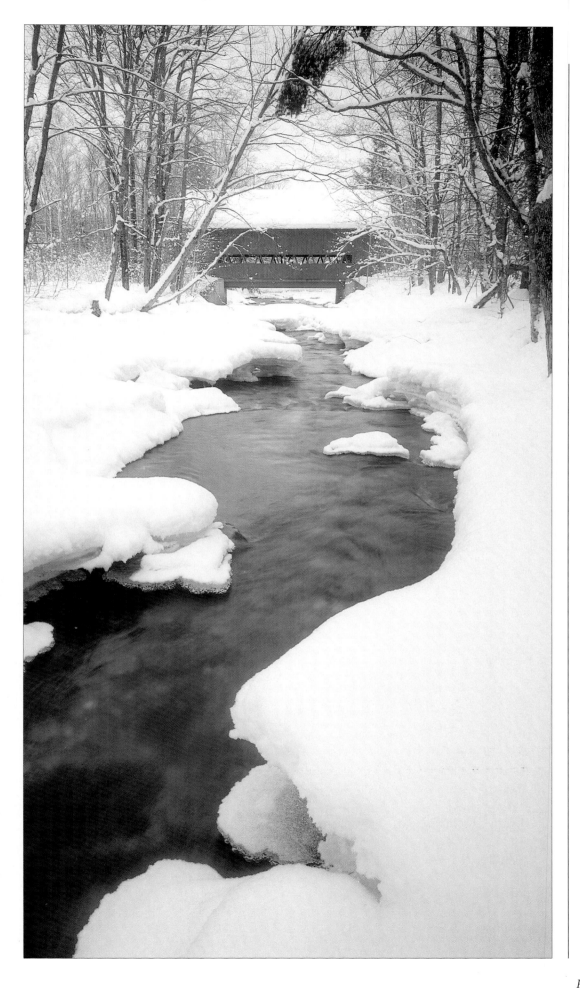

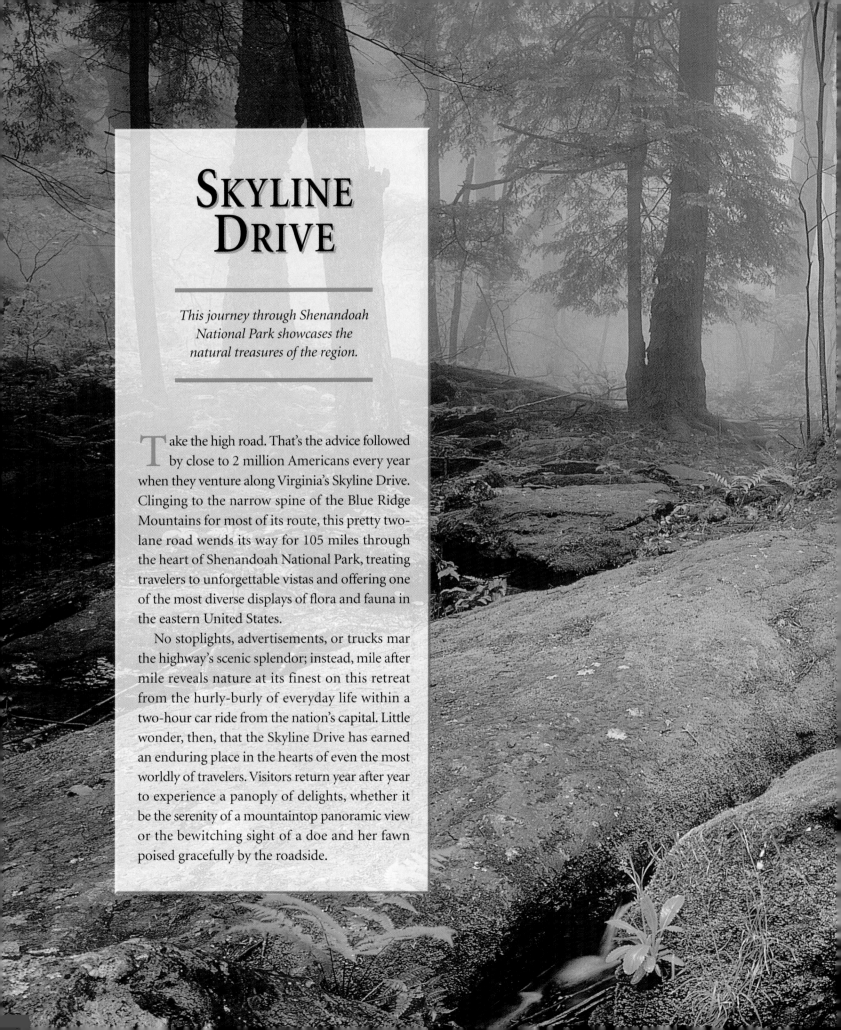

SKYLINE DRIVE

This journey through Shenandoah National Park showcases the natural treasures of the region.

Take the high road. That's the advice followed by close to 2 million Americans every year when they venture along Virginia's Skyline Drive. Clinging to the narrow spine of the Blue Ridge Mountains for most of its route, this pretty two-lane road wends its way for 105 miles through the heart of Shenandoah National Park, treating travelers to unforgettable vistas and offering one of the most diverse displays of flora and fauna in the eastern United States.

No stoplights, advertisements, or trucks mar the highway's scenic splendor; instead, mile after mile reveals nature at its finest on this retreat from the hurly-burly of everyday life within a two-hour car ride from the nation's capital. Little wonder, then, that the Skyline Drive has earned an enduring place in the hearts of even the most worldly of travelers. Visitors return year after year to experience a panoply of delights, whether it be the serenity of a mountaintop panoramic view or the bewitching sight of a doe and her fawn poised gracefully by the roadside.

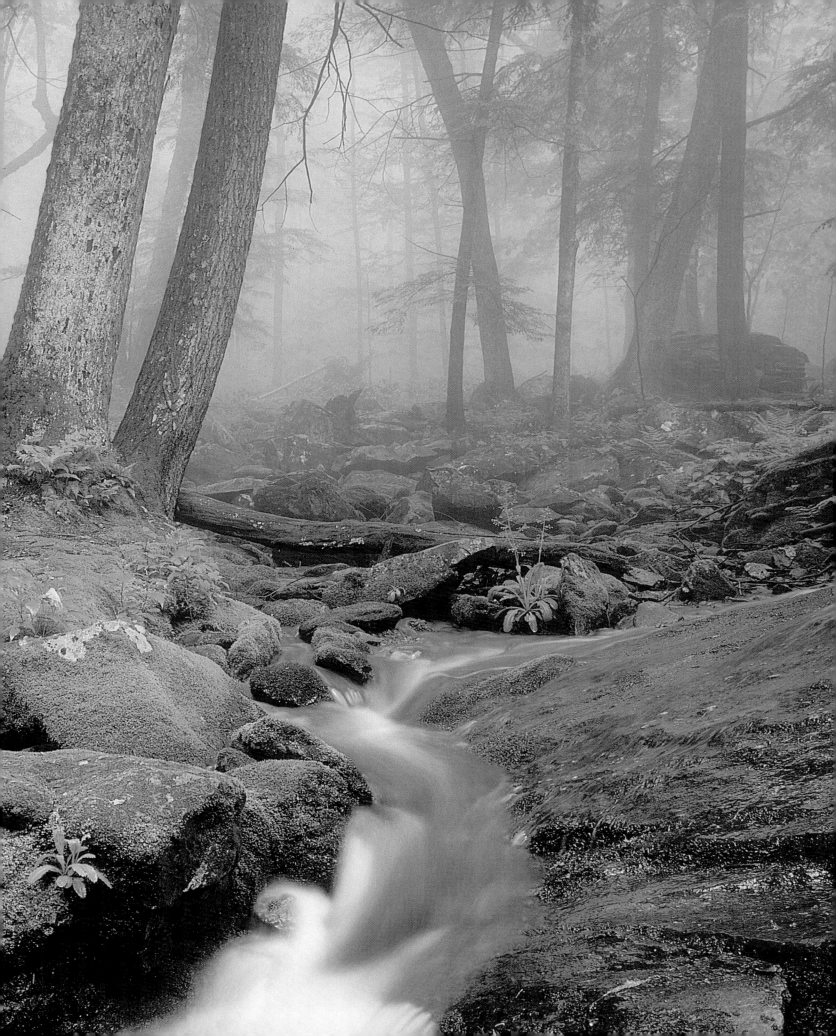

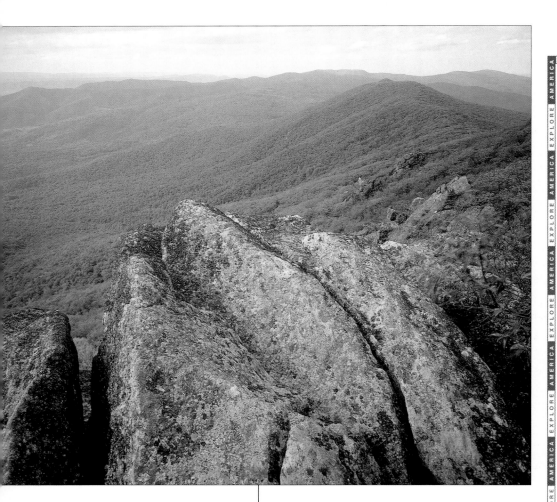

GREEN, GREEN VALLEY
From Pinnacles Overlook, above, the verdant spring carpet of Shenandoah National Park stretches into the distance.

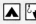
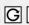

INFORMATION FOR VISITORS

The Skyline Drive is 105 miles long. It can be accessed at four points: at Rockfish Gap on I-64 near Waynesboro; Swift Run Gap on Hwy. 33 east of Elkton; Thornton Gap on Hwy. 211 between Luray and Sperryville; and just outside Front Royal on Hwy. 340. A speed limit of 35 miles an hour must be maintained at all times. Shenandoah National Park is open year-round, but facilities and services are seasonal. Backcountry camping permits are required and can be obtained, along with trail maps for hiking and horseback riding, at the park headquarters, visitor centers, and entrance stations. Guided horseback rides are offered from May through October at Skyland. Schedules for guided nature walks, slide shows, and campfire programs are available at the visitor centers. For more information: Shenandoah National Park, 3655 U.S. Hwy. 211 E., Luray, VA 22835; 540-999-3500.

MEDICINAL PLANT
False hellebore, below, makes an appearance in Shenandoah National Park in early spring. Substances extracted from the plant are used in treating hypertension.

HIDDEN HOLLOW
Overleaf: Shrouded in mist, a swift-flowing creek and moss-covered rocks heighten the atmosphere of the aptly named Dark Hollow in Shenandoah National Park.

For many people, the Skyline Drive is synonymous with Shenandoah National Park—and with good reason: the history of the two is inextricably linked. In 1926 the U.S. Congress passed a bill to authorize a park in the Blue Ridge Mountains, with the proviso that no federal funds be spent to buy land. More than 24,000 Virginians raised a total of $1.3 million for the land, the state legislature provided another $1 million, and in 1935 Shenandoah National Park was officially established.

Work on the Skyline Drive began in 1931 and took eight years to complete. The first section to open, in 1934, was the middle third of the route, which runs from Thornton Gap to Swift Run Gap. The drive quickly earned accolades and bumper-to-bumper traffic. The last section was completed in 1939. The total cost for the route was just under $5 million, or $47,000 a mile—a bargain, as anyone who has driven the route would attest.

LEISURELY DRIVE

The speed limit along the length of the Skyline Drive is a sedate 35 miles an hour, which is not a hardship since most drivers want to take their time. There are interstate highways in the valleys and lowlands for travelers intent on speed. On this drive, reaching the destination isn't important; it is the journey itself that counts. Concrete markers posted every mile along

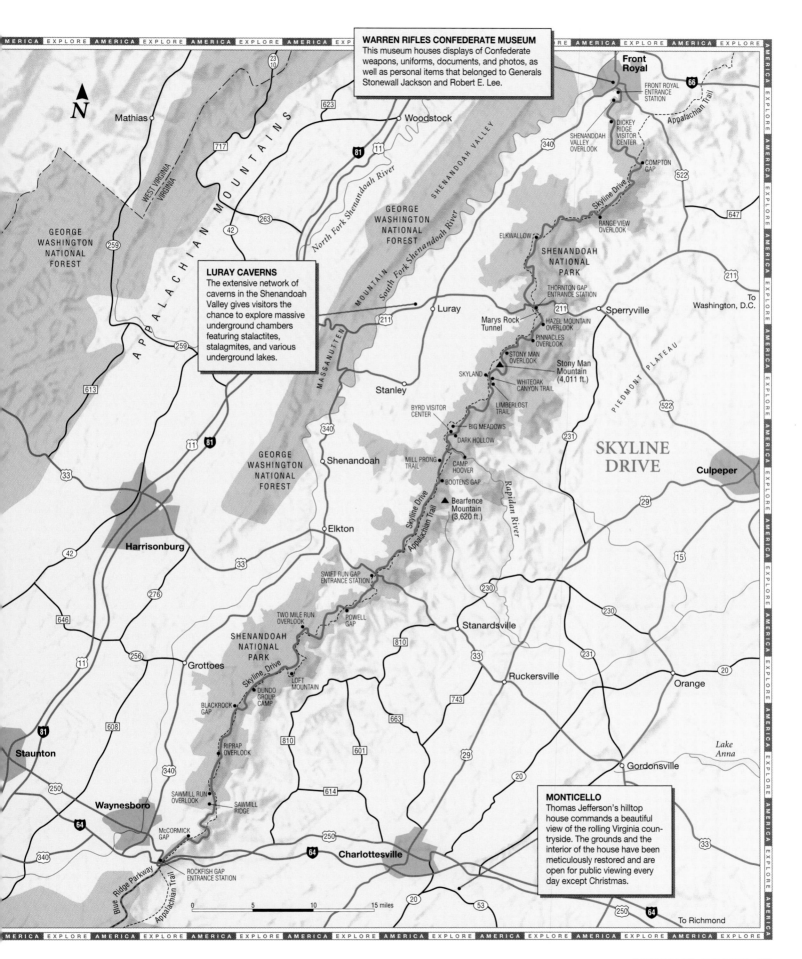

WARREN RIFLES CONFEDERATE MUSEUM
This museum houses displays of Confederate weapons, uniforms, documents, and photos, as well as personal items that belonged to Generals Stonewall Jackson and Robert E. Lee.

LURAY CAVERNS
The extensive network of caverns in the Shenandoah Valley gives visitors the chance to explore massive underground chambers featuring stalactites, stalagmites, and various underground lakes.

MONTICELLO
Thomas Jefferson's hilltop house commands a beautiful view of the rolling Virginia countryside. The grounds and the interior of the house have been meticulously restored and are open for public viewing every day except Christmas.

N

Mathias

Woodstock

Front Royal

FRONT ROYAL ENTRANCE STATION

DICKEY RIDGE VISITOR CENTER

SHENANDOAH VALLEY OVERLOOK

COMPTON GAP

Appalachian Trail

Skyline Drive

RANGE VIEW OVERLOOK

ELKWALLOW

SHENANDOAH NATIONAL PARK

WEST VIRGINIA
VIRGINIA

GEORGE WASHINGTON NATIONAL FOREST

GEORGE WASHINGTON NATIONAL FOREST

APPALACHIAN MOUNTAINS

North Fork Shenandoah River

South Fork Shenandoah River

SHENANDOAH VALLEY

MASSANUTTEN MOUNTAIN

Luray

Stanley

Shenandoah

Elkton

Harrisonburg

THORNTON GAP ENTRANCE STATION

Sperryville

To Washington, D.C.

Marys Rock Tunnel

HAZEL MOUNTAIN OVERLOOK

PINNACLES OVERLOOK

STONY MAN OVERLOOK

SKYLAND

Stony Man Mountain (4,011 ft.)

WHITEOAK CANYON TRAIL

LIMBERLOST TRAIL

BYRD VISITOR CENTER

BIG MEADOWS

DARK HOLLOW

MILL PRONG TRAIL

CAMP HOOVER

BOOTENS GAP

Bearfence Mountain (3,620 ft.)

Skyline Drive

Appalachian Trail

Rapidan River

PIEDMONT PLATEAU

SKYLINE DRIVE

Culpeper

SWIFT RUN GAP ENTRANCE STATION

TWO MILE RUN OVERLOOK

POWELL GAP

Stanardsville

SHENANDOAH NATIONAL PARK

Grottoes

Skyline Drive

LOFT MOUNTAIN

DUNDO GROUP CAMP

BLACKROCK GAP

RIPRAP OVERLOOK

Staunton

Ruckersville

Orange

Lake Anna

Gordonsville

SAWMILL RUN OVERLOOK

SAWMILL RIDGE

McCORMICK GAP

Waynesboro

Blue Ridge Parkway

Appalachian Trail

ROCKFISH GAP ENTRANCE STATION

Charlottesville

To Richmond

0 5 10 15 miles

SHADES OF RED AND PINK
In early spring the Skyline Drive is resplendent with vibrant colors. Pink azaleas, right, are a common sight along the road, and the bright red plumage of cardinals, below, can be glimpsed among the thickets and shrubs.

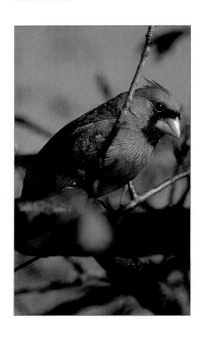

the west side of the route are numbered from north to south, making it easy for travelers to locate park facilities, services, and areas of interest.

The Skyline Drive begins at an elevation of 660 feet, just south of Front Royal, Virginia, which is a popular stopover for visitors bound for the drive into Shenandoah National Park. After passing through the northernmost entrance to the drive—and one of only four gateways to the route—the road begins its climb up to the ridge top. In springtime the green of budding trees creeps up these mountains at the rate of 100 feet a day, reaching the highest peaks only in late May.

The drive to the top of the ridge tests the motorist's skill on a series of hairpin turns and long sweeping curves that soon reach the Shenandoah Valley Overlook, the first of 75 vantage points scattered generously along the drive that beckon drivers to soak up the breathtaking views. To the west, the Shenandoah River is seen meandering across the valley. Confederate general Stonewall Jackson swung by this spot during his legendary Valley Campaign in the Civil War, when his small band of outnumbered soldiers repeatedly outfoxed their Union opponents. The actions of Jackson and other Confederates proved to be such a thorn in the side of the North that Gen. Ulysses S. Grant commanded his troops to lay waste to the valley, "so

that crows flying over it . . . will have to carry their provender with them."

The orders were carried out with alacrity. The Union forces commandeered livestock and torched the countryside, reducing the Breadbasket of the Confederacy to a wasteland. It is a measure of time's remarkable healing touch and the rejuvenating powers of nature that, seen from Shenandoah Valley Overlook today, the lush fields below sustain tidy riverside towns and prosperous farmlands.

AGE-OLD TRAIL

The drive reaches the crest of the Blue Ridge Mountains at Compton Gap, which also marks the highway's first encounter with the Appalachian Trail, the celebrated 2,159-mile-long footpath that extends from Springer Mountain in Georgia to Mount Katahdin in Maine. The historic trail parallels the Skyline Drive in Shenandoah National Park, crisscrossing it 28 times. More than 400 miles of side paths radiate from the trail and the road, taking hikers to the loftiest peaks in the park, through hushed aisles of cathedral-like forests, and down into moist, cool ravines where spectacular waterfalls spill noisily into pools. The Whiteoak Canyon Trail leads to five waterfalls, including one cataract that tumbles down more than 80 feet.

On its southward course, the Skyline Drive offers overlooks on both sides of the ridge. To the west stands Massanutten Mountain, a 40-mile-long rampart that splits the Shenandoah River in two—the North and South forks. During the Civil War, the mountain's Signal Knob was taken over as a Confederate semaphore site for relaying messages. Beyond the northern fork of the Shenandoah River, the Alleghenies rise in silhouette against the horizon. The rolling hills and farms of the Piedmont Plateau recede gently to the east.

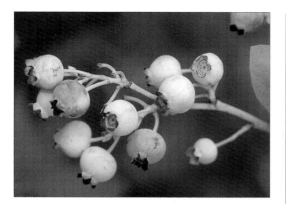

NATURE'S MAGIC HUES

No matter where visitors cast their gaze, the reason the Blue Ridge Mountains earned their name quickly becomes apparent. The quality of light in this part of the world, transformed by water vapors emitted by the trees, works a magic all its own. The deep green vegetation of the nearby hills fades gradually into an ineffable bluish hue and the ever-present haze blurs the demarcation between land and sky so that the two appear to blend seamlessly into one another.

The overall blue and green color scheme is animated by the wildflowers that line the drive and carpet the surrounding forest. The changing display begins as early as February, when the delicate pink and lavender of the hepatica blooms, and it doesn't let up until asters and goldenrods brandish their blue and yellow artistry in October. In the months between, almost every color of the spectrum is on view, from the hot pink profusion of wild azaleas to the pure white of large-flowered trilliums. In all, the national park supports close to 1,000 species of flowering plants—more than are found in all of Europe—including dogtooth violets, blazing stars, Turk's cap lilies, sweet cicelies, cut-leaf toothworts, and Dutchman's-breeches.

The trees add their own majestic sweeps of color in the fall, when the leaves of oaks, ash, sour gum hickories, dogwoods, and a host of other

AUTUMN IN THE MOUNTAINS
Seen from the Hazel Mountain Overlook, the contours of the Blue Ridge Mountains, below, are lightly overpainted with the yellows and oranges of early fall.

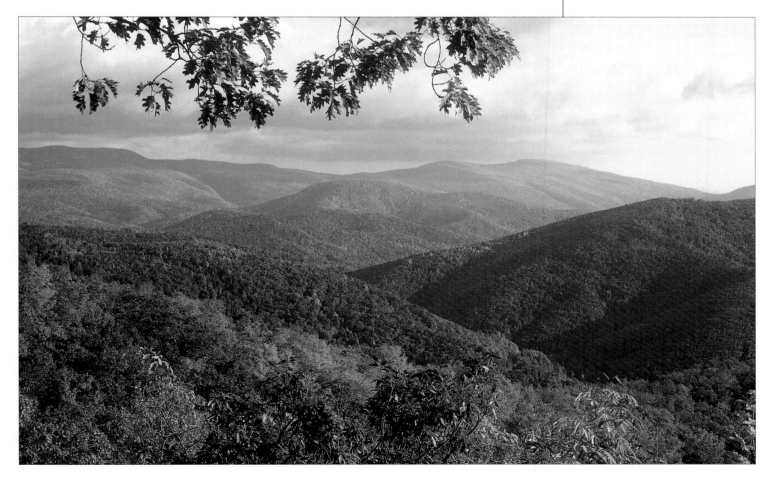

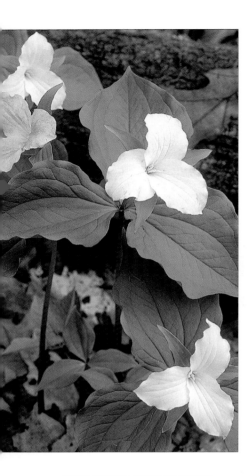

White and pink trilliums, above, common to Virginia's southeastern woods, grace Shenandoah National Park. Trilliums, which got their name from the Latin for "three," sport three leaves and three colorful petals.

The dark forms of lichen-covered hardwood trees can be seen through the early morning fog on the Appalachian Trail, right. The trail crisscrosses the Skyline Drive at numerous points.

species paint the mountains a stunning palette of red and yellow shades. The visual feast is richly appreciated by motorists: more than 400,000 people follow the Skyline Drive every year in October when this leafy pageantry is at its height.

After dropping down to Thornton Gap, the drive slices its way through more than 600 feet of granite and greenstone at Marys Rock Tunnel. The road makes a circuitous climb up to its highest point—3,680 feet—at Skyland, one of several facilities for tourists along the route. The resort traces its roots to the 1880's, when an entrepreneur named George

Freeman Pollock built a series of cabins there in the hope of attracting wealthy Washingtonians to his mountaintop sanctuary. When Pollock first saw nearby Stony Man Mountain in 1886 he was awestruck by the mountains that enveloped him. "Beauty beyond description," he wrote. Today Skyland includes the original cabins, new residential units, and a dining hall where people can sit down for a meal while they admire the view.

Just east of Skyland stands a tract of 400-year-old hemlocks known as the Limberlost, a name given to the area by George and Addie Nairn, who

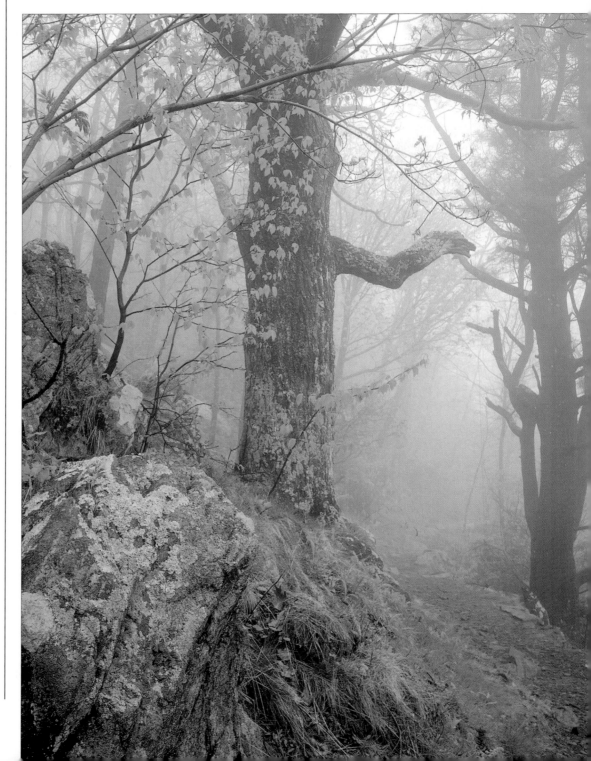

took it from a popular novel of the early 1900's titled *Girl of the Limberlost*, by Gene Stratton Porter. Loggers were intent on cutting down the towering trees until the Pollocks offered them $10 each for 100 of the oldest trees. The Pollocks' legacy—one of the few remaining old-growth forests in the park—is reached by the Limberlost Trail, which begins at mile 43 of the drive. The National Park Service had covered the winding path with a layer of crushed greenstone to create the park's first wheelchair-accessible trail, only to have it partially destroyed by a hurricane the day before it opened in the summer of 1996.

| NATURE'S RESILIENCE | Pollock was a forerunner in the attempt to preserve the natural beauty of the region. By the time Shenandoah National |

Park was created, decades of relentless logging, iron and charcoal production, cattle grazing, and the chestnut blight (a deadly fungus that killed off the American chestnut) had left sections of the forest denuded. However, once the trees within the park were protected, they rebounded with surprising swiftness. Nature's resilience is visible everywhere: in 1976 nearly 80,000 of the park's 196,000 acres were officially designated as wilderness, and today forest covers 95 percent of the park.

A few open areas remain. The largest of these is found at mile 51, where the forest suddenly draws back its protective cloak to reveal a 130-acre expanse at Big Meadows. Created originally either by a fire set by Native Americans or as the result of a lightning strike, the clearing probably predates Christopher Columbus' arrival in the New World. To manage the trees and shrubs that are encroaching on the meadow and boggy wetlands, the National Park Service periodically mows the area and sets controlled fires, which allow grasses and wildflowers to thrive. More than 270 species of plants grow here, including non-native species such as coltsfoot and charlock, which made their appearance in the mid-1960's.

On July 3, 1936, Pres. Franklin Delano Roosevelt dedicated Shenandoah National Park at Big Meadows, just two miles from the weekend getaway of his predecessor, Herbert Hoover. Camp Hoover was built in the woods east of the drive, where two mountain streams join to form the trout-rich waters of the Rapidan River. Now a National Historic Landmark, the camp played a pivotal part in persuading Hoover to create the Skyline Drive. It was on one of his horseback rides along the crest of the Blue Ridge Mountains in 1930 that the president reportedly declared, "These mountains are made for a road and everybody ought to have a chance to get the views from here."

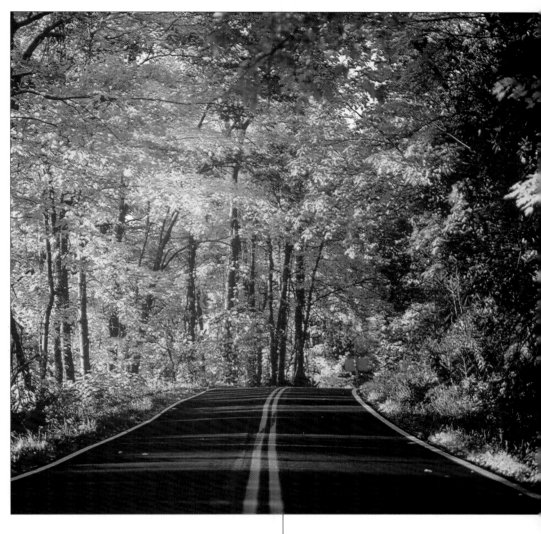

Construction of the Skyline Drive began the following year. When Hoover retired in 1933, he donated his 160-acre tract of land to the park.

Today, Camp Hoover's cabins are open to the public during scheduled ranger-led tours, and on the weekend closest to Hoover's birthday, August 10, two of the cabins on his estate are open for tours. Buses shuttle passengers from Big Meadows to the cabins. Experienced walkers can make their way on foot from Big Meadows through forests and orchards along the Mill Prong Trail.

Camp Hoover is a reminder of Shenandoah National Park's rich human history. Just a few years before work on the Skyline Drive began, some 2,000 mountain men and their families lived in the area that was to become the park. They were mostly farmers working small pieces of property in the wild hollows that lead down from the Blue Ridge. When the park was established, a handful of the residents were allowed to keep their homes for their lifetimes; however, most of them moved or were relocated to surrounding communities—some of them against their will. Annie Shenk, the last of the park's inhabitants, died in 1978.

LEAFY TUNNEL
A canopy of tree branches arches over the blacktop of the Skyline Drive, above.

WINTER AUSTERITY

A young white-tailed deer, right, forages for food in Shenandoah National Park. Shy and elusive, this species prefers wooded areas where it can graze on berries, buds, twigs, and grass.

AUTUMN FERNS

A dense undergrowth of ferns flourishes within Shenandoah National Park, below.

From the drive's overlooks, visitors can peer into the ravines where many of those fiercely independent people lived. Few obvious signs of their presence remain. The rare vine-covered chimney, family cemetery, and old stone wall have survived, mute testaments to the generations who played out their lives in these parts.

Beyond the Mill Prong Trail, the Skyline Drive travels through Bootens Gap before it skirts Bearfence Mountain. A hiking trail, accessible from the road, climbs Bearfence to an overlook with one of the few 360-degree panoramas in the park.

The view tells something of the geological history of these mountains. The bedrock of the Blue Ridge was created more than 1 billion years ago when molten magma from the earth's mantle solidified to become the granite that forms the region's underlying rock base. About 750 million years ago the granite split and basaltic lava flowed up through the fissures and spread over the land, followed by

deposits of silt and sediment that reacted with the rock to form greenstone. Now, hundreds of millions of years after the shifting of the earth's tectonic plates had thrust the land skyward, the erosion-resistant greenstone is still visible in rocky outcroppings at Bearfence and Stony Man mountains. Time and the elements have worked together to gradually wear down and smooth the jagged peaks into the stunning Blue Ridge Mountains that motorists on the Skyline Drive traverse today.

At Swift Run Gap the drive crosses into the southern section of Shenandoah. The gap was once part of a route that crossed the Blue Ridge Mountains. It was here in 1716, according to legend, that the young governor of Colonial Virginia, Alexander Spotswood, and 50 fellow pioneers cut a path through the mountains and into the Shenandoah Valley in the hope of expanding their settlement. When the group emerged from its foray in the wilderness, Governor Spotswood presented his companions with a small commemorative golden horseshoe, earning them an unusual moniker—the Knights of the Golden Horseshoe.

SHENANDOAH TRAVELERS

Spotswood and company had slept on the hard ground and they woke up complaining of "pains in our bones." But today's campers enjoy conveniences such as the showers and laundry facilities at Loft Mountain and three other campgrounds along the drive. The campsites also offer a variety of services, including ranger-led talks and guided walks through the woods. Loft Mountain is one of the best places to find white-tailed deer, which—like the park itself—seem to flourish as the years go by. The park was restocked with 15 deer from Mount Vernon in 1935 and now boasts more than 5,000 of these fleet-footed creatures. They are most often glimpsed at dawn and dusk, but they are also seen at other times of the day nibbling grass by the roadside. The sight of them can hold up a procession of cars and send visitors scrambling for their cameras.

Black bears are much harder to spot. The park population numbers some 300 to 500 of these animals—one of the largest concentrations in the world. They tend to avoid human contact, but occasionally a lucky motorist will catch sight of a bear ambling across the drive to snack on roadside

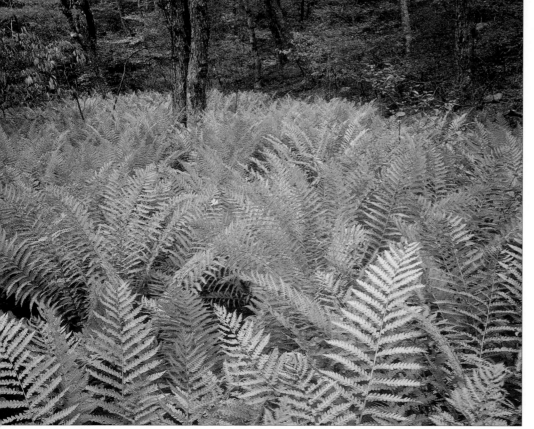

blueberries or gnaw on succulent roots. An impressive menagerie also roams the woods, from woodchucks and opossums to bobcats and foxes.

South of Loft Mountain the forest becomes more southern in character, with an increase in Virginia pine and scrub oak trees and lush growths of mountain laurel that explode into color in late May. Stone retaining walls are a legacy of the Roosevelt administration's Civilian Conservation Corps, established during the Depression and the largest peacetime organization in U.S. history. The walls border the road here, as they do for much of the drive. In 1933 some 1,000 workers set up camps in Shenandoah National Park and built many of the facilities in use in the park today.

After treating motorists to the last sweeping panoramas at Sawmill Run and McCormick Gap, the drive makes the long, leisurely descent to its southern entrance station just before Rockfish Gap. Ahead, the Blue Ridge Parkway beckons—a beautiful drive that connects the Shenandoah with the Great Smoky Mountains. But travelers may find it hard to leave behind the mountain-topping, soul-stirring ride along the Skyline Drive.

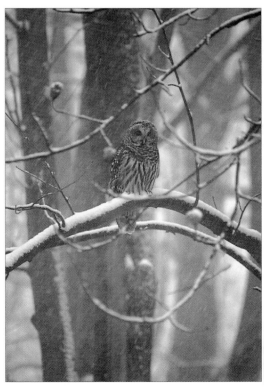

BEAUTY SUBTLE AND STRONG
Delicate wildflowers cluster around the massive trunk of an oak tree, above, in Shenandoah National Park. At left, a barred owl sits out a gentle valley snow.

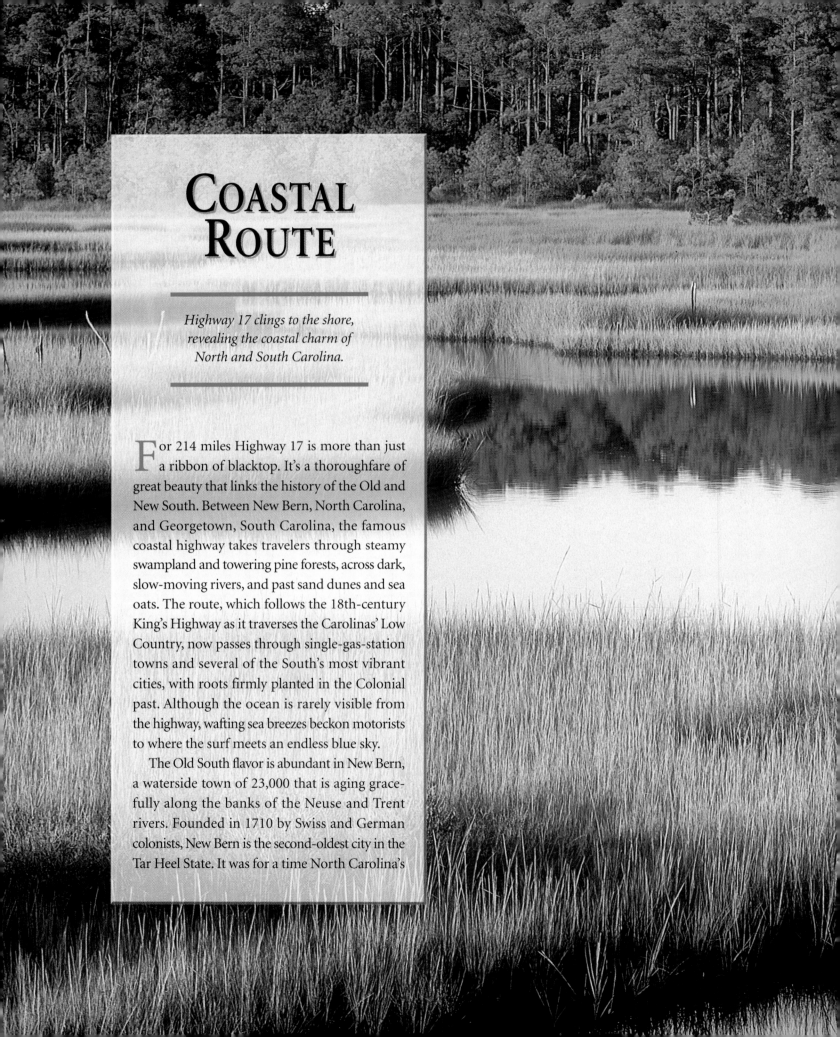

COASTAL ROUTE

*Highway 17 clings to the shore,
revealing the coastal charm of
North and South Carolina.*

For 214 miles Highway 17 is more than just a ribbon of blacktop. It's a thoroughfare of great beauty that links the history of the Old and New South. Between New Bern, North Carolina, and Georgetown, South Carolina, the famous coastal highway takes travelers through steamy swampland and towering pine forests, across dark, slow-moving rivers, and past sand dunes and sea oats. The route, which follows the 18th-century King's Highway as it traverses the Carolinas' Low Country, now passes through single-gas-station towns and several of the South's most vibrant cities, with roots firmly planted in the Colonial past. Although the ocean is rarely visible from the highway, wafting sea breezes beckon motorists to where the surf meets an endless blue sky.

The Old South flavor is abundant in New Bern, a waterside town of 23,000 that is aging gracefully along the banks of the Neuse and Trent rivers. Founded in 1710 by Swiss and German colonists, New Bern is the second-oldest city in the Tar Heel State. It was for a time North Carolina's

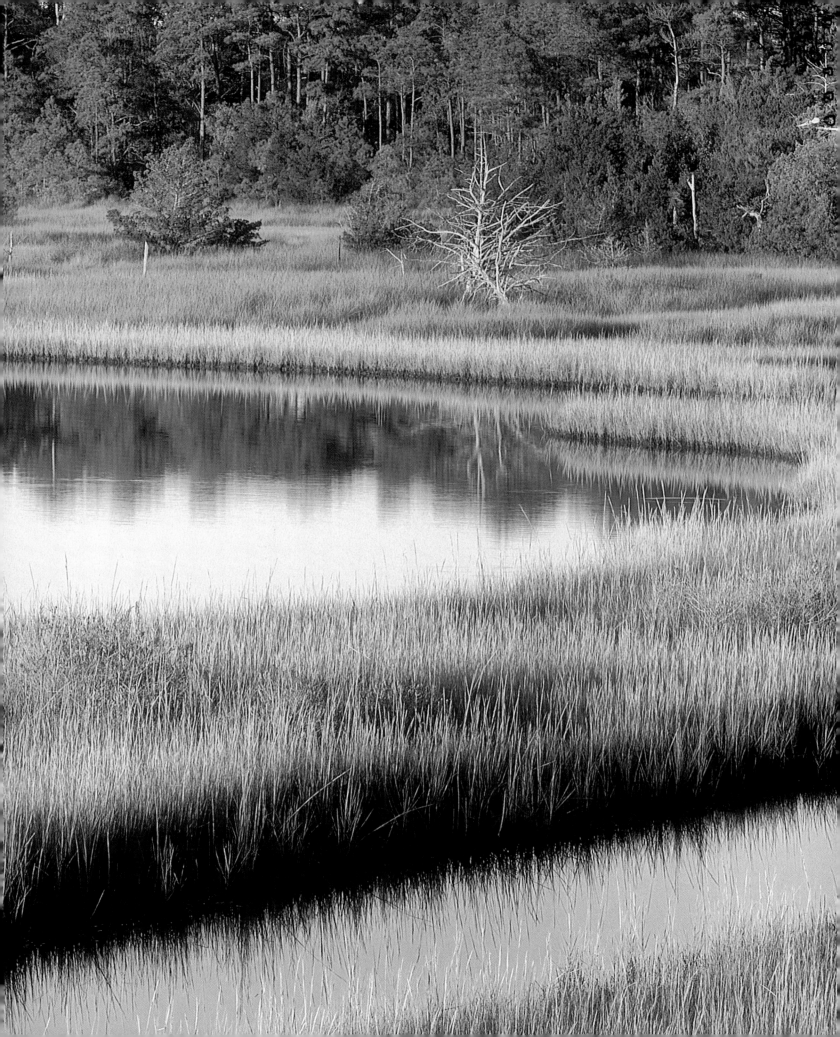

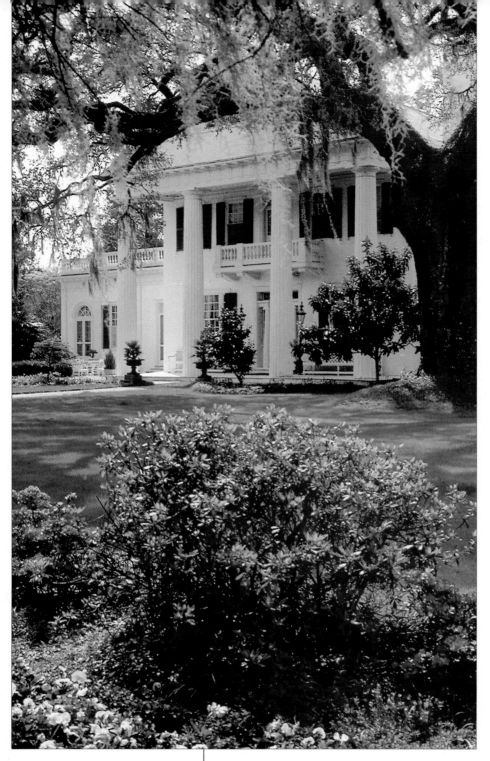

Academy, now a museum, surveys the region's history and its role in the conflict.

New Bern's historic district features no fewer than 145 structures, the highlight of these being Tryon Palace, referred to in the Colonial era as one of the most beautiful buildings in America. Of the original structures built in 1770 by Colonial governor William Tryon, only the stables remained standing when reconstruction efforts were started in the 1950's. Now that the elegant Georgian mansion has been completely restored, visitors can tour its extensive collection of antiques and art and wander in the palace's well-tended gardens.

HEADING SOUTH

From New Bern, Highway 17 bends southward along the rim of the Croatan National Forest and takes motorists through the Carolina lowlands. This Southern swampland drains into cypress forests dotted with small lakes and then seeps southeastward into Bogue Sound and the Atlantic Ocean. Side roads spin off to crossroad communities with names like River Bend, Pumpkin Center, and Gumbranch. Residents of some of these communities work in Jacksonville, where the U.S. Marine Corps' Camp Lejeune and Marine Corps Air Station New River are situated.

Just a few blocks off Highway 17 on Lejeune Boulevard in Jacksonville is the poignant Beirut Memorial, which salutes the 241 American troops killed in the 1983 terrorist attack on the headquarters of the 1st Battalion, 8th Marines, in Beirut, Lebanon. A life-sized bronze statue of an American Marine in full battle dress stands guard over a wall bearing the names of the Beirut bombing victims and of the three Marine pilots killed in Grenada. To most of the world the names inscribed on the monument belong to military professionals; to Jacksonville the names recall family members, neighbors, fellow churchgoers, and Little League baseball and soccer coaches.

South of Jacksonville, the highway stretches through the flat farmland of eastern North Carolina, passing stands of loblolly pine, gum, and turkey oak trees, and fields of corn and soybeans. The road makes its way through the communities of Verona, Dixon, Folkstone, and Holly Ridge. Antique shops, country stores, and gas stations share the roadside with modern farmsteads and the occasional abandoned tenant shack.

All along the road the Old South bumps up against the New South. Just out of sight to the east lie North Carolina's popular new oceanside housing developments, including Surf City and Topsail Beach. The western shoulder of the highway remains the rural South, with its acres of cypress swampland that empty into the Northeast Cape

Colonial capital. The city also played an important part in the American Civil War—for the Union side—that many North Carolinians of the day deplored. After the Confederates suffered a defeat in the Battle of New Berne in 1862, the city was occupied by Northern forces and became a key Federal post in the heart of coastal North Carolina. From their position in New Berne (the *e* in Berne was later dropped), Federal troops were a constant threat to Confederate forces in the region.

The New Bern Civil War Museum displays one of the nation's most extensive private collections of Civil War–era artifacts. The nearby New Bern

POPLAR GROVE HISTORIC PLANTATION
This plantation, established in 1795, features an antebellum manor built by planter Joseph Foy in 1850. The estate's 16 acres are the remnants of a 628-acre plantation. Guides attired in period costumes escort visitors on tours of the house, outbuildings, and gardens. An on-site arts center hosts craft shows, and a gift shop sells old-fashioned treats.

CONWAY
This tobacco town on the Waccamaw River has an Old South atmosphere. Tourists stroll through the historic downtown streets filled with restaurants, antique stores, and handsome churches. The town also offers a county museum and a popular riverside boardwalk.

FRANCIS MARION NATIONAL FOREST
Named after Revolutionary War general Francis Marion, the 250,000-acre forest encompasses a landscape of swampland, oak and pine forests, coastal sand areas, and small lakes believed to have been created by meteorites.

COASTAL ROUTE

ATLANTIC OCEAN

INFORMATION FOR VISITORS

Highway 17, which runs from Virginia to Florida, connects New Bern, North Carolina, with Georgetown, South Carolina. As it hugs the shore, the highway travels through small towns, forest, and marshland, and links the cities of New Bern, Jacksonville, Wilmington, and Georgetown, each of which has a commercial airport. Visitors should check local weather conditions before beginning their journey. Although hurricanes are rare, they can cause considerable damage to roads. There are gas stations, hotels, rest areas, and restaurants along the entire length of the route.

For more information: North Carolina Division of Travel and Tourism, 301 North Wilmington St., Raleigh, NC 27601; 919-733-4171. South Carolina Department of Parks, Recreation and Tourism, Division of Tourism, Edgar Brown Building, Suite 114, 1205 Pendleton St., Columbia, SC 29201; 803-734-0129.

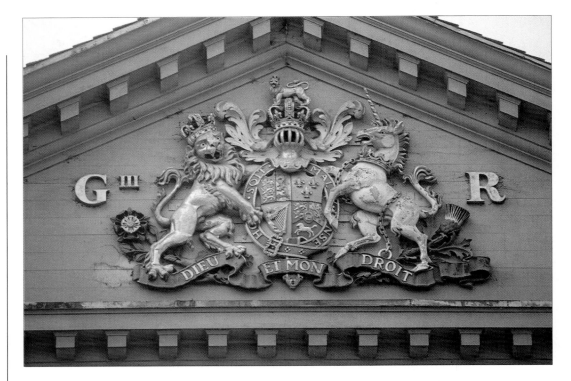

North Carolina's coat of arms presides over the front entrance to the Tryon Palace in New Bern, right. The magnificent edifice was built on the eve of the American Revolution as a meeting place for the Colonial assembly and residence for royal governor William Tryon.

A boardwalk crosses the swamps in the Santee National Wildlife Refuge, right. The 15,095-acre sanctuary's extensive pine forest attracts songbirds in spring and bald eagles during winter.

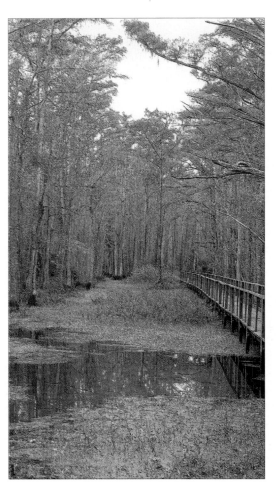

Fear River. The route meanders through muggy swampland and fragrant pine forests on its way to metropolitan Wilmington.

A scenic delight, Wilmington is also steeped in history dating back to Colonial times. This city of 65,000 perched above the Cape Fear River holds the Southern charm of much larger coastal cities—minus the traffic. Established in 1524, the town went through a succession of names, including New Carthage, New Liverpool, and Newton, before it was finally incorporated as Wilmington in 1739. The town's strategic position at a river junction some 20 miles north of where the Cape Fear River empties into the Atlantic explains its significance as a Carolina seaport during the Colonial period. The city acted as a kind of second Charleston, shipping naval stores, lumber, and cotton to Great Britain. A preservation movement, begun in the 1960's by a group of local business people called the Committee 100, has maintained and enhanced the city's riverside historic district.

Three blocks up Market Street from the river stands one of Wilmington's principal historical attractions, the Cornwallis House, believed to have been the headquarters of Lord Charles Cornwallis during the Revolution. Officially known as the Burgwin–Wright House, the Georgian-style mansion was once the home of North Carolina's Colonial treasurer, John Burgwin.

The Bellamy Mansion, which is also located on Market Street, looks as if it comes straight out of Gone With the Wind. During the Civil War, the house served as headquarters for Gen. Joseph Hawley, the commander of the Federal troops who captured the bustling seaport in 1865. In 1972 an arsonist set fire to the house, severely damaging its interior. It has since been restored, and work continues on other parts of the site.

The Cape Fear Museum, another Market Street attraction, surveys Wilmington and Cape Fear history from the Colonial era to the present, and is acclaimed by some as one of the finest regional museums in the nation. Wilmington's role in the

Civil War is illustrated through innovative displays and a fascinating collection of artifacts.

Just as in its heyday before the Civil War, when Wilmington exported shiploads of cotton, rice, and peanuts, it now exports New South products, including wood pulp, electronic equipment, and textile machinery. At the North Carolina State Port Authority, situated downstream from the center of Wilmington, ships hailing from the Far East, Europe, and South America unload a range of consumer goods, steel, and fertilizer. From 1942 to 1945 liberty ships were built and launched at the site, and during the Persian Gulf War, row upon row of military equipment awaited overseas shipment in Wilmington. The port continues to be one of the busiest in the Southeast.

SEASIDE DETOUR

From Wilmington the highway crosses creeks and wetlands and heads toward South Carolina's popular beach resort area, the Grand Strand, where the humid salt air awakens the senses. A short detour on Highway 421 brings travelers within sight and sound of the sea. The road heads south on a parallel course to the Cape Fear River, and crosses the Intracoastal Waterway, providing a glimpse of both the Cape Fear River to the west and the Atlantic Ocean to the east. The highway winds through the small seaside resorts of Carolina Beach and Kure Beach. At Carolina Beach the peninsula narrows and the road, flanked by condominiums and more rustic 1950's-style beach cottages, lies just yards away from sea oats that sway gracefully in the breeze along a hilly row of sand dunes. Walkways lead to a white-sand beach studded with seashells, where the Atlantic laps at the shore.

South of Kure Beach, Highway 421 takes travelers by Fort Fisher—the Civil War bastion that became a lifeline for the embattled Confederacy by keeping Wilmington's port open to blockade-runners. Visitors to the Fort Fisher State Historic Site can circle the towering earthen walls of the South's greatest coastal fortification and examine artifacts excavated at the fort and recovered from numerous underwater Civil War shipwrecks.

The Fort Fisher Ferry carries visitors and their automobiles across the mouth of the Cape Fear River on a 20-minute cruise to Southport. Civil War blockade-runners crossed the same waters, bearing essential war goods from Great Britain to the beleaguered South. Gulls dart and dip behind the ferryboat as it approaches the thick, dark green forest of Cape Fear's western shore and the deserted line of sand dunes that lie to the east. The dune line slowly melts into the distance where the mouth of the river meets the ocean.

Southport is an upscale fishing village offering seafood restaurants and antique shops. At the Brunswick Town State Historic Site travelers learn

TWIN BERTHS
A replica of a 19th-century paddle-wheel steamboat, Henrietta II, *and the authentic World War II battleship U.S.S.* North Carolina *lie on opposite sides of the Cape Fear River, left. The steamboat, which is berthed at Wilmington's Hilton Hotel Riverwalk, takes visitors on sightseeing cruises along the river. The U.S.S. North Carolina Battleship Memorial offers self-guided tours.*

Wilmington's historic churches display diverse styles of architecture, including the First Presbyterian Church, below, which combines Elizabethan, Norman, and English Decorated Gothic features. Other churches in town include the First Baptist Church, St. Mary's Catholic Church, and St. Paul's Evangelical Lutheran Church in the English Gothic Revival, Spanish Baroque Revival, and Greek Revival styles, respectively.

The six-column Adam portico of the main house of Hampton Plantation, right, was added to the original 1735 structure in 1791 for an upcoming visit by Pres. George Washington. Robert Adam's neoclassical architectural style, which also adapted neo-Gothic, Egyptian, and Etruscan motifs, was very popular in the late 18th century.

about the 18th-century Colonial settlement of Brunswick, which struggled, thrived for a time, and eventually collapsed, leaving behind an avenue of ruins and colorful tales about pirates, hurricanes, and the lives of the determined colonists.

From Southport, State Road 211 connects with Highway 17 and enters the dense Carolina pine forests, the source of quality masts for the world's navies in the 18th and 19th centuries. The pine forests that close in on the highway from either side make it easy for travelers to imagine a time when men labored in these woods, tapping the tall pines for resin to make turpentine, tar, and pitch—the essential materials for waterproofing the wooden hulls of sailing vessels. Many of the small tracts of farmland along the road that once cultivated corn and tobacco crops remain, highlighted by an occasional weathered farmhouse. Row crops and flue-cured tobacco are big business in the counties bordering the state line.

Less than 50 miles south of Wilmington, the highway delivers travelers to the quaint village of Calabash, which is situated near the border with South Carolina. Calabash bills itself as the seafood capital of the world. Here, diners can indulge in all manner of tasty dishes from hush puppies to oyster roasts. But beware, Calabash-style food is pure Southern: it is dipped in batter, then fried.

Once south of the state line, the next 55 miles of highway parallel the Atlantic shoreline on a course through the Grand Strand. The route cruises by long stretches of woodlands, some destined for preservation, but much of it soon to be cleared and swallowed up by the building boom that has made the Grand Strand into one of the fastest-growing regions in America. Every year more than 12 million vacationers visit the Grand Strand, the heart of which is Myrtle Beach, a resort that has been attracting vacationers since 1900. Back then a local business leader, Franklin G. Burroughs, came up with the idea of running a rail line from nearby Conway through the pine forest along the beach, hoping it would serve tourists as well as the timber industry. The fledgling railroad terminus of New Town, renamed Myrtle Beach in 1900 for a common native shrub, grew beyond all expectations. But development has not scarred the area. Nearby Myrtle Beach State Park preserves a serene landscape of sea oats and sand dunes, as does Huntington Beach State Park, which lies to the south of Murrells Inlet.

Around Murrells Inlet, the terrain begins to change as beaches yield to the signature marshland of the Carolina Low Country. More than 2,000 varieties of Low Country flowers, trees, and shrubs are featured at Brookgreen Gardens, a world-class

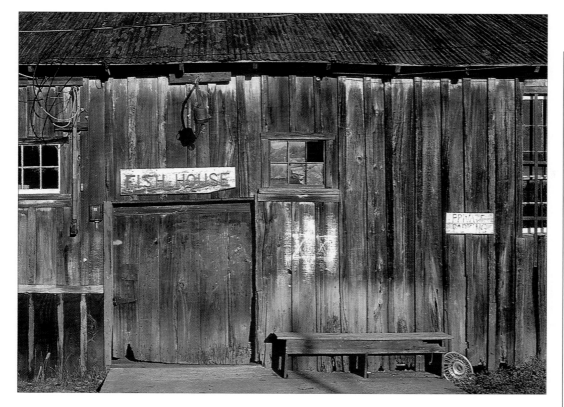

complex of outdoor sculptures on a 9,100-acre preserve. Encompassing four antebellum rice plantations, Brookgreen Gardens was established in 1931 by the American business leader Archer Milton Huntington and his wife, the sculptress Anna Hyatt Huntington. The complex contains some 580 works by 250 American sculptors and includes outstanding examples by such luminaries as August Saint-Gaudens and Charles Parks. The sculptures have been set up on the grounds near a beautiful alley of live oak trees that was planted in 1750. Brookgreen also offers a wildlife park and aviaries for cypress birds and raptors.

CAROLINA RICE

Highway 17 bears south from Brookgreen Gardens and then passes over Waccamaw Neck, a peninsula formed by the Waccamaw River to the west and the Atlantic Ocean to the east. Some historians believe that Waccamaw Neck's glory days as prime rice plantation land may have begun when a British sea captain named Thurber shared a bag of rice seed from Madagascar with Dr. Henry Woodward, one of the region's first settlers, soon after the colony was founded in 1670. Other historians believe that African-American slaves from Sierra Leone brought rice with them to supplement their meager diets. A third version credits some enterprising British businessmen with introducing rice to the region after their 1763 scouting trip revealed similarities between the Low Country and Barbados, already the source of Britain's staple export. Rice quickly replaced deerskins and indigo as South Carolina's premier export and soon the region became the largest rice-growing area in America, second in the world only to India. Waccamaw Neck's succession of baronial rice plantations stretched from river to ocean. Today almost all of the plantations have disappeared and the land is overgrown by pine and hardwood forest. But deep in the woods, double lines of ancient live oak trees still mark the carriage roads that once led to the plantation homes.

South of Myrtle Beach, side roads from Highway 17 lead to oceanside towns such as Litchfield Beach and Pawleys Island, communities that are famous for their wide sandy beaches and sparkling shorelines. Other roads pass through marshlands and tidal oyster beds guarded by long-legged herons and egrets, silent sentinels over their domain.

At the southern rim of the Grand Strand, Highway 17 passes by Winyah Bay, one of the few remaining bays on the Atlantic Coast that is preserved naturally. Surrounded almost entirely by marsh and forest, muddy Winyah Bay is fed by the Pee Dee, Waccamaw, Black, and Sampit rivers. The bay's northern shoreline is owned by Hobcaw Barony, an immense area of former rice plantations that were acquired discreetly in the early 20th century by the Wall Street wizard Bernard Baruch. The son of a Confederate officer, Baruch grew up in New York City, but adored his native South Carolina, calling it "bone of my bone and flesh of my flesh." He was especially fond of the coast, where he established Hobcaw, a private hunting and fishing preserve. Friends and associates, including Franklin D. Roosevelt and Winston Churchill, enjoyed the retreat. In 1964 Baruch's daughter,

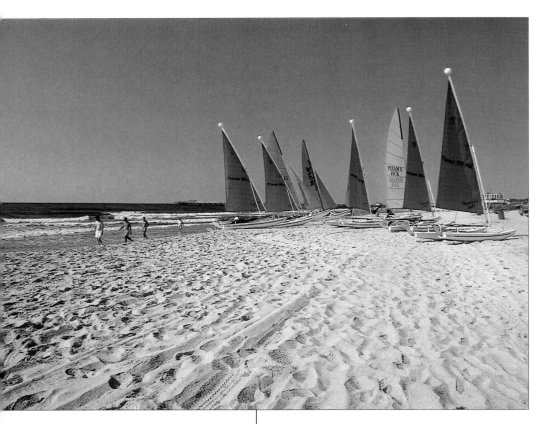

Belle, established the Belle W. Baruch Foundation to ensure that the barony would be preserved. It is now open on a limited basis to the public.

NEW SOUTH AND OLD Nestled alongside Winyah Bay is South Carolina's third-oldest city, Georgetown, where the Old and New South meet and merge. Evidence of the New South is everywhere: a handsome, well-kept walk along the Sampit River attracts strollers with its picturesque views; the marinas lining nearby Winyah Bay are chock-full of speedboats and sailboats; steel and paper mills fuel the local economy; and restaurants and shopping malls abound. With a population of 10,000, Georgetown is like a younger sister of Charleston. The past still wields a powerful influence over the town, and a drive through its historic district reveals house after house dating from the Colonial period, when Georgetown was at the heart of the thriving American rice trade.

Visitors to the Georgetown Rice Museum view exhibits on South Carolina's vanished rice empires. They learn that the rice plantation fields were feats of engineering involving extensive diking and canal

SUN, SAND, AND SAILS
A cluster of colorful sails, above, hails visitors to the inviting sands of Myrtle Beach, one of the southeast coast's most popular Atlantic resorts.

SOUTHERN TOUR
On his 1791 tour of the South, Pres. George Washington dined at Tryon Palace and stayed at the nearby home of local merchant, John Wright Stanly, right.

building, often carried out by slaves who had acquired their skills on the Rice Coast of Africa. On display in the museum are some of the slaves' tools for West-African–style rice cultivation, including flail sticks, mortars and pestles, and winnowing baskets. The rice empires eventually crumbled after a series of setbacks, including the abolition of slave labor, bad weather, and the mechanization of farming techniques, which gave the rice growers of the Midwest an insurmountable advantage.

Every spring the Prince George Winyah Parish Episcopal Church offers special tours of some 25 neighboring plantations. Most of the mansions are normally closed to the public, except Hopsewee and Hampton plantations, which are open to visitors year-round. Hopsewee is perched on a bluff above the North Santee River, and from this high point its rice fields stretch out as far as the eye can see. The plantation's main house, erected in 1740, is austere compared to Wilmington's Bellamy

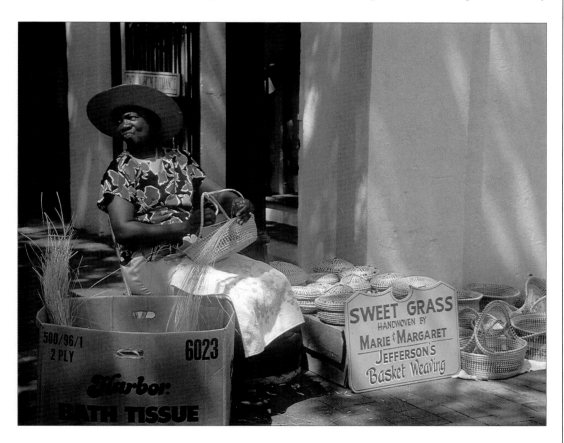

SKILLED CRAFTSWOMAN
A Georgetown resident weaves a sweet grass basket during the town's yearly Harborwalk Festival, left. The celebration, which takes place in June, includes arts and crafts displays, entertainers, and a lively street dance.

Georgetown's Chamber of Commerce offers a trip to abandoned rice fields as well as a tour of the town's historic district. One of the stops takes visitors inside Prince George Winyah Episcopal Church, constructed in 1721 and claiming one of the oldest cemeteries in the South. The church survived the British Army's occupation of Georgetown during the American War for Independence, when church pews were said to have been hauled onto the street so that the British soldiers could stable their horses inside. Memorials to planter aristocrats adorn the walls, but the church's most memorable feature is its beautiful stained-glass window, dedicated to the Low Country's slaves. The window is now installed behind the pulpit, but it was originally crafted by order of Plowden C. J. Weston, the wealthy owner of long-gone Hagley Plantation, for a small chapel he had built for his slaves. The church continues to hold regular services.

Mansion. Hopsewee was the home of Thomas Lynch, who was an official delegate to the 1774 Continental Congress in Philadelphia. When he suffered a stroke before he was able to affix his signature to the Declaration, his son Thomas Lynch Jr. signed in his stead. As Georgetown's rice planters became more successful, they built more opulent mansions in big-city Charleston.

Three and a half miles farther along the highway lies the most famous of Georgetown's rice plantations. Now part of 322-acre state park, Hampton Plantation was the summer home of Archibald Rutledge, poet-laureate of South Carolina. In his 1941 book *Home by the River*, Rutledge described his beloved Carolina Low Country as "beautiful with the forbidding charm of a spiritual autumn . . . though the civilization that it cradled and nourished has passed away, the charm survives. The home remains lovely after the guests are gone."

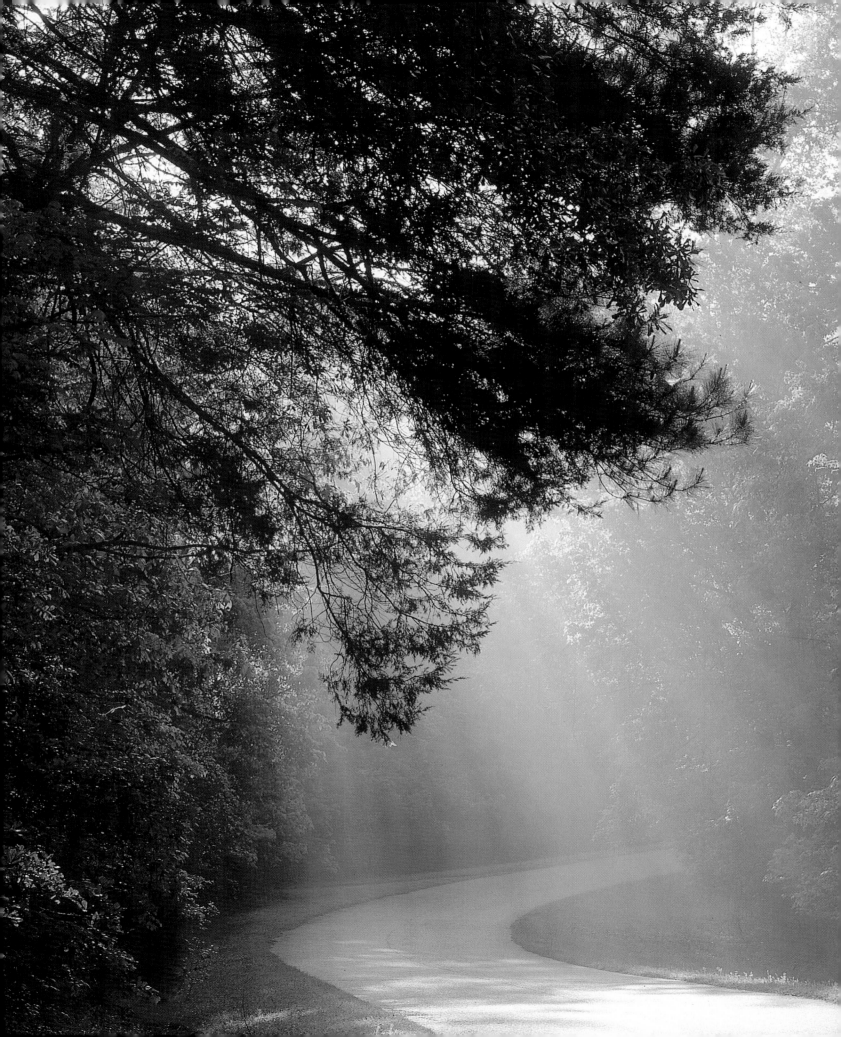

Natchez Trace Parkway

Roughly paralleling a frontier trail, this road plunges into a wilderness that was tamed by early pioneers.

The Natchez Trace is more than just a highway through natural splendor—it is a fascinating journey to eras long gone. Once a buffalo trail, the path became a vital artery in the westward expansion of America, cutting a diagonal gash across the South from Natchez, Mississippi, to Nashville, Tennessee. Now a 425-mile parkway in the custody of the National Park Service roughly follows the original trail, and few scenic drives in the nation can compare to it. Unspoiled by neon signs, billboards, or traffic lights, virtually every aspect of the road's storied past has been laid out and labeled for visitors.

Nearly 100 roadside plaques and interpretive exhibits recount the trace's history of Indian burial mounds and the mysterious deaths of frontier heroes; of perilous river crossings; of inns and way stations where men, women, and children were brutally attacked by roving bands of vicious highway robbers; and of forest clearings where,

GHOSTLY LIGHT

Overleaf: Sunlight streams through an early morning mist along a stretch of the Natchez Trace Parkway. The road, whose projected length is 443 miles, delights those looking for an escape from the demands of modern life.

according to local legend, witches once used to dance, rendering the rich soil eternally barren with their footsteps.

Two hundred years ago, mail-carriers covered the trace in a week. Modern-day travelers could easily take as long if they were to meander along the Natchez Trace Parkway—a paved two-lane road that overlies or parallels much of the route of the Old Trace. The parkway has been under construction for 60 years and its projected length is 443 miles. The last five miles of the northern terminus in Tennessee were opened to the public in June 1996, and the final segments are expected to be completed in the first decade of the next century. The speed limit is 50 miles an hour or slower; commercial traffic is forbidden; and there are dozens of inviting places to stop and linger.

TIMELESS TRAIL

The parkway is a paradise for cyclists and hikers alike. Nature trails branch off in various directions and lead to streams and waterfalls, past Native American ceremonial grounds, and to the grave sites of unknown Confederate soldiers. Here and there, portions of the Old Trace have survived almost unchanged for centuries. The road burrows like a tunnel through pines and timeless oaks, enters crowded chambers of bald cypress and water tupelo trees, and exits into sunlit alleys lined with hickory, beech, and ash. Picnic sites are plentiful, but provisions are scarce for the most part and must be taken along. There is but one gas station and convenience store on the entire route.

The sense of seclusion is a cleverly crafted deception. The parkway skirts cities such as Jackson and

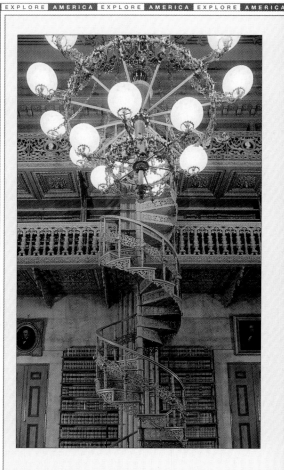

OPULENT SEAT OF GOVERNMENT
A wrought-iron spiral staircase and intricate chandelier, above, adorn the library in the Tennessee state capitol in Nashville.

INFORMATION FOR VISITORS

The Natchez Trace Parkway stretches 425 miles between Natchez, Mississippi, and Nashville, Tennessee. The nearest commercial airports are in Memphis, Jackson, Tupelo, and Nashville. There are no accommodations along the route; however, there are eight campgrounds, and tent and trailer camping are permitted at three designated sites: Rocky Springs Site (mile marker 54.8), Jeff Busby Site (mile marker 193.1), and Meriwether Lewis Site (mile marker 385.9). Drivers should follow the speed limit at all times and be on the lookout for animals, especially white-tailed deer, which sometimes wander across the road. Visitors should be alert for fire ants, poison ivy, and venomous snakes. Natural, historical, and archeological objects must not be disturbed. For more information: Superintendent, 2680 Natchez Trace Parkway, Tupelo, MS 38801; 601-680-4025 or 800-305-7417.

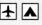 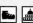

PASTORAL BEAUTY

A herd of cattle, below, grazes tranquilly in pastures alongside the Natchez Trace Parkway.

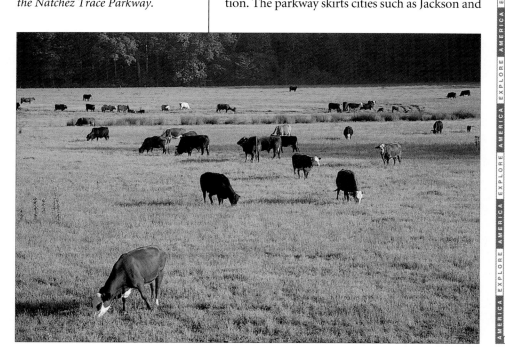

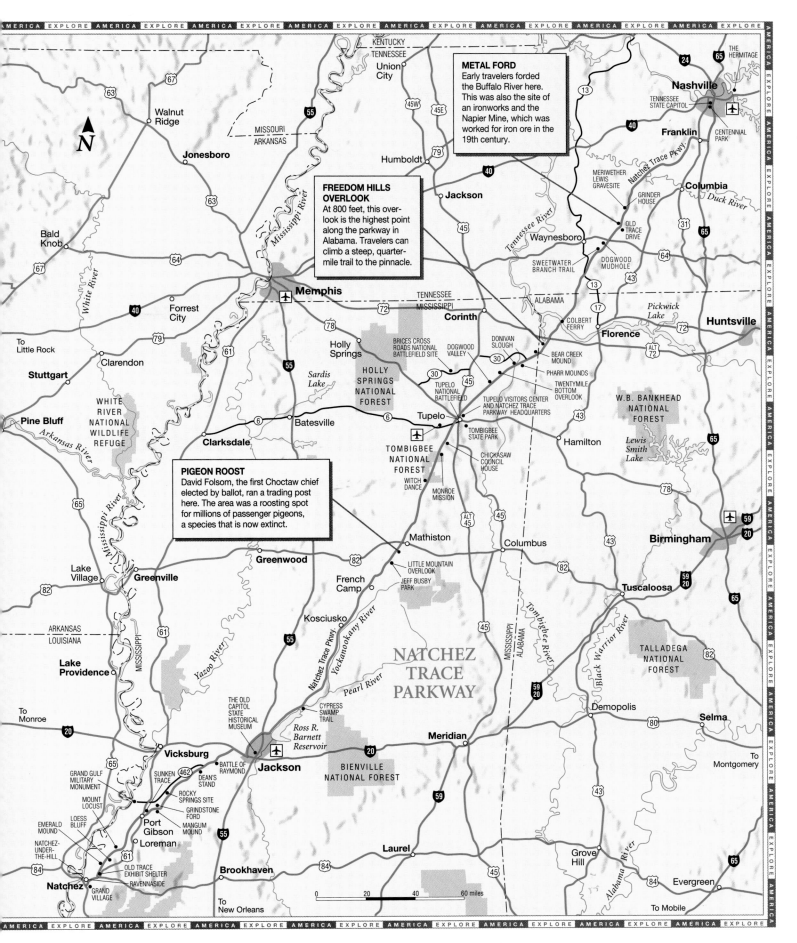

METAL FORD
Early travelers forded the Buffalo River here. This was also the site of an ironworks and the Napier Mine, which was worked for iron ore in the 19th century.

FREEDOM HILLS OVERLOOK
At 800 feet, this overlook is the highest point along the parkway in Alabama. Travelers can climb a steep, quarter-mile trail to the pinnacle.

PIGEON ROOST
David Folsom, the first Choctaw chief elected by ballot, ran a trading post here. The area was a roosting spot for millions of passenger pigeons, a species that is now extinct.

NATCHEZ TRACE PARKWAY

0 20 40 60 miles

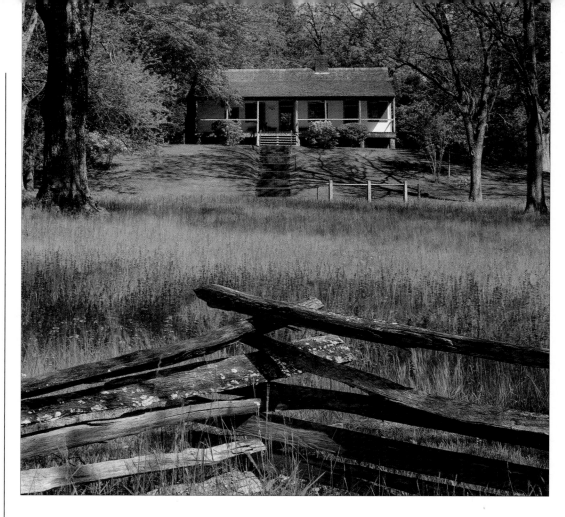

WELCOME REST STOP
Just off the trace is Mount Locust
Inn, right, which began as a stand.
The wayfarer's rest stop has been
restored to its 1800's appearance.

TOBACCO COUNTRY
The sight of tobacco hanging to
dry, above, is common along the
Natchez Trace Parkway, which
slices through predominantly
agricultural areas.

the Chickasaw Indians near the area that is desig-
nated as the Tombigbee National Forest, which
straddles the trail. Almost two centuries later French
explorers came to the region, and the route appears
on their maps as early as 1733.

The animal trail that was charted by the French
would become a full-scale road over the course of
the next half century as settlers began to migrate
to the area and populate the Ohio River valley of
Tennessee, Ohio, Indiana, and Kentucky. Farmers
and tradesmen loaded their flour, butter, wagons,
furs, tobacco, and livestock onto flatboats and float-
ed them down the Ohio River to the Mississippi
and on to markets in Natchez and New Orleans.
In the local idiom the boatmen, who came from
many different states, were known as Kaintucks.
Because poling upriver was a tedious business, they
sold the boats for their lumber at the end of the
journey. Steamboats did not yet ply the inland
waterways and the return trip had to be made over-
land along the trace. By 1810 as many as 10,000
Kaintucks had returned home by that route.

It was not an easy journey. The path was remote
and hazardous: the Kaintucks had to wade in
murky bayous and spend wakeful nights in forests
inhabited by wild animals and poisonous snakes—
dangers and hardships that earned the trace the
nickname Devil's Backbone. An injury or illness
suffered during the passage often meant death.

Tupelo, and for much of the route, farmlands, small
towns, and superhighways lie just out of sight.

By most reckonings, the Natchez Trace is more
than 8,000 years old, having been "traced out" by
migrating buffalo and later trod by tribes of hunter-
gatherers. Spanish explorers arrived in the 16th
century and probably followed portions of the trace.
Before Hernando de Soto crossed the Mississippi
River in 1541, he spent the winter living among

Nature posed only some of the perils, however. The trace passed through territory claimed by two Native American tribes—the Chickasaw and the Choctaw. Although the Indians often provided Kaintucks with food and shelter, they also saw them as trespassers and occasionally stole from them. Even worse were the bands of thieves who preyed on defenseless travelers transporting the earnings from an entire year's labor.

Some of the most dramatic stories about the Natchez Trace pertain not to its history as a commercial route, but to the cruel acts of the villains who stalked the pioneers. Men such as Micajah and Wiley Harpe from North Carolina terrorized wayfarers the length of the route. The brothers' methods were so vile that even other outlaws scorned them. The Harpes killed their victims, then eviscerated them, filling their abdominal cavities with rocks and sinking the bodies in the swamps. They murdered one sleeping traveler simply to silence his snoring and killed another by lashing him to a horse and then driving it over a cliff. The Harpes were eventually captured and executed, but the tales of their abominations have been passed along the trace for more than a century.

Despite the trace's reputation for barbarism, by 1800 commercial traffic along the route had drawn enough settlers to the region that the federal government began sending post riders, forerunners of the Pony Express riders, on regular runs between Nashville and Natchez. A year later a treaty was negotiated with the Choctaw and the Chickasaw nations, opening the path to development.

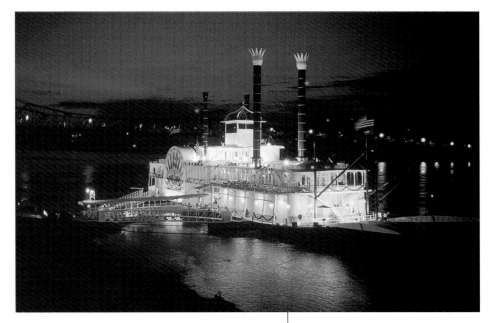

Although the Choctaw and Chickasaw agreed to have the road through their territory widened, they reserved the sole right to establish inns and stands on the trace. However, the stream of settlers and wagons became so relentless that ferryboats were soon operating along the rivers and, despite the tribes' objections, stands run by settlers sprang up along the route. Most were small, rough huts set every 10 or so miles apart; an average day's journey was 20 miles. For 10 to 25 cents, weary travelers could buy a meal of milk and mush and a place to sleep, usually on a crowded floor or even outside. By 1810 the Natchez Trace was the most heavily traveled road throughout this part of the frontier, then known as the American Southwest.

THE PRICE OF PROGRESS

The trace's heyday was short-lived. In 1812 the steamboat *New Orleans* made its way up the Mississippi River and landed in Natchez. With travelers now able to journey easily upriver, river traffic increased steadily. As steamers became larger and faster, they pushed deeper inland, making regular runs to St. Louis, Nashville, and Louisville. By the 1830's the Natchez Trace had become all but obsolete and soon it was abandoned entirely. Most of the trail and its stands were reclaimed by the wilderness.

The trace might have become a forgotten fragment of America's past but for the concerted efforts of the Mississippi Chapter of the Daughters of the American Revolution. In 1909 the group began to mark the Old Trace for future generations to enjoy. The old Indian trail was surveyed in 1934, and in 1938 the route was established as a parkway under the National Park System.

The parkway can be accessed at numerous points, but there are good reasons to begin the drive at the Natchez end, where the Kaintucks unloaded their

RIVERBOAT GAMBLING
Lights shine from a casino boat, above, docked on the Mississippi River near Natchez. Riverboat gambling was legalized here in 1990.

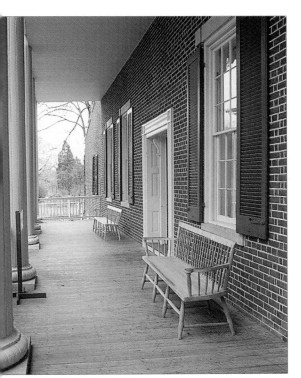

PRESIDENTIAL RETREAT
Wooden benches rest beneath a columned portico, left, at the Hermitage estate in Nashville. President Andrew Jackson lived at the estate from 1804 until his death in 1845.

cargoes and began their return journey northward by foot and wagon. Natchez, perhaps more than any other town along the route, evokes the area's past and sets the mood for this trek back in time.

Natchez began life as the center, or Grand Village, of the vanished, sun-worshiping Natchez Nation. Visitors can tour the village site, which was excavated in 1930. Rare artifacts from that dig, along with several burial sites, and a ceremonial mound are all that are left of this Native American tribe. In 1716 the French built Fort Rosalie near Grand Village, and within a few years were demanding that the Natchez surrender their tribal lands. Determined to resist, the Natchez attacked the fort in 1729, killing most of the men stationed there. The following year the French countermassacred. A few Natchez are believed to have escaped and been assimilated by the Chickasaw and Cherokee.

Over the ensuing years control of the region passed from the French to the English, then to the Spanish, and finally into American hands. In 1798 Natchez became the capital of the U.S. territory of

VERDANT CANOPY
A sunken section of the Old Natchez Trace, below, that reaches into the Loess Hills has changed very little in the past 200 years.

Mississippi. The town's fortunes rose swiftly because of its proximity to the profitable cotton and indigo plantations. Before the Civil War more than half of the millionaires in the entire nation lived in Natchez.

The town's affluence is evident in its antebellum grandeur, which was unscathed by the Civil War because Federal troops occupied Natchez early on. More than 500 historic buildings from Natchez's Golden Age have survived and many of them have been converted to museums, restaurants, luxury hotels, and bed-and-breakfasts. The preservation of the buildings and their azalea and magnolia tree plantings keeps the town nestled in a time warp.

Ravennaside, the 1870 vintage home of Roane Fleming Byrnes, is one of a dozen historic homes that are open for tours. As president of the Natchez Trace Association, Mrs. Byrnes tirelessly continued the drive to mark the Old Trace that was begun by the Daughters of the American Revolution. Her house, which also operates as a bed-and-breakfast inn, displays an extensive collection of Natchez Trace memorabilia.

Even the city's seedy red-light district, Natchez-Under-the-Hill, along the riverboat landing, has endured. The area's saloons, brothels, and gambling dens offered just about every form of vice and debauchery and attracted the worst criminals on the frontier. It is said that many a Kaintuck departed for home with empty pockets and a monumental hangover after a night at Under-the-Hill.

The landing, which is listed in the National Register of Historic Places, has been restored and converted into a strip of shops, restaurants, and taverns. The nightlife here is quite tame, even aboard the legal floating casinos moored nearby.

LEISURELY BEGINNING From Natchez, Highway 61 runs north to the temporary entrance to the parkway, about seven miles from town. It soon becomes apparent to the motorist why this journey calls for a leisurely timetable. Barely a mile down the road the Old Trace Exhibit Shelter gives visitors their first glimpse of the original footpath.

Another obligatory sight, Emerald Mound, is just a mile and a half beyond the shelter. Built 700 to 800 years ago by the ancestors of the Natchez, the eight-acre mound is the second largest of its kind in the United States. A trail leads to the top of a grassy plateau that is a primary mound measuring 35 feet high, and 770 feet by 435 feet at its base. Two secondary mounds, built on the primary mound, are believed to have once supported ceremonial structures.

Farther along the road lies Loess Bluff, where visitors can learn about the geological features of the

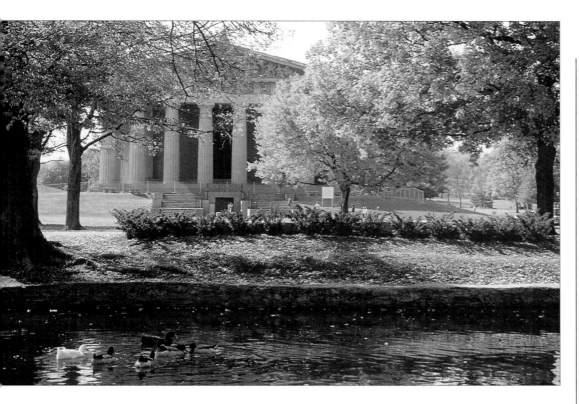

A replica of the Parthenon, left, built in 1897, resides in Nashville's Centennial Park. The magnificent edifice serves as an art museum and exhibits a 42-foot-tall statue of the Greek goddess Athena.

Old Trace that made travel difficult. The bluff is composed of loess—dusty topsoil that was carried by the relentless powerful winds of the Pleistocene epoch from the Western Plains and then deposited east of the Mississippi, mostly between southern Louisiana and Tennessee. In places the deposits were 30 to 90 feet deep, and where the trace crossed them it became a sunken road, reaching 20 feet or more into the spongy loess.

After having negotiated this uneven terrain, the early traveler might have sought refuge for the night at Mount Locust, one of the trail's first stands. Built in 1779, the original 16-by-20-foot cabin was later converted to an inn for Kaintucks. Several rooms were added over the years and after traffic on the trace declined, the inn became a family residence.

Of the 50 or so inns that were scattered along the trace, Mount Locust is the only one still standing. It was purchased by the National Park Service in 1937 and subsequently restored. The inn is a peaceful place offering interpretive exhibits and footpaths that lead through grounds shaded by large oaks and scented by sweet olive trees. The restored structure gives visitors further insight into the rigors of travel on the Old Trace: at times, as many as 50 travelers bedded down for the night in a room barely large enough to hold two automobiles; their belongings were stacked up to the ceiling and hung from the rafters.

At this point the parkway splits from the Old Trace and parallels it for nearly 25 miles to Port Gibson. A greater understanding of the region's history can be gained here in this former bayou landing where Union general Ulysses S. Grant routed Confederate forces in May of 1863, just weeks

before the siege of Vicksburg. Grant elected to forgo his standard practice of torching defeated Southern towns, declaring Port Gibson "too beautiful to burn." That beauty is still on glorious display in the town's many antebellum mansions, churches, and public buildings.

More Civil War history awaits travelers who make a short detour to the Grand Gulf Military Monument on the Mississippi. Here, in a five-and-a-half-hour battle with Union gunboats, rebel soldiers foiled Grant's first attempt to cross the river, forcing him downstream. The 400-acre park offers campgrounds, and a museum displays a whole

Main Street in Natchez, below, bustles with life on sunny afternoons. Its shops offer a variety of crafts made by local artisans.

range of artifacts, from Civil War memorabilia to fossils and mastodon bones.

Back on the parkway, the route passes Mangum Mound—another in the series of ancient Native American burial sites found along the trace—and arrives at Grindstone Ford. To Kaintucks and post riders this site marked the end of the tamed wilderness, for across the bayou, they entered the perilous territory of the Choctaw Nation. A roadside marker indicates the location of a trail that leads visitors to the Old Trace.

OUTSKIRTS OF CIVILIZATION The parkway curves toward Jackson on a lonely course that nearly tracks the route of the Old Trace. Markers identify the site of the Battle of Raymond, another skirmish in Grant's march toward Jackson, and the location of a roadside inn called Dean's Stand, where Grant made his headquarters after that battle. A picnic area shaded by dogwood trees invites motorists to pull off the road for a while. Most of the stretch of the parkway leading up to Rocky Springs is lined with hardwood and pine trees. A path leads from an upper parking lot to the old town site.

Established in the late 1700's beside a natural spring, Rocky Springs became the economic center of the region's prosperous cotton plantations. Before the Civil War, its population exceeded 4,000, about half of whom were slaves. By the end of the 19th century, Rocky Springs had deteriorated into a ghost town, its downward spiral precipitated by the war and sped along by yellow fever and boll weevil infestations. Although little of the town remains but ruins, one structure, the red brick

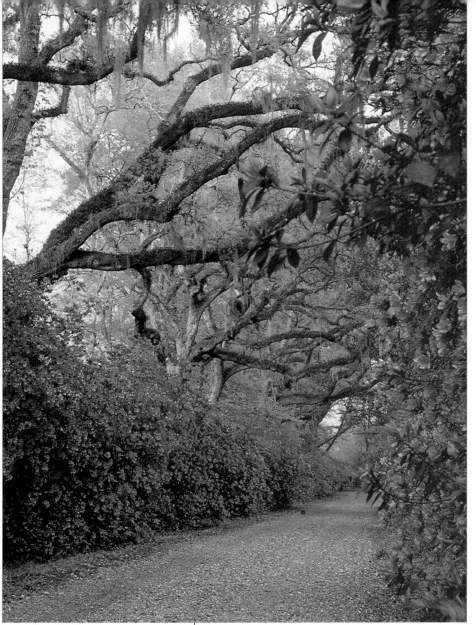

TRACE'S GREENERY
Much of the trace is adorned with dazzling blossoms and hanging moss, above. There are also numerous Native American mounds near the road, such as Emerald Mound, right, which was constructed by the ancestors of the Natchez Indians.

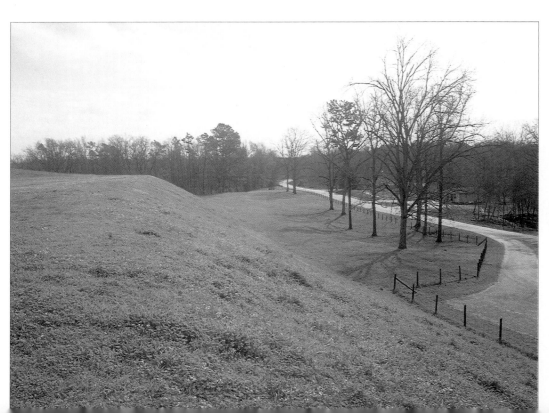

46

Methodist church built in 1837, still stands and holds regular services.

Following the route of Grant's march into Jackson, motorists come upon a segment of the parkway that has not been completed, forcing them to take a detour through town. Jackson was battered by the Civil War. After General Grant's army captured the town from the Rebel Army, the general ordered that it be burned down rather than leave troops behind to defend it while he marched on to Vicksburg. It was the torching of Jackson that earned the town its nickname, Chimneyville, and led Gen. William Sherman to utter his immortal words, "War is hell."

Among the few historic structures that escaped the incineration is the Old Capitol, now the State Historical Museum. The 1833 Greek Revival building's numerous rooms branch off from a 120-foot rotunda and contain a variety of cultural artifacts from different periods.

The Ross R. Barnett Reservoir sprawls for 15 miles alongside the parkway north of Jackson before trailing off at Cypress Swamp. From this point, hikers can follow a short trail toward the Pearl River and gaze upon a stunning terrain where wetland collides with uplands flora. Thick-bodied alligators still bask in the sun at the swamp, but as old creek beds and low-lying areas fill with sediment, the swamp's cypress and tupelo trees are slowly giving way to the maples, sycamores, and black willows that thrive in drier terrains.

Continuing its sinuous climb north, the parkway follows the Yockanookany River to Myrick Creek, where a short walk along a nature trail may reward spectators with the sight of beavers felling trees and building dams. Some of these industrious animals reach weights of 60 pounds.

The next town on the trace is Kosciusko, a picturesque hamlet named for Thaddeus Kosciusko, an engineer and Revolutionary War hero from Poland who designed numerous fortifications for the Colonial forces. Local tour guides direct visitors to a dozen historic structures, including one of more recent significance: the church once attended by television talk-show host Oprah Winfrey, who was born in the town of Kosciusko.

North of Kosciusko is French Camp, built by Louis LeFleur in 1812. French Camp started as a stand and was converted over time into a school for youngsters from troubled homes—a role it still plays today. The wooded 1,200-acre campus now includes cabins and a rustic bed-and-breakfast inn for travelers. Farther along the road, visitors come to Jeff Busby Park, named after congressman Thomas Jefferson Busby, who introduced a bill in 1934 that called for the surveying and marking of the Old Natchez Trace. From here visitors can hike

to a plateau called Little Mountain Overlook. At 603 feet, it is one of the highest points in Mississippi. On a clear day visitors can see for 20 miles or more. Jeff Busby Park also has the only gas station along the entire length of the parkway.

Just outside the Tombigbee National Forest, travelers can inspect more prehistoric Native American mounds and a place of legend called Witch Dance. Here, so the story goes, witches and sorcerers gathered among the fragrant pines to dance and practice their black magic.

Near the northern outskirts of the national forest stands Monroe Mission, where missionaries baptized the Chickasaw Indians and taught them about Christianity. The forest lies at the center of the Chickasaw Nation, and the tribe's history is interpreted at numerous other points. Markers indicate the site of the Chickasaw Council House

ANDREW JACKSON CONNECTION
A storage barn on the Hermitage estate, below, is made of logs that were originally used to build cabins at Hunter's Hall, a nearby plantation that Andrew Jackson owned before he purchased the Hermitage property. The barn is one of 14 buildings on the grounds. The tomb of Pres. Andrew Jackson and his wife, Rachel, is also located here.

and the place where U.S. agents for the tribe lived until 1825, shortly before the Chickasaw were deported to Oklahoma Territory as part of a massive Native American relocation. In Tupelo, exhibits placed beside a meandering walkway describe the history and daily village life of the more than 2,000 Chickasaw who once occupied the land.

Tupelo, famous for being the birthplace of rock and roll icon Elvis Presley, was also the scene of two Civil War battles. In the first encounter, Confederate general Nathan Bedford Forrest and 3,500 rebel troops outmaneuvered 8,300 Union soldiers led by Gen. Samuel D. Sturgis. This battle is commemorated at the Brices Cross Roads National Battlefield Site, 18 miles north of Tupelo.

One month later, Forrest staved off another Union assault on Tupelo. The one-acre Tupelo National Battlefield memorializes this conflict. A few miles outside of town, past the Tupelo Visitors Center and Natchez Trace Parkway Headquarters, visitors can stroll along the original trace, marked by the burial sites of 13 unidentified Confederate men.

From here the road rolls across some of the most magnificent scenery on the entire drive as it dips into the Dogwood Valley's pink and white splash of colors, passes the fields of Twentymile Bottom, and spans cypress-lined Donivan Slough. Rising from the ground are the Pharr Mounds, eight earthen domes dating back nearly 2,000 years that belong to one of the most extensive Native American ceremonial sites in the country.

Near Bear Creek Mound, the parkway enters Alabama and twists toward the Tennessee River, crossing the river at the point on the Old Trace where George Colbert operated a ferry and a stand from 1800 to 1819. Half Scot and half Chickasaw, Colbert was a shrewd businessman who negotiated with the government on behalf of the Chickasaw. He once charged Andrew Jackson $75,000 to transport his army across the river. Travelers can visit the site of the inn and follow a section of the Old Trace to a bluff overlooking the river.

Ten miles ahead the parkway enters Tennessee, where the hills seem to grow darker. Trails enter the woods at Sunken Trace, Sweetwater Branch, and Dogwood Mudhole, names that aptly describe what lies at the end of each of them. Travelers in search of a close-up view of nature can walk the Colbert Creek nature trail at Rock Spring, near mile marker 330, or stroll amid brilliant wildflowers along the Sweetwater Branch trail, which runs beside a clear, fast-flowing stream. It is on this portion of the parkway that motorists enjoy their best view of the Old Trace: Old Trace Drive, a one-way journey northbound, features two and a half miles' worth of stunning overlooks.

MYSTERY ON THE TRACE

Mile marker 385.9 on the trace is posted next to a stone monument indicating the final resting place of Meriwether Lewis. He was the senior commander of the Lewis and Clark expedition sent to explore the Louisiana Territory and lands to the west between 1804 and 1806. The monument is situated about 230 yards from the ruins of an old inn called Grinder's Stand.

Lewis, who had served as the governor of the Louisiana Territory and as an aide to Pres. Thomas Jefferson, died in the Grinder House on October 11, 1809, while en route to Philadelphia to write up the story of that expedition. Over the years, suicide and foul play have been suspected in Lewis'

death, but the circumstances of his demise have never been officially determined.

By the time the Natchez Trace Parkway ends about 15 miles outside the lively city of Nashville it has cut a swath through more than 400 miles of forest and underbrush. But a journey along this highway offers motorists more than a sampling of the region's natural beauty. As they follow segments of the original trace, travelers take a step back to the days when pioneers blazed trails to points west and Pony Express riders rode hell-for-leather along the same route.

THE GREAT PLATTE RIVER ROAD

Extending across Nebraska, the Great Platte River Road links the farmlands of the Midwest with the prairies of the West.

Nebraska exhibits a subtle beauty best savored at a leisurely pace. Travelers who ramble along the Great Platte River Road from Omaha to Kimball drive for some 420 miles through an understated landscape of checkerboard fields of corn and wheat, lush green pastures, and grasslands that roll all the way to the horizon. The Platte and South Platte rivers wind alongside a large section of the historic road, their sinuous channels spreading out like the strands of a twisted rope beneath an enormous blue sky.

For 19th-century travelers accustomed to the swift, deep rivers of the East, the Platte was most unusual. One immigrant wrote in his diary in 1850 that the river looked like a "great inland sea," adding that it was "wider than the Mississippi and showed to much better advantage, there being no timber on the banks to check the scope of the human eye."

Although the Platte was immensely wide—in some spots stretching a full mile from bank to bank—its depth ranged from several feet to only a few inches. The shallow waters promised that the river would be easy to ford, but people and livestock tended to lose their footing in its constantly shifting sandbars and currents. Yet the fickle Platte was a welcome sight for these early travelers, who looked to it as a lifeline on their journey westward.

Long before European settlers first glimpsed the Platte, the river nourished the soil of the prairies. It originated in the high, steep mountains of Wyoming and Colorado and swelled each spring with melting snow, flooding the prairie land below. The changeable river produced as many as 10 different channels through the marshlands and sloughs, which expanded or shrank with the water levels. Grasses, berries, and other vegetation grew along

SIMPLE BUT INGENIOUS
Windmills such as the one above are a common sight on the Nebraska plains, where they are used to pump up groundwater. The vane, which extends beyond the edge of the wheel, keeps it from spinning out of control when the wind blows strongly.

GREAT INLAND SEA
Overleaf: Despite engineering projects designed to regulate the flow of the Platte and the North Platte, the rivers are still subject to the whims of nature. They swell with floodwaters in the spring that completely submerge the sandbars. During droughts the rivers become narrow ribbons of water.

the banks, providing sustenance for huge herds of buffalo and for the numerous Native American tribes that lived near the river.

From the 1840's to the 1860's, more than 500,000 immigrants crossed this wide region in what was one of the largest migrations in human history. Pioneers heading to the Northwest followed the Oregon Trail on the south side of the Platte River. Mormons traveled on the north side to avoid encounters with other immigrants, who sometimes committed violent acts against them.

JUMPING-OFF PLACE Visitors begin their journey along Interstate 80 in Omaha, where the Western Heritage Museum, housed in the former railroad station's beautiful Art Deco building, describes how the city served as a jumping-off place for points west. Omaha was also a convenient place to ford the Missouri River and stock up on supplies. The museum displays restored engines and railcars from the Union Pacific Railroad Collection, including a 10-wheel steam engine built in the 1890's and a car from 1914, decorated with imported burled African walnut, that was used by Union Pacific executives. The car is occasionally still used by the chairman of the company.

Before the railroads linked the country, only the very hardy or the lucky could survive the arduous trip across Nebraska on foot or by wagon. During the winter of 1846–47, some 5,000 Mormons camped on the site of today's Mormon Trail Center at the Historic Winter Quarters and Mormon Pioneer Cemetery in Omaha. The Mormons experienced two of Nebraska's harshest winters and before they moved on, more than 600 of their group had been buried along the banks of the Missouri River. Today travelers can stroll through the cemetery, which is situated on the crest of a peaceful wooded hill. The visitor center describes the many hazards faced by the men, women, and children who braved the trek across the state.

From Omaha, the Great Platte River Road heads south, then west through undulating fields of corn and soybeans. From a rise about 20 miles down

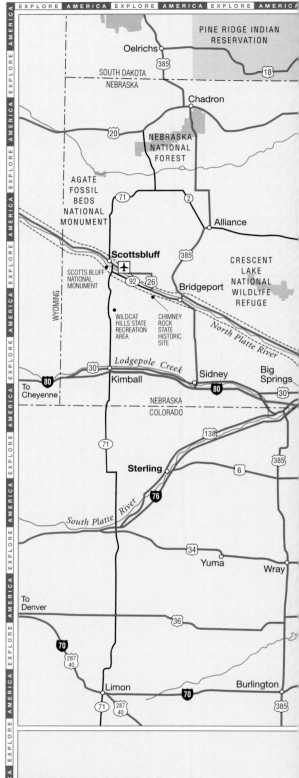

ATTENTION TO DETAIL
Fine craftsmanship produced the devilish visages, left, that greet visitors to the 1880 Andrew's Building on Central Avenue in downtown Kearney. The building now houses a clothing store for men and women.

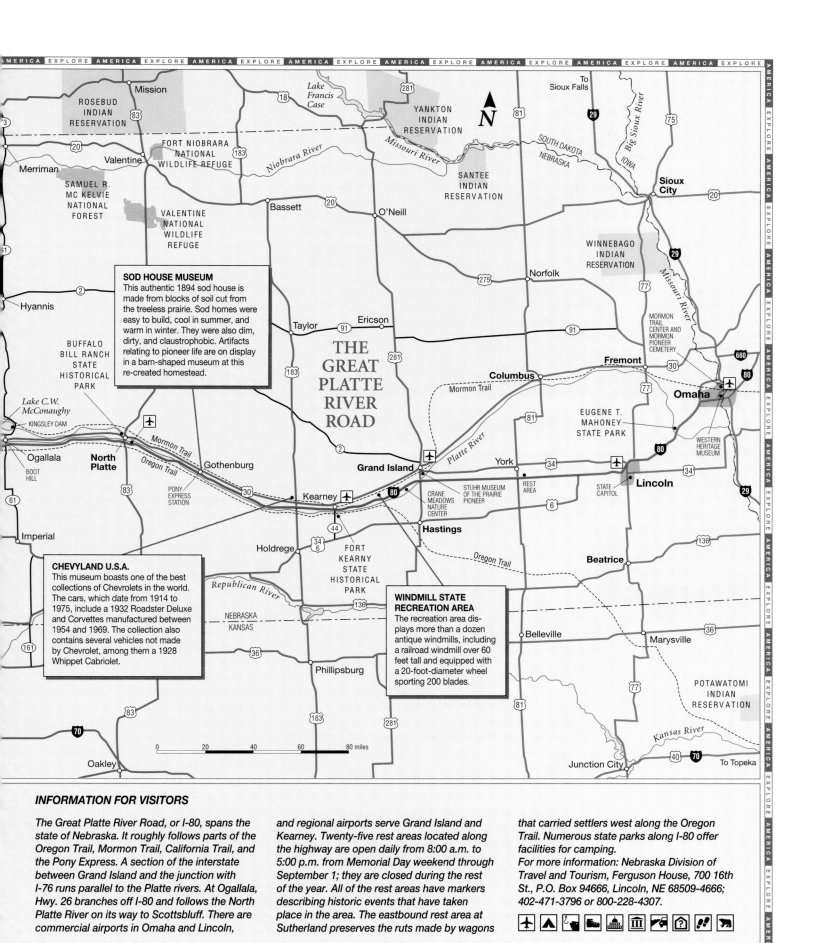

To
Sioux Falls

Mission

ROSEBUD
INDIAN
RESERVATION

YANKTON
INDIAN
RESERVATION

Lake
Francis
Case

SOUTH DAKOTA
NEBRASKA

Big Sioux River

IOWA

Valentine

FORT NIOBRARA
NATIONAL
WILDLIFE REFUGE

Niobrara River

Missouri River

Merriman

SANTEE
INDIAN
RESERVATION

Sioux
City

SAMUEL R.
MC KELVIE
NATIONAL
FOREST

Bassett

O'Neill

VALENTINE
NATIONAL
WILDLIFE
REFUGE

WINNEBAGO
INDIAN
RESERVATION

Missouri River

Hyannis

Norfolk

SOD HOUSE MUSEUM
This authentic 1894 sod house is
made from blocks of soil cut from
the treeless prairie. Sod homes were
easy to build, cool in summer, and
warm in winter. They were also dim,
dirty, and claustrophobic. Artifacts
relating to pioneer life are on display
in a barn-shaped museum at this
re-created homestead.

Taylor

Ericson

MORMON
TRAIL
CENTER AND
MORMON
PIONEER
CEMETERY

BUFFALO
BILL RANCH
STATE
HISTORICAL
PARK

**THE
GREAT
PLATTE
RIVER
ROAD**

Columbus

Mormon Trail

Fremont

Omaha

Lake C.W.
McConaughy

Mormon Trail

EUGENE T.
MAHONEY
STATE PARK

KINGSLEY DAM

Oregon Trail

Ogallala

North
Platte

Gothenburg

Grand Island

Platte River

York

WESTERN
HERITAGE
MUSEUM

BOOT
HILL

PONY
EXPRESS
STATION

Kearney

STUHR MUSEUM
OF THE PRAIRIE
PIONEER

REST
AREA

STATE
CAPITOL

Lincoln

Imperial

Holdrege

CRANE
MEADOWS
NATURE
CENTER

Hastings

CHEVYLAND U.S.A.
This museum boasts one of the best
collections of Chevrolets in the world.
The cars, which date from 1914 to
1975, include a 1932 Roadster Deluxe
and Corvettes manufactured between
1954 and 1969. The collection also
contains several vehicles not made
by Chevrolet, among them a 1928
Whippet Cabriolet.

Republican River

FORT
KEARNY
STATE
HISTORICAL
PARK

Beatrice

**WINDMILL STATE
RECREATION AREA**
The recreation area dis-
plays more than a dozen
antique windmills, including
a railroad windmill over 60
feet tall and equipped with
a 20-foot-diameter wheel
sporting 200 blades.

NEBRASKA
KANSAS

Belleville

Marysville

Phillipsburg

Oregon Trail

POTAWATOMI
INDIAN
RESERVATION

Kansas River

0 20 40 60 80 miles

Oakley

Junction City

To Topeka

INFORMATION FOR VISITORS

The Great Platte River Road, or I-80, spans the
state of Nebraska. It roughly follows parts of the
Oregon Trail, Mormon Trail, California Trail, and
the Pony Express. A section of the interstate
between Grand Island and the junction with
I-76 runs parallel to the Platte rivers. At Ogallala,
Hwy. 26 branches off I-80 and follows the North
Platte River on its way to Scottsbluff. There are
commercial airports in Omaha and Lincoln,

and regional airports serve Grand Island and
Kearney. Twenty-five rest areas located along
the highway are open daily from 8:00 a.m. to
5:00 p.m. from Memorial Day weekend through
September 1; they are closed during the rest
of the year. All of the rest areas have markers
describing historic events that have taken
place in the area. The eastbound rest area at
Sutherland preserves the ruts made by wagons

that carried settlers west along the Oregon
Trail. Numerous state parks along I-80 offer
facilities for camping.
For more information: Nebraska Division of
Travel and Tourism, Ferguson House, 700 16th
St., P.O. Box 94666, Lincoln, NE 68509-4666;
402-471-3796 or 800-228-4307.

AMERICA EXPLORE AMERICA EXPLORE AMERICA EXPLORE AMERICA EXPLORE AMERICA EXPLORE AMERICA EXPLORE AMERICA EXPLORE AMERICA EXPLORE AMERICA EXPLORE

THE GREAT PLATTE RIVER ROAD 53

Travelers along I-80 often sight sandhill cranes, right, from around mid-February to early April, when hundreds of thousands of the birds gather in the wetlands of Nebraska's central Platte River valley. They feed and court there before heading north to their breeding grounds.

BOOTS ON BOOT HILL
A weathered tombstone, above, stands on Boot Hill in Ogallala. Many of the cowboys who died while driving cattle from Texas to Ogallala are buried here.

FRONTIER WORKSHOP
The blacksmith's and carpenter's shop, right, at the Fort Kearny State Historical Park, was made of sod in 1864 and converted to adobe and brick when it was rebuilt in 1964. Other features of the park include a powder magazine and an interpretive center with exhibits that explain the fort's importance to the immigrants heading west.

the road, motorists catch the first glimpse of the Platte River valley. Bordered by tall cottonwoods, the river is wide and shallow with sandbars visible beneath its waters. Small dams have decreased the flow of the Platte; its water now nourishes many cities upstream and irrigates more than 500,000 acres of farmland, transforming this dry land into a rich agricultural breadbasket.

ROADSIDE ART

After crossing the Platte, I-80 continues southwest and heads to Lincoln, the state capital, and then due west through some of the Midwest's most productive farmland. Rows of corn and alfalfa stretch as far as the eye can see, broken here and there by scattered farmsteads encircled by trees. At the westbound rest area near York, travelers can stop and look at artist Bradford Graves' sculpture, *Crossing the Plains,* which is composed of large pieces of stone arranged at the four corners of a compass. Nine rest areas on I-80 feature outdoor works of art as part of Nebraska's Museum Without Walls program. The metal and stone sculptures by contemporary artists form a 500-mile gallery on the pioneer theme.

The interstate meets the Platte River again near Grand Island. Here the river is bordered by wide wetlands of native grasses and the occasional clump of trees—a vital habitat for millions of geese, ducks, and shorebirds, and for huge flocks of sandhill cranes. Each spring during their annual migration nearly a half million cranes rest here for six weeks en route from Texas to the Arctic Circle. They feed in the nearby fields during the day and roost on the river's sandbars at night. Visitors traveling through Nebraska in February to early April may see the elegant gray birds in the distance as they

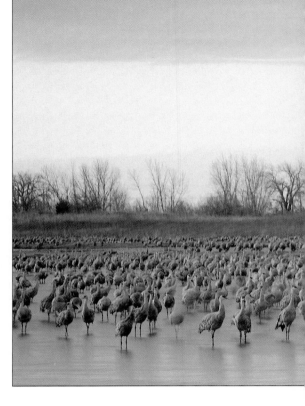

feed along the river's edge. Some pairs of cranes may be seen performing their mating dance, in which they face each other, spread their wings, and raise and lower their heads—sometimes in perfect unison. The Crane Meadows Nature Center near Grand Island offers educational displays on the unique and fragile ecosystem that is essential to the sandhill cranes' survival. The site includes 240 acres of wetlands and native prairie threaded with five miles of hiking trails.

Grand Island is also home to the Stuhr Museum of the Prairie Pioneer, one of the nation's largest living-history museums. The site's 200 acres of

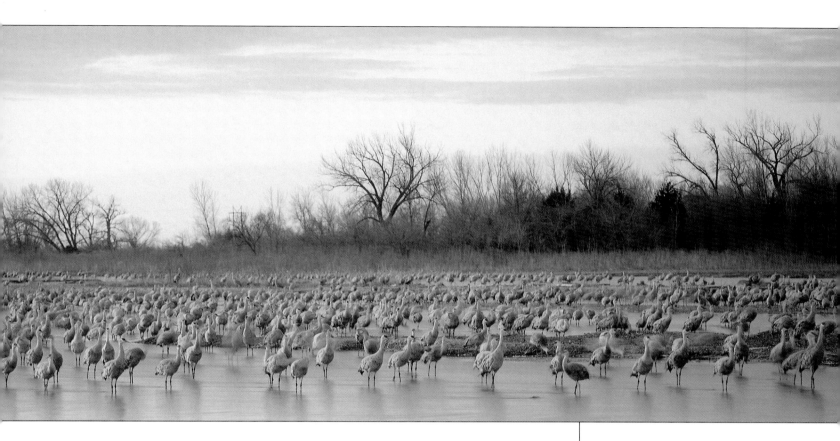

exhibits include an 1880's railroad town complete with more than 60 shops, homes, and barns. Visitors can imagine how the advent of the Iron Horse ended the isolation of the prairie and changed the lives of sodbusters forever.

From Grand Island the highway heads west toward Kearney, hugging the north bank of the Platte as it goes through more prime wetland habitats dotted with small pristine lakes. Many of these lakes are stocked with game fish for anglers.

Kearney grew up on the site of Fort Kearny, the first of the forts built to protect travelers on the Oregon Trail. Visitors can tour the reconstructed stockade at the 40-acre Fort Kearny State Historical Park. From 1848 to 1871, the fort served as the headquarters of military and local government. It also saw duty as a Pony Express, telegraph, and stagecoach station, and as an outfitting depot for campaigns against the Plains Indians.

The route west from Kearney crosses an important, though invisible, demarcation: it is the 100th meridian, an imaginary line that separates the American East from the West. The meridian also marks off eastern Nebraska—a landscape of fertile fields and trees—from the drier, more barren land that characterizes the western portion of the state. Although the changes wrought by dams and modern irrigation systems somewhat blur the differences between these landscapes today, travelers will still note changes in the scenery as they continue west. The color of the fields shifts from green to browner tones. It is here that the West of popular imagination takes over.

The legacy of one of the American West's most famous ventures can be seen farther along I-80 at Gothenburg, the Pony Express capital of Nebraska. In the town's Ehmen Park is a rough-hewn log cabin that served as a Pony Express station from 1860 until 1861, when the completion of the overland telegraph put the Pony Express out of business. Newspapers ads called for young male riders who weighed under 135 pounds, specifying "orphans preferred." Braving outlaws, Indians, and the extremes of weather, the riders relayed the mail

FAMILY FORTITUDE
The courage of Nebraska's early settlers is celebrated in Elizabeth Dolan's mural titled Spirit of the Prairie, *detail above. It is painted on a wall of the Law Library at the Nebraska state capitol in Lincoln. Upon completion of the capitol in 1932, architectural experts declared it to be one of the world's 10 most beautiful buildings.*

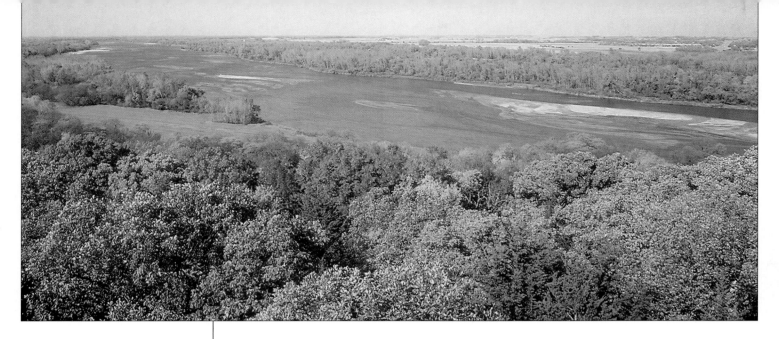

RIVERSIDE PARK
The Eugene T. Mahoney State Park, above, is located on the bluffs of the Platte between Omaha and Lincoln. Its 700 acres provide visitors with ample picnicking, hiking, and camping opportunities. Two lakes within the park are stocked with game fish, and, from the top of a 70-foot observation tower, visitors get a panoramic view of the surrounding landscape.

BLUSHING MARSHLAND
Foxtail barley, right, flourishes wherever there is marshy land along the Platte and the North Platte rivers.

almost 2,000 miles from St. Joseph, Missouri, to Sacramento, California, following the Platte River between Fort Kearny and Fort Sidney.

West of Gothenburg, the road is lined by mile after mile of ranch properties where Hereford, Charolais, and Black Angus cattle are raised. This cowboy territory prepares travelers for the Buffalo Bill Ranch State Historical Park in the town of North Platte. William Frederick Cody worked as a trapper, Pony Express rider, army scout, and buffalo hunter before he hit on the idea of the Buffalo Bill Wild West Show. In 1878 he moved to North Platte and built a ranch named Scout's Rest with profits from his show. The 258-acre park encompasses 16 acres of Cody's original ranch and includes his 1887 horse barn and 18-room ranch house. The house displays a wealth of memorabilia from the frontiersman's long and eventful life, including film footage shot by Thomas Edison. Carved into one of the rafters of the barn is a heart-shaped bull's-eye with a bullet hole—the logo of sharpshooter Annie Oakley.

Just west of the town of North Platte, the interstate follows the South Platte River. Immigrants either continued along the North Platte to Scottsbluff, or they followed the banks of the South Platte and Lodgepole Creek, traveling past Ogallala to Fort Sidney, where they turned north and joined the North Platte in the region of Bridgeport.

Motorists can retrace much of this last pioneer route by driving along Highway 26, which connects with I-80 in Ogallala.

Chimney Rock, a slender 350-foot-high spire, and 800-foot Scotts Bluff, another milestone on the Oregon Trail, are both visible from Highway 26. These important landmarks signaled the end of the prairie and the beginning of the High Plains to the pioneers in the Conestoga wagons that jolted single file through Mitchell Pass just west of the city of Scottsbluff. Scotts Bluff National Monument preserves some of the ruts left by wagons and maintains a museum that documents the history of the Oregon Trail. A short hiking trail and a paved road lead to the top of the bluff. Rising 100 miles to the northwest in Wyoming is 10,272-foot-high Laramie Peak. By doubling back along Highway 26 to the interstate, motorists will see Nebraska's sandhills to the east. These ancient dunes are now covered by a thin layer of soil where native grasses have taken root.

Located nine miles north of Ogallala, Lake C. W. McConaughy is Nebraska's largest reservoir. It was created when Kingsley Dam was completed in 1941. The dam helps irrigate more than 190,000 acres of arable land on either side of the Platte. The reservoir is 20 miles long and 3 miles wide and boasts two state recreation areas offering camping, swimming, boating, and fishing.

At the height of the westward exodus, lines of wagons might be backed up for 20 to 30 miles waiting to cross the South Platte River around Ogallala. Between 1875 and 1888 the town was the terminus of the Texas Trail, the cattle drive route from Texas. After having spent long months on the trail, cowboys would cut loose in Ogallala, earning the town its nickname, the Gomorrah of the Plains.

Those rollicking days are brought to life again on Front Street, a re-creation of Ogallala's frontier era. The street boasts the Cowboy Capital Museum, the 1887 Mansion on the Hill, and the Crystal Palace Revue, a summer saloon show named after a notorious 1875 Ogallala dance hall.

TREELESS LANDSCAPE

From Ogallala I-80 continues west through a landscape that grows increasingly sparse and arid. As it nears Big Springs the South Platte River parts from the highway and goes south toward Colorado, while the highway follows the banks of Lodgepole Creek toward Wyoming. Softly contoured ranch lands alternate with fields of ripening wheat watered by irrigation systems. Trees are scarce in the open landscape, though there are more now than during the pioneer days. One immigrant, traveling through the region in 1848, wrote in her diary that her companions were so excited to see a tree at last that "many of the company walked quite a distance for the pleasure of standing a few moments under its branches."

As the road enters this sparsely populated corner of America close to the Nebraska-Wyoming border, the ghosts of Plains Indians, immigrants, gold miners, Pony Express riders, and the railroad men who worked along the Platte River seem to draw near. Their stories, like the faint cries of a hawk, are audible to anyone who takes the time to stop and listen for them in the prairie wind.

OPEN FOR BUSINESS
A tinsmith stands in front of his shop, above, in Grand Island's Stuhr Museum of the Prairie Pioneer. The shop is 1 of 60 buildings that were moved here and restored to re-create a 19th-century railroad town.

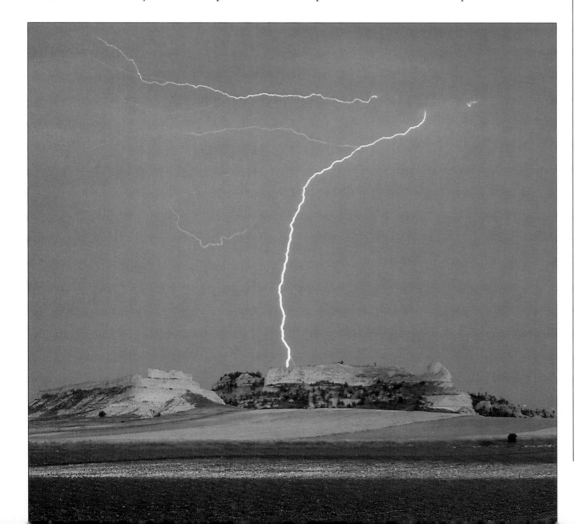

HERALDING RAIN
Lightning strikes a butte in the Wildcat Hills, left, where the yearly rainfall averages between 11 and 13 inches. Summer storms are quick and violent, and little of the rain seeps into the Ogallala aquifer, the vast, ancient reservoir that lies under the region and provides the groundwater needed to irrigate crops.

THE BEARTOOTH HIGHWAY

*This stretch of Highway 212 winds, twists, doubles back,
and climbs through an alpine wonderland between
Red Lodge and Yellowstone National Park.*

Up this highway, say folks in Red Lodge, lies the top of the world. That's strong talk in Montana's Big Sky Country, where breathtaking vistas unfold in every direction. But the 69-mile-long journey on the Beartooth Highway proves this is no idle boast. The road climbs to dizzying heights. It dives through mountain forests and sweeps across treeless plateaus scoured by wind, gouged by glaciers, and softened by brilliant arrays of alpine wildflowers. It is a road of such extraordinary beauty that television correspondent Charles Kuralt, renowned for his *On the Road* series, called it one of "the most beautiful drives in America."

The air is thin at the top of the world and on a clear day you can see forever. The Beartooth Mountains, for which this stretch of U.S. Highway 212 is named, feature no fewer than 20 peaks with elevations over 12,000 feet. Glaciers still move through the northern slopes of the highest summits. On the highway's loftiest heights, such as at Beartooth Pass, roadside snowbanks sometimes remain through July and snow flurries may take travelers by surprise as early as August.

Red Lodge is a memorable starting point for the drive along the Beartooth Highway. Founded in 1884, the town boomed for a while as a coal mining center. Now a quiet community of about 2,300 people, it is part resort and part Old West. The owners of a local hardware store dispense cheerful advice along with snow shovels, penny nails, and camping gear; upstairs in the sports shop, where tips on the choicest fly are exchanged, the small talk has a refreshing down-home flavor. Red Lodge's downtown has many 19th- and early 20th-century buildings, some of which are now listed in the National Register of Historic Places, and the town offers a mix of

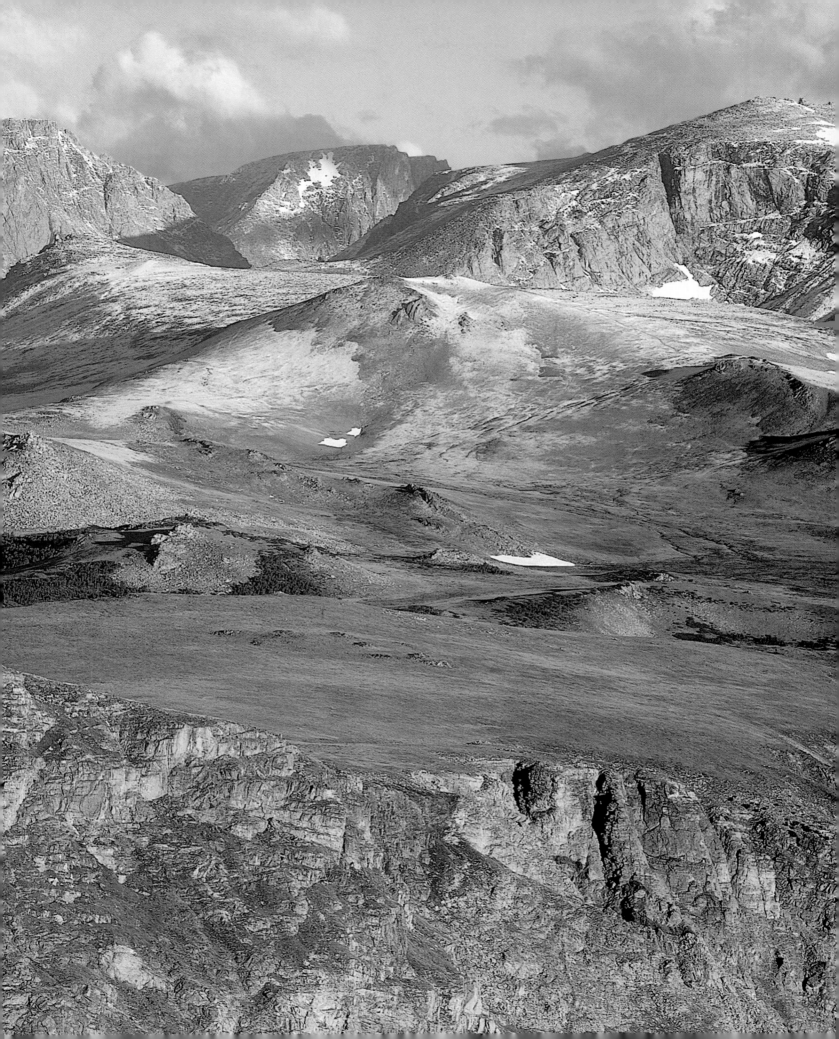

ON THE ROAD
A motor home swings around the sharp curves of the Beartooth Highway, above.

ICE-AGE ARTISTRY
Overleaf: Thousands of years ago glaciers carved the valleys, cirques, and horns of the Beartooth Mountains. Streams of ice on the mountains' highest peaks await the next glacial advance, which will push them into action once again.

appealing restaurants and lodgings. Nearby dude ranches range in style from the rustic to the luxurious—all of them proving the cowboy maxim that the West is best seen from the saddle.

PROUD HERITAGE

At 5,555 feet above sea level, Red Lodge is situated at the same elevation as "mile-high" Denver. According to local lore, the town took its name from the ocher-colored lodge favored by the long-forgotten Mountain Crow, who lived in the area. The Mountain Crow was the larger of two bands of Crow; a second band, known as the River Crow, lived on the high plains to the east. The Crow were a proud people who battled ceaselessly with their bitter enemy, the Sioux, now known as the Lakota. The Crow eagerly furthered the contest with the Sioux by serving as scouts for the U.S. Army during the Sioux wars. Today descendants of these fierce warriors live on a reservation southeast of Billings at the Crow Agency in Montana.

The height of the tourist season in Red Lodge lasts from Memorial Day to mid-October, when the Beartooth Highway is open. The town hosts

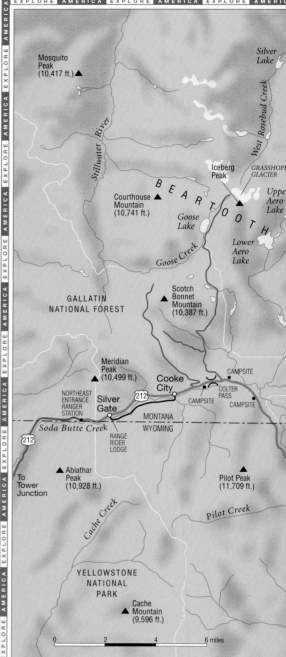

Mosquito Peak (10,417 ft.) ▲

Silver Lake

Stillwater River

West Rosebud Creek

B E A R T O O T H

Iceberg Peak

GRASSHOPPER GLACIER

Courthouse Mountain (10,741 ft.) ▲

Goose Lake

Upper Aero Lake

Lower Aero Lake

Goose Creek

GALLATIN NATIONAL FOREST

Scotch Bonnet Mountain (10,387 ft.) ▲

Meridian Peak (10,499 ft.) ▲

Cooke City

CAMPSITE

NORTHEAST ENTRANCE RANGER STATION

Silver Gate

212

COLTER PASS

CAMPSITE

CAMPSITE

MONTANA
WYOMING

Soda Butte Creek

RANGE RIDER LODGE

212

To Tower Junction

Abiathar Peak (10,928 ft.) ▲

Pilot Peak (11,709 ft.) ▲

Cache Creek

Pilot Creek

YELLOWSTONE NATIONAL PARK

Cache Mountain (9,596 ft.) ▲

0 2 4 6 miles

INFORMATION FOR VISITORS

To reach the Beartooth Highway from Billings, take I-90 and then U.S. Hwy. 212 to Red Lodge. The highway extends southwest from Red Lodge for 24.2 miles to the Montana-Wyoming border, west-southwest in Wyoming for 20 miles, northwest for 15 miles to the Montana-Wyoming border, and 8.7 miles west-northwest into Montana through Cooke City to the northeast entrance to Yellowstone National Park. The road usually opens on Memorial Day weekend, and is kept open until snow in the upper elevations inhibits traffic—sometimes as early as October 15. It is maintained by the states of Montana

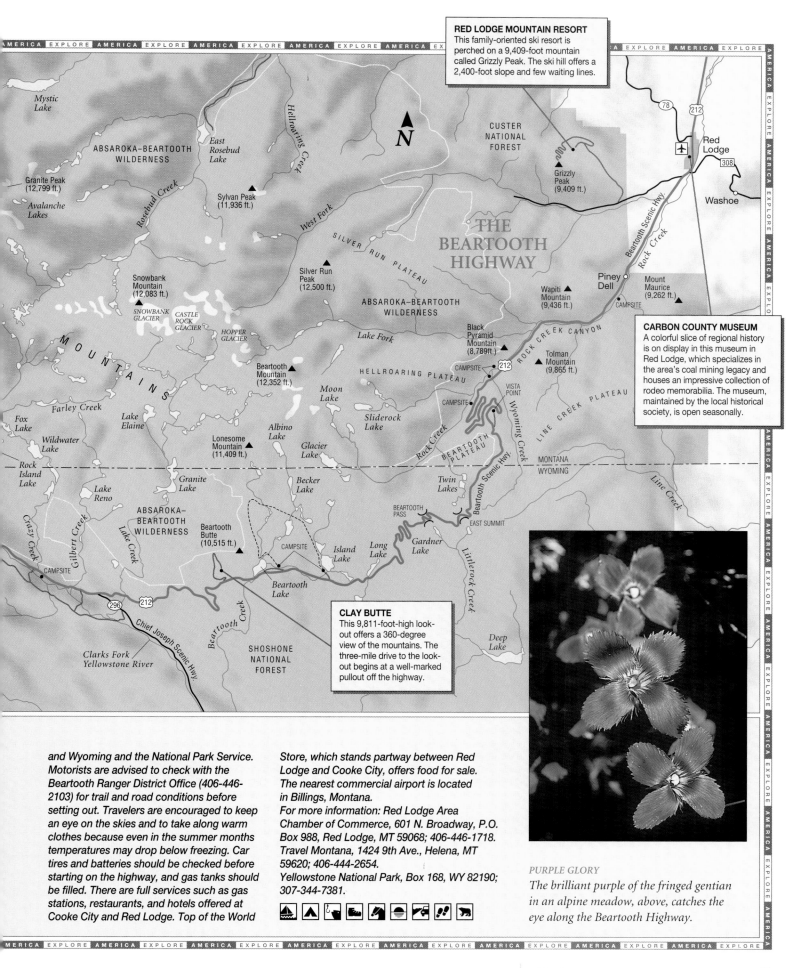

RED LODGE MOUNTAIN RESORT
This family-oriented ski resort is perched on a 9,409-foot mountain called Grizzly Peak. The ski hill offers a 2,400-foot slope and few waiting lines.

CARBON COUNTY MUSEUM
A colorful slice of regional history is on display in this museum in Red Lodge, which specializes in the area's coal mining legacy and houses an impressive collection of rodeo memorabilia. The museum, maintained by the local historical society, is open seasonally.

CLAY BUTTE
This 9,811-foot-high lookout offers a 360-degree view of the mountains. The three-mile drive to the lookout begins at a well-marked pullout off the highway.

Map labels:
Mystic Lake
ABSAROKA–BEARTOOTH WILDERNESS
East Rosebud Lake
Hellroaring Creek
CUSTER NATIONAL FOREST
Red Lodge
Granite Peak (12,799 ft.)
Sylvan Peak (11,936 ft.)
Rosebud Creek
West Fork
Grizzly Peak (9,409 ft.)
Washoe
Avalanche Lakes
N
THE BEARTOOTH HIGHWAY
Beartooth Scenic Hwy.
Rock Creek
SILVER RUN PLATEAU
Snowbank Mountain (12,083 ft.)
Silver Run Peak (12,500 ft.)
ABSAROKA–BEARTOOTH WILDERNESS
Wapiti Mountain (9,436 ft.)
Piney Dell
Mount Maurice (9,262 ft.)
SNOWBANK GLACIER
CASTLE ROCK GLACIER
HOPPER GLACIER
Lake Fork
Black Pyramid Mountain (8,789 ft.)
CAMPSITE
ROCK CREEK CANYON
Tolman Mountain (9,865 ft.)
M O U N T A I N S
Beartooth Mountain (12,352 ft.)
Moon Lake
HELLROARING PLATEAU
CAMPSITE
212
VISTA POINT
LINE CREEK PLATEAU
Farley Creek
Lake Elaine
Sliderock Lake
CAMPSITE
Wyoming Creek
Fox Lake
Wildwater Lake
Lonesome Mountain (11,409 ft.)
Albino Lake
Glacier Lake
Rock Creek
BEARTOOTH PLATEAU
MONTANA
WYOMING
Line Creek
Rock Island Lake
Granite Lake
Becker Lake
Twin Lakes
Lake Reno
Lake Creek
ABSAROKA–BEARTOOTH WILDERNESS
Beartooth Butte (10,515 ft.)
CAMPSITE
BEARTOOTH PASS
EAST SUMMIT
Beartooth Scenic Hwy.
Crazy Creek
Gilbert Creek
CAMPSITE
Island Lake
Long Lake
Gardner Lake
Littlerock Creek
296
212
Beartooth Creek
Beartooth Lake
Chief Joseph Scenic Hwy.
Deep Lake
Clarks Fork Yellowstone River
SHOSHONE NATIONAL FOREST
78
212
308

and Wyoming and the National Park Service. Motorists are advised to check with the Beartooth Ranger District Office (406-446-2103) for trail and road conditions before setting out. Travelers are encouraged to keep an eye on the skies and to take along warm clothes because even in the summer months temperatures may drop below freezing. Car tires and batteries should be checked before starting on the highway, and gas tanks should be filled. There are full services such as gas stations, restaurants, and hotels offered at Cooke City and Red Lodge. Top of the World Store, which stands partway between Red Lodge and Cooke City, offers food for sale. The nearest commercial airport is located in Billings, Montana.

For more information: Red Lodge Area Chamber of Commerce, 601 N. Broadway, P.O. Box 988, Red Lodge, MT 59068; 406-446-1718. Travel Montana, 1424 9th Ave., Helena, MT 59620; 406-444-2654. Yellowstone National Park, Box 168, WY 82190; 307-344-7381.

PURPLE GLORY
The brilliant purple of the fringed gentian in an alpine meadow, above, catches the eye along the Beartooth Highway.

Parry's townsendia and buttercups brighten a mountain meadow that borders Island Lake, right, where a variety of wildflowers flourish each spring in the wake of retreating snowbanks. The distant peak of Lonesome Mountain is visible through the trees.

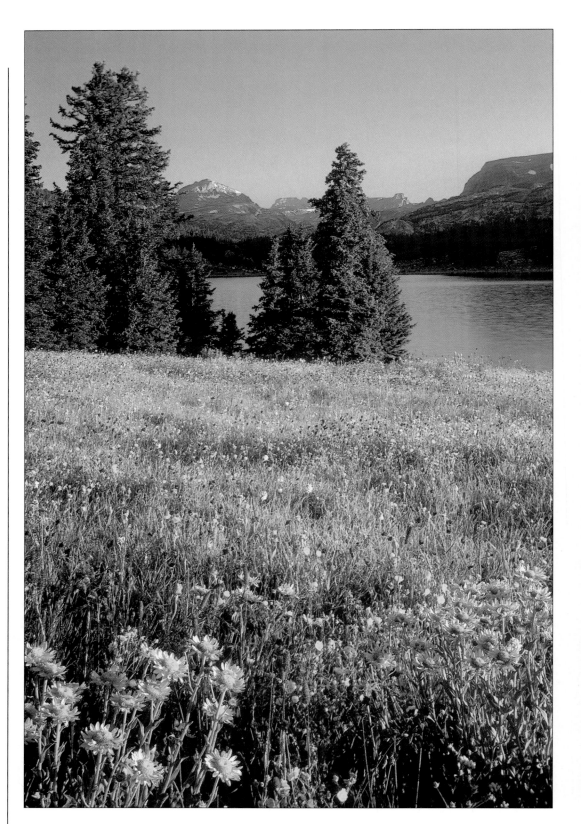

many festivals in these mountains, including events such as an Independence Day parade and rodeo; a Festival of Nations, featuring international food and crafts; and the Red Lodge Mountain Man Rendezvous, a nine-day affair in which more than 150 participants re-create the midsummer trading rendezvous of early 19th-century fur trappers. The country south and west of Red Lodge was a prime stomping ground for the legendary mountain men, whose wanderings through the wilderness in search of valuable beaver pelts helped open up the West.

Visitors may enjoy Red Lodge's special occasions, but the town's indisputable main attraction is its dramatic location. Poised on the edge of Custer National Forest, it is the jumping-off point for treks into Shoshone National Forest, Gallatin National Forest, and the sprawling, 945,000-acre Absaroka-Beartooth Wilderness. Absaroka—pronounced

locally as "ab-sor-ki"—is an Indian word for crow. Hardy backpackers intent on hiking, camping, fishing, or hunting in these parts stop in Red Lodge to buy supplies, upgrade their gear at local outfitters, and obtain information at the National Forest Service's Beartooth Ranger District Headquarters. Those who plan to drive the Beartooth Highway can buy gas and have their cars checked before heading out. It takes approximately three hours to drive from Red Lodge to the northeast entrance of Yellowstone National Park. But most motorists will want to take their time, pausing at the many overlooks that offer spectacular views, or stopping to picnic—with binoculars, a camera, and, of course, plenty of film at the ready.

| EASY START |
As Highway 212 leaves Red Lodge, it gives visitors a gentle introduction to the wonders ahead. It eases through Rock Creek Canyon, a steep-walled valley marked by handsome groves of lodgepole pine, Engelmann spruce, and Douglas fir. At first Rock Creek is seen on the left, racing over rocks and pooling around boulders. Then the road crosses the stream and runs parallel to it under the boughs of weeping willows and past alder bushes and stands of quaking aspen and cottonwood. Sometimes moose are seen browsing in the lowlands, and mule and white-tailed deer can be glimpsed in patches of meadow.

Squirrels chatter high in the lodgepoles. Along this stretch of highway the National Forest Service has cleared and maintains five primitive campsites that offer fire pits, hand pumps, and outhouses. One of the campgrounds is located near two-acre Greenough Lake, which is visible from the road and stocked with trout.

Past Greenough Lake and well into the canyon, the Beartooth abruptly changes character and begins to live up to its reputation as an exciting

WINTER FORAGE
Snow-covered meadows, above, in Yellowstone's Lamar Valley are winter range territory for elk and bison in Yellowstone National Park. Pronghorn antelopes—the swiftest mammal in North America—and coyotes are other animals frequently sighted in the valley.

RACING MARATHON
Bicyclists in Red Lodge find their marks for the 70-mile-long Peaks to Prairie Race, left. At the start of the race, competitors run 8 miles, then cycle 45 miles to Laurel, where they dismount and complete the race by rowing to Billings, Montana, on the Yellowstone River.

drive. Well-graded and skillfully designed switchbacks climb Rock Creek Canyon's wall. Although the road does not rise at more than a 3 percent to 6 percent grade, the steady ascent can produce white knuckles in some travelers. For most people, though, the journey is one of sheer exhilaration.

The building of this road was a mammoth achievement for the workers who blasted and graded their way up the mountainside. The highway's premier promoter was Dr. J. C. F. Siegfriedt, a Bear Creek physician who feared that the closing of the region's coal mines in the early 20th century might devastate his community. If a highway were constructed that scaled the mountain and transported visitors to Yellowstone National Park, the doctor reasoned, millions of people might come to see the beauties of the high country—and

their tourist dollars would easily make up for any loss in mining money. It took Dr. Siegfriedt more than a decade of persuasive lobbying, but eventually Congress acted on his vision and earmarked federal dollars for the project. Construction began on the highway on September 4, 1931, and for nearly five years road crews labored up, over, and along the mountains. When the work was finally done, the cost of the highway had reached a staggering amount—$2.5 million.

The heart-pounding drive to the very top of the canyon wall ends at an overlook where drivers can park and walk a paved pathway to 8,155-foot Vista Point. The perspective on the region from here is startling: Rock Creek Canyon appears as if in miniature, and due west the Hellroaring Plateau stretches away to the horizon.

Steep ridges, drops, and upland meadows flank the highway as it heads south from Vista Point. After it crosses into Wyoming, the road climbs East Summit, whose heights reach almost 11,000 feet. A series of lookouts, located a couple of miles below the summit, provide gorgeous vistas of Twin Lakes to the northwest.

OLYMPIAN HEIGHTS

Leaving East Summit behind, the highway makes another ascent as it takes travelers over 10,947-foot Beartooth Pass. Mountain Crow warriors had been using the pass for centuries when the first Europeans crossed it in 1882 as part of a detachment of the U.S. Army led by Gen. Philip H. Sheridan. The troops blazed a trail in 1882 that connected Cooke City to Billings. Later, pioneers and wagon trains further defined the trail, but it was not until 1936, when the highway was completed, that Beartooth Pass began to see travelers in significant numbers.

The next few miles after Beartooth Pass afford sharp-eyed visitors opportunities to spot mountain goats on the surrounding peaks and ridges. Bighorn sheep can also sometimes be sighted in the area, as well as marmots. In lower meadows and forests, elk, mule deer, and black bears are occasionally seen. This is not grizzly country, although grizzlies do roam the nearby Sunlight Basin, some sections of Shoshone National Forest, and Yellowstone National Park.

About five miles south of Beartooth Pass a lookout leads to Island Lake Campground and the trailhead for Beartooth High Lake Trail. It is an easy hike that offers superb views of Island Lake. However, at 9,518 feet, even a trail like this can leave hikers winded, so novices are advised to pace themselves carefully. Foot travel anywhere off the highest trail is banned: it takes centuries to form an inch of soil at such high elevations, so the ground needs to be protected.

At 8,901 feet, Beartooth Lake Campground offers more hiking trails and trout fishing. In the middle of summer the upland meadows display the color range of an artist's palette. Lupines, Indian paintbrushes, phlox, alpine avens, columbines, and buttercups decorate the high country in a brief but glorious splash of hues. From various stretches along this section of the road travelers can see Beartooth Butte, its jagged summit reminiscent of a giant grizzly's molar.

About 50 miles from Red Lodge the highway passes south of Clay Butte, which is accessible during the summer by a dependable unpaved road. A lookout at the site takes in a sweeping panorama, including 12,799-foot-high Granite Peak in the north, the highest peak in mountainous Montana.

SUNSHINE STROLL
Broadway Avenue, above, in Red Lodge offers sunshine and shopping sprees to visitors.

Visitors who stop at the next lookout along the road can see Wyoming's Index Peak and Pilot Peak, remnants of a once-extensive volcanic field.

A few miles farther along, as it drops into glacial lake country, the Beartooth intersects Wyoming Highway 296, which is better known as Chief Joseph Scenic Highway. The route leads travelers on a dazzling side trip into Wyoming's picturesque Sunlight Basin. The road curves, loops, and glides by the sheer-walled canyon that cradles the roaring headwaters of Clarks Fork Yellowstone River. It bridges the gorge about 10 miles southeast of the intersection with the Beartooth. The site provides visitors with parking and a bridge walkway for an arresting view of the precipitous drop. Chief Joseph and his band of Nez Perce Indians made their way through here in an attempt to escape pursuing federal troops during the 1877 Nez Perce War.

Just past its intersection with Highway 296, the Beartooth turns northwest and heads back toward Montana. Before it recrosses the state line, about eight miles from the 296 intersection, the highway passes a lookout near Crazy Creek Campground, which is administered by the National Forest Service. After savoring the surrounding views, travelers can hike upstream a short way to enjoy a series of waterfalls that are especially impressive in early summer, when the snowmelt sends a fusillade of crystal-clear water rushing and splashing over the rocky route.

TOP OF THE WORLD

Right, the land rises sharply from Twin Lakes to the Shoshone National Forest, and then to the snow-streaked mountain peaks in the distance.

POINTED PEAKS

Below, the jagged snowcapped peaks of the Beartooth Mountains are seen from the highway where it crosses Crazy Creek.

EXPLORERS' COMPANION

A few miles beyond the Crazy Creek lookout, the Beartooth Highway crosses Colter Pass at about 8,000 feet, revealing more spellbinding views: rows of snowcapped peaks shape the horizon and virgin stands of timber, backed by upland meadows, crowd the highway.

The pass has an interesting history. It is named for explorer and adventurer John Colter, who accompanied Lewis and Clark on their epic pathfinding journey through the West. On the expedition's return to St. Louis, they encountered a pair of outward-bound adventurers who persuaded Colter to lead them back into the Rockies to hunt for beaver. Dazzled by all he had seen, Colter agreed. But he had more than beaver profits in mind: he wanted to see what lay on the other side of the mountains—every mountain.

During the winter of 1807–08, Colter traveled through Wyoming, Montana, and Idaho, becoming the first to report the wonders of Yellowstone Country. So spectacular were Colter's descriptions of the region's natural features that some folks back East refused to believe him. Equally unimaginable were some of his personal experiences. Colter told fascinated listeners that he and a fellow trapper were once ambushed by Blackfoot warriors northwest of the Beartooth Mountains. The Indians killed his companion, stripped Colter of his clothing, and ordered him to run for his life with the warriors in hot pursuit. Although barefoot, he outdistanced most of his pursuers and managed to kill their leader with the warrior's own lance. After that, Colter escaped by hiding under a river logjam. He walked naked for 200 miles to the nearest outpost.

The raw beauty of this area matches its history. But in cruising along this final section of the Beartooth Highway, travelers may have trouble imagining the life-and-death struggles that took place here. Cooke City's quaint and pleasant atmosphere belies its past as a rough-and-tumble gold mining camp. The community began as a ramshackle tent city named Shoo Fly and grew to become a false-front boomtown counting 135 log cabins, a couple of general stores, and no fewer than 13 saloons. Shoo Fly was renamed in 1880 to flatter Jay Cooke Jr., principal investor in the local mining industry and son of one of the great railroad barons of the day.

Today the town numbers about 80 year-round residents, who happily endure the high country winters in exchange for the sublime isolation the region offers. It's a roadside town with a smattering of restaurants, motels, and souvenir shops. In the summer Cooke City experiences a modest boom, catering to Beartooth Highway travelers, fishing buffs, and mountain-lovers. The Cooke City Visitor's Center provides anglers with directions to good trout fishing on Soda Butte Creek, along the headwaters of the Stillwater River, and in nearby lakes. It also dispenses information on hiking, biking, and horseback riding in the area and offers pointers on interesting local landmarks.

A favorite side trip for many experienced hikers takes them northeast of Cooke City to the edge of the Absaroka–Beartooth Wilderness. A glacier there on the north side of Iceberg Peak has grasshoppers frozen into it. The grasshoppers were heading for the plains about 300 years ago when freezing weather stopped them in their tracks. At Cooke City Store visitors can obtain topographical maps of the area and directions on how to reach the ridge for the spectacular views of the glacier. The best time to make the trek is during the month of August, when the previous year's snow accumulation has melted and left the grasshoppers exposed to view.

Four miles west of Cooke City, the Beartooth passes through Silver Gate. A former gambling casino here has been turned into a mountain inn called the Range Rider Lodge. It bills itself as the largest native lodgepole hotel in the West after the Old Faithful Inn in Yellowstone National Park.

The Beartooth Highway slides to a finish three miles west of Silver Gate, at the beginning of Yellowstone National Park. Although this northeast entrance is the least used in the park, some visitors claim it as their favorite. The majesty of the park's Lamar Valley is a fitting climax to the journey that began in Red Lodge, for only a landscape of such great splendor could hope to compete with the natural wonders found along the entire length of the Beartooth Highway.

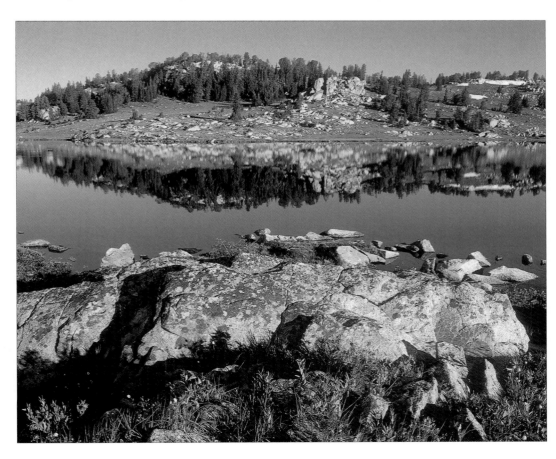

MIRROR IMAGES
The glassy surface of Long Lake, left, on the Beartooth Plateau, reflects the image of the surrounding trees and rock formations.

SAWTOOTH DRIVE

This circular drive along three scenic byways takes travelers through a stunning landscape of volcanic wasteland, fertile farms, and sky-piercing mountains.

At sunrise the flaming peaks of the Sawtooth Range spear the steely Idaho sky. The canyons shed their misty cloaks and the rivers sing along a thousand rapids. Elk bugle across alpine meadows, and from distant aeries, eagles set sail on wings of dark brown. In the distance a car, dwarfed by the mountains, is making its way along a deserted road. The solitary vehicle is following the scenic Sawtooth Drive, a stretch of blacktop that threads through a magnificent region of rock, water, and light that puts the many facets of Idaho's untamed beauty on display.

The drive begins in the state capital, Boise—a perfect balance of frontier flavor and urban sophistication. Families wander through Zoo Boise, art aficionados peruse the Boise Art Museum, and history buffs tour the historic district, where the settings for many of the city's events are preserved in wood and stone. Like every outpost, Boise seems to hold the promise of something special around every corner.

Highway 21, the Ponderosa Pine Scenic Byway, travels eastward from the city, curving along the Boise River through the sage-covered slopes and forested vales of the Boise Front. But the scenery meant little to prospector George Grimes and his small party of prospectors when they trudged through the valley in 1862. They were after an immediate reward—one that no awe-inspiring vista could provide.

In a remote canyon 38 miles farther up the road, the riverbed gravels surrendered the precious gold the men sought. News of the strike unleashed a torrent of gold hunters on the Boise Basin and virtually overnight, tent towns sprang up side by side in canyons that had known little more than the song of the mountain bluebird.

With its dependable flow of water, Idaho City, located northeast of Boise on Highway 21, became the mining center in the region. By 1864 a reputed 20,500 people lived in Idaho City, making it the largest settlement in the Pacific Northwest. Within two

SINGLE HORSEPOWER
Horse-drawn carriages on Main Street in Boise, above, transport visitors on a nostalgic journey into the city's past. The leisurely mode of travel allows passengers to savor the city's many riches.

decades, the basin had yielded finds of the precious metal worth $250 million of today's dollars—before the inevitable bust.

Once rowdy and roaring, Idaho City is a relatively sedate place today that profits from the outdoor adventure trade and preserves the heritage of its heyday as a mining capital. The Boise Basin Historical Museum is a good place for travelers to mine for memories. With the help of period photographs, tools, clothing, and other artifacts, the past pulses again with life.

The dreams of many a desperate miner were consumed by this boisterous town. But it also exerted a civilizing influence on the region. Idaho City's historic buildings include the Boise County Courthouse, Saint Joseph's Catholic Church, and the Old Masonic Hall, built in 1865 and said to be the oldest Masonic temple still in use.

A BURN ZONE REBORN

Highway 21 meets the South Fork of the Payette River at the picturesque town of Lowman. The nearby mountains, once cloaked in pine trees, have been reforested: a fire in July 1989, which was started by lightning, left a ghostly landscape of charred stumps and burned logs jumbled together like giant pickup sticks. Plants and animals have recolonized the burn zone, but it will take several generations before the trees provide shade again. Interpretive signs along the road describe the devastating fire and its aftermath, helping visitors to understand the effects of fires and

WINTER'S MANTLE
Overleaf: A snow-encrusted fence stretches across the frozen rangeland of Idaho's Sawtooth Valley.

BOISE RIVER GREENBELT
A 13-mile-long pathway on either side of the Boise River attracts walkers, runners, and cyclists. During the summer, the river is a popular spot for rafting trips.

OWYHEE COUNTY HISTORICAL MUSEUM
This museum, located in the small town of Murphy, boasts a collection of Native American artifacts, cowboy memorabilia, and a preserved schoolhouse.

INFORMATION FOR VISITORS

The Sawtooth Drive begins in Boise and loops in a clockwise direction along Hwys. 21, 75, 93, 30, I-84, Hwys. 78 and 45, and leads back to Boise. The drive is about 345 miles long. The region's largest commercial airports are located in Boise and Idaho Falls; there is a regional airport in Twin Falls. Float trips on the Middle Fork of the Salmon

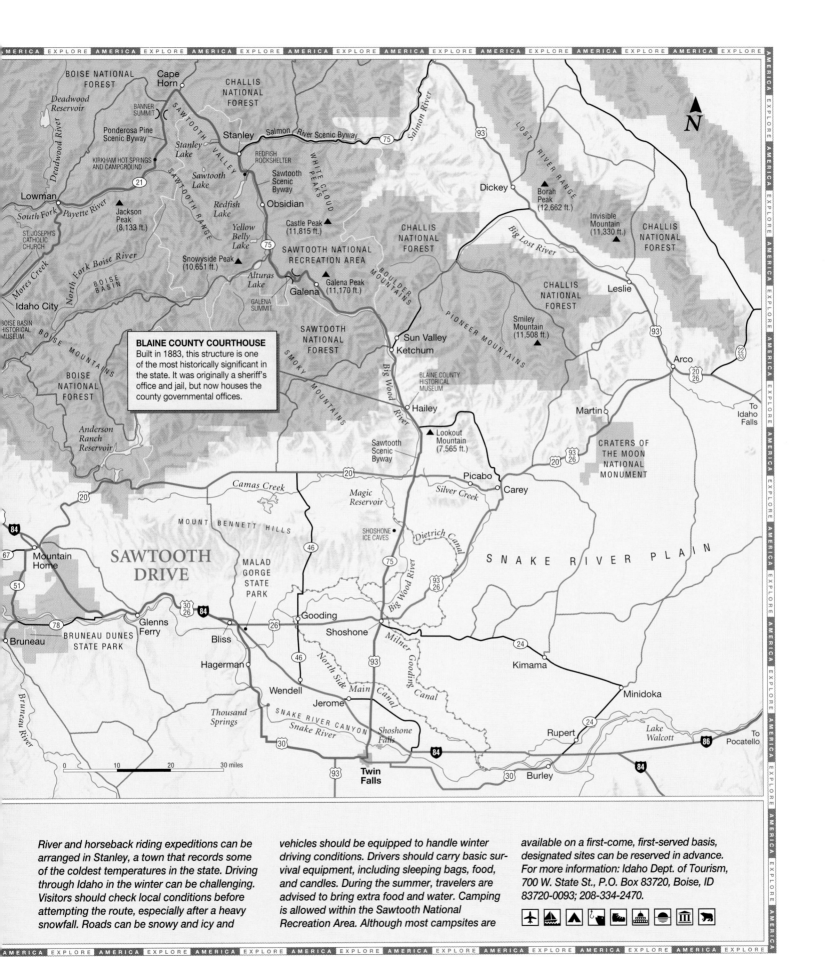

BOISE NATIONAL FOREST

Cape Horn

CHALLIS NATIONAL FOREST

Deadwood Reservoir

BANNER SUMMIT

Ponderosa Pine Scenic Byway

Stanley

Salmon River Scenic Byway

75

Salmon River

93

LOST RIVER RANGE

N

KIRKHAM HOT SPRINGS AND CAMPGROUND

Stanley Lake

REDFISH ROCKSHELTER

Sawtooth Scenic Byway

Dickey

Borah Peak (12,662 ft.)

Lowman

21

Sawtooth Lake

Sawtooth Scenic Byway

WHITE CLOUD PEAKS

Invisible Mountain (11,330 ft.)

CHALLIS NATIONAL FOREST

South Fork Payette River

Jackson Peak (8,133 ft.)

Redfish Lake

Obsidian

Castle Peak (11,815 ft.)

CHALLIS NATIONAL FOREST

Big Lost River

ST. JOSEPH'S CATHOLIC CHURCH

Yellow Belly Lake

75

SAWTOOTH NATIONAL RECREATION AREA

Leslie

93

North Fork Boise River

Snowyside Peak (10,651 ft.)

Alturas Lake

Galena

Galena Peak (11,170 ft.)

BOULDER MOUNTAINS

CHALLIS NATIONAL FOREST

Smiley Mountain (11,508 ft.)

BOISE BASIN

Idaho City

GALENA SUMMIT

PIONEER MOUNTAINS

Arco

22 33

BOISE BASIN HISTORICAL MUSEUM

SAWTOOTH NATIONAL FOREST

Sun Valley

Ketchum

93

20 26

BLAINE COUNTY COURTHOUSE
Built in 1883, this structure is one of the most historically significant in the state. It was originally a sheriff's office and jail, but now houses the county governmental offices.

SMOKY MOUNTAINS

Big Wood River

BLAINE COUNTY HISTORICAL MUSEUM

Hailey

Martin

20 26

To Idaho Falls

BOISE NATIONAL FOREST

Anderson Ranch Reservoir

Sawtooth Scenic Byway

Lookout Mountain (7,565 ft.)

Picabo

Carey

93 26

CRATERS OF THE MOON NATIONAL MONUMENT

20

Camas Creek

Magic Reservoir

Silver Creek

84

MOUNT BENNETT HILLS

46

SHOSHONE ICE CAVES

Dietrich Canal

SNAKE RIVER PLAIN

67

Mountain Home

MALAD GORGE STATE PARK

75

Big Wood River

93 26

SAWTOOTH DRIVE

51

30 26

84

Milner

24

78

Glenns Ferry

Bliss

26

Gooding

Shoshone

Gooding Canal

Kimama

Bruneau

BRUNEAU DUNES STATE PARK

Hagerman

46

North Side Main Canal

93

Minidoka

Wendell

Jerome

Lake Walcott

86

Thousand Springs

SNAKE RIVER CANYON

Shoshone Falls

Rupert

To Pocatello

Bruneau River

30

Snake River

84

24

0 10 20 30 miles

93

Twin Falls

30

Burley

84

River and horseback riding expeditions can be arranged in Stanley, a town that records some of the coldest temperatures in the state. Driving through Idaho in the winter can be challenging. Visitors should check local conditions before attempting the route, especially after a heavy snowfall. Roads can be snowy and icy and

vehicles should be equipped to handle winter driving conditions. Drivers should carry basic survival equipment, including sleeping bags, food, and candles. During the summer, travelers are advised to bring extra food and water. Camping is allowed within the Sawtooth National Recreation Area. Although most campsites are

available on a first-come, first-served basis, designated sites can be reserved in advance. For more information: Idaho Dept. of Tourism, 700 W. State St., P.O. Box 83720, Boise, ID 83720-0093; 208-334-2470.

AMERICA EXPLORE AMERICA EXPLORE AMERICA EXPLORE AMERICA EXPLORE AMERICA EXPLORE AMERICA EXPLORE AMERICA EXPLORE AMERICA EXPLORE

SAWTOOTH DRIVE 71

STILL WATERS RUN DEEP
The weathered dock of the Redfish Lake Marina juts into the lake, right. One of the area's most developed lakes, Redfish has a public boat launch, two swimming areas, and can be used for motorboating, sailing, and fishing in the summer.

SNAKE RIVER TREASURES
Grasses and sagebrush cover the banks of the Snake River where it meanders past Hagerman Fossil Beds National Monument, below. The site encompasses one of the world's richest deposits of Pliocene epoch terrestrial fossils.

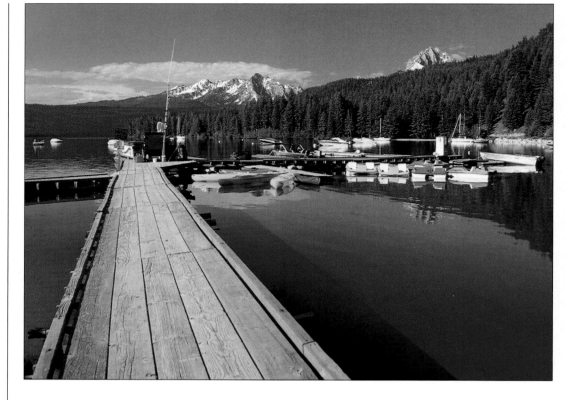

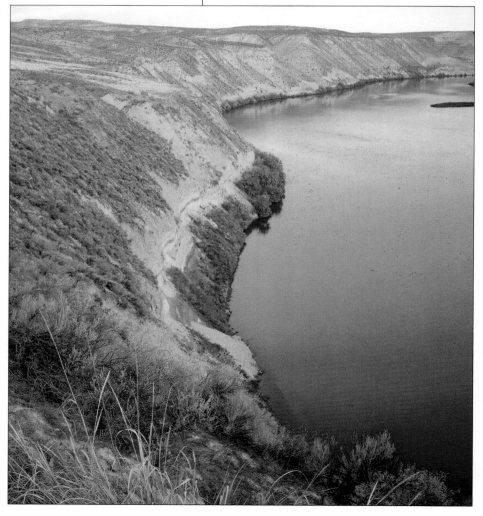

their beneficial role in forest ecosystems, so that they can appreciate the healing power of nature.

At Kirkham Hot Springs and Campground, water bubbles up out of the ground at 140°F. Idaho boasts more than 200 major natural hot springs, but few are as accessible as Kirkham, located just a few steps from the highway. About 25 miles down the road, the highway reaches the 7,056-foot peak of Banner Summit, then slips into the Stanley Basin. An irresistible detour takes visitors to Stanley Lake, set in a bezel of granite and pine. The lake offers a hint of the alpine wonders to come.

SCENIC CROSSROADS

More history awaits motorists in Stanley, a tiny village of some 75 inhabitants located at the crossroads of three scenic byways—the Ponderosa Pine, Sawtooth, and Salmon River. Visitors can stop for a tour of the Stanley Museum, which displays artifacts and photographs from the pioneer era. For nearly a century, the isolation and severe winters in the Stanley Basin daunted trappers and miners. But today the town prospers as the jumping-off place for excursions on the Salmon River—one of the longest wild rivers in the continental United States—and through the Frank Church–River of No Return Wilderness, which is the largest roadless region in the contiguous 48 states. Fearless rafters and kayakers slash mercilessly through the rapids, and hardy adventurers clamber along sheer canyon walls, sometimes catching glimpses of mountain goats.

Turning south onto Highway 75, the road rolls across the Sawtooth Valley. To the east rise the White Cloud Peaks and the Boulder Mountains. To the west the signature form of the Sawtooth Range juts skyward. In geological terms, the Sawtooth Range belongs to the Idaho batholith. The range is a gigantic spine more than 8 million years old made of granodiorite, a rock similar to granite. The formation of the Sawtooths began more than 200 million years ago, when two enormous slabs of the earth's crust—the North American continental plate and the Pacific seafloor plate—collided. The Pacific plate sank into the earth's mantle, while the upper plate surged higher.

Eventually, the upper plate became a mountain range 20,000 feet high. Far below, in the mantle, the sinking oceanic crust dissolved, giving off huge amounts of steam that bubbled upward. Gradually the steam helped to melt the lowest layers of the continental crust, creating granite magma. Over millions of years the magma rose to within seven miles of the surface and recrystallized into granite rock. Then, like a white bird hatching from a dark shell, the Sawtooths cracked the older mountains

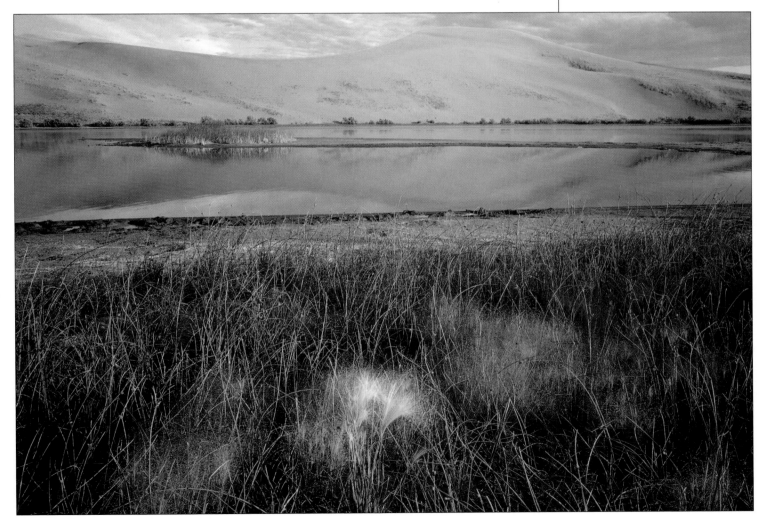

MAN-MADE AND NATURAL BEAUTY The gleaming white walls of St. Joseph's Catholic Church in Idaho City, left, look much as they did when the church was established in 1863. Beauty on an epic scale awaits visitors to Bruneau Dunes State Park, below, where the lakes and ponds scattered amid the sand dunes resemble oases in a desert.

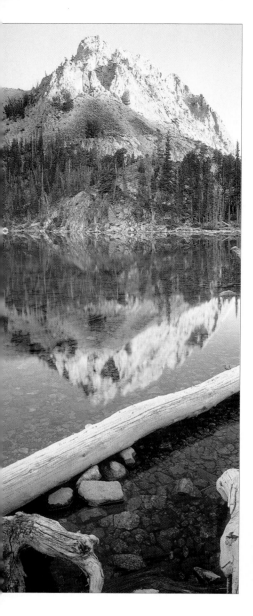

apart. The final job of sculpting the Sawtooths fell to ice-age glaciers, which carved out a notched comb of glittering, pinkish granite 30 miles long.

More than 40 Sawtooth peaks soar above 10,000 feet. The heights are an alpine world dotted with more than 300 crystal lakes and inhabited by gray wolves, lynxes, wolverines, and other elusive animals. Old mining and forest roads lead to trailheads where backpackers, climbers, and travelers on horseback depart for the Sawtooth Wilderness, the 200,000-acre core of the Sawtooth National Recreation Area. Visitors who decide not to undertake the hike can park by the side of a lake to admire the view and listen to the summer symphony of warblers, thrushes, and jays.

Redfish Lake lies nestled in a valley in the heart of the Sawtooth Range, which rises about a mile off its southern shore. The lake's tranquil waters are surrounded by lodgepole pines and rimmed by sandy beaches.

Signs of human presence at Redfish Rockshelter date back more than 9,500 years. Then, as now, the lake supported large salmon populations; in fact, it takes its name from the spawning sockeye whose huge numbers once turned the waters red. Redfish is the only known place in Idaho where sockeye spawn. But in recent years, the species'

epic 800-mile-plus journey to the sea and back has been impeded by dams, farming, and other changes to the landscape. In an effort to help the endangered sockeye, the nearby state fish hatchery releases nearly 3 million fingerlings every year. Tours of the hatchery will acquaint visitors with the life cycle of the salmon.

From Redfish Lake, the highway passes turnoffs for Yellow Belly, Pettit, and Alturas lakes. Climbing above the headwaters of the Salmon River, the road reaches the 8,701-foot Galena Summit overlook, which provides travelers with a last view of the Sawtooth Valley. From here, the highway follows part of a mining road built in 1880. That dirt track was once so harrowing that to brake their vehicles, descending wagon masters felled large trees and dragged them behind their loads. The Big Wood River skips along the route on its way to Ketchum.

Originally a mining and smelting center, by 1932 Ketchum had become little more than a sleepy village of sheepherders. Then the Austrian count Felix Schaffgotsch blew into town on an errand for W. Averell Harriman, the powerful chairman of the Union Pacific Railroad. Harriman wanted to expand tourism in the West by establishing a ski resort on a par with those in the Swiss Alps, which blended the rustic and refined to produce the last

OMNIPRESENT MOUNTAINS
One of the Sawtooth Range's jagged peaks is reflected in the still waters of Sawtooth Lake, above. The Boulder Mountains rise dramatically behind the Big Wood River valley, right, which is painted in the hues of autumn.

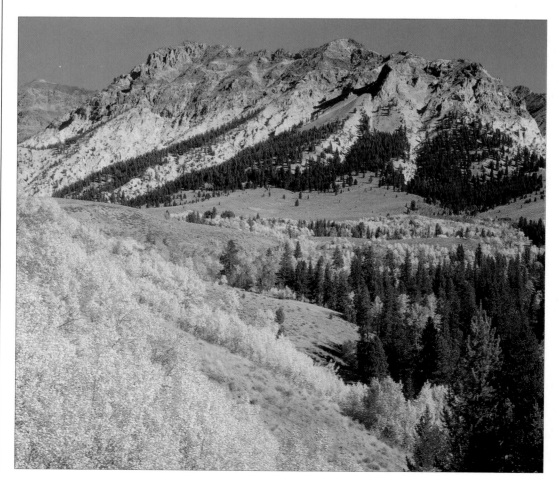

word in luxury. The search for an ideal location proved difficult, and Schaffgotsch had nearly given up when someone told him about the Big Wood River valley. After touring Ketchum, Schaffgotsch wired Harriman that the valley "combines more delightful features than any place I have seen in the United States, Switzerland or Austria." Harriman left for Ketchum at once and purchased a ranch along Trail Creek, which became the nucleus of Sun Valley. In four short years Harriman built a lodge and installed the world's first alpine-ski chairlift—adapted from a device used to hoist bananas onto cargo ships. He assembled flashy Hollywood stars and East Coast financiers for his 1936 grand opening, and with Gary Cooper leading ski trips and Olympic skater Sonja Henie etching the ice rink, Sun Valley soon became a popular destination with winter-sport enthusiasts.

SUN VALLEY TODAY

Even Harriman would marvel at the luxury resort that has grown out of his original plan. The elegant lodge, restored to its 1930's elegance, is now surrounded by a small city of condominiums. Sun Valley offers year-round activities such as tennis, horseback riding, cycling, and hot-air ballooning; the off-season crowds rival those of the Christmas rush.

During the winter Sun Valley basks in its reputation as America's top ski resort. Heavy snowfalls yield to week after week of crisp, sunny days. Dollar Mountain, the resort's original ski hill, now offers beginner slopes, while new runs trickle down majestic Bald Mountain like fanciful dessert toppings. Nonskiers can enjoy traditional sleigh rides under a canopy of glittering stars.

Sun Valley is just outside the interesting town of Ketchum, an eclectic blend of old-time saloons, recreational outfitters, and upscale galleries and cafés that once appealed to the likes of American writer Ernest Hemingway, who retired to Ketchum in 1959. Hemingway experienced some of his most enjoyable hunting and fishing expeditions in the Big Wood River valley; it was also the site where, in failing health, the author took his own life in 1961. Just east of the resort, a small memorial in a creekside glade of trees commemorates Hemingway as one of America's leading men of letters.

Hailey, which is situated farther down the highway, is the birthplace of another American writer and poet, Ezra Pound. The Pounds moved East when Ezra was almost two, but their white wood-frame house on Second Avenue remains intact.

Massive vacation villas are scattered throughout the valley and Hollywood celebrities have taken the place of the hardscrabble prospectors who once roamed the town. Bullion Street snakes into the

CHANGING SEASONS
Sun Valley blooms in spring with countless varieties of wildflowers, above. Christmas decorations add a touch of holiday cheer to a rustic barn in the valley, left.

hills to the sites of camps such as Bullion City and mines like Mayflower, which thrived in the 1880's by chipping out millions of dollars in lead, silver, and gold. The Blaine County Historical Museum tells the story of the area's fluctuating fortunes.

Soon the Big Wood River valley widens into a belt of fertile farmland. A side trip eastward on

REAPING WHAT THEY SOW
Freshly baled hay, above, dries in an Idaho field. Of the many agricultural products grown in the rich Idaho soil, none is more famous than the potato.

Highway 20 takes travelers to Silver Creek, a legendary fly-fishing stream that flows through the Picabo Hills in a nature conservancy preserve. The 15-mile-long spring-fed creek supports a busy wildlife community. Casting a line into the creek is the essence of relaxation, Idaho-style. Even if rod and reel aren't at hand, one can marvel at the serene majesty of sandhill cranes taking flight and the boisterous frolicking of otters in creekside rushes.

BIZARRE MOONSCAPE

Continuing east, Highway 20 leads past Carey and, where it joins Highway 93, enters the landscape of black rubble, cinder cones, and bottomless chasms that comprises Craters of the Moon National Monument. Curving in a scythelike swoop, the monument straddles the Great Rift, a 60-mile-long fault line in the earth's crust. A hotbed of volcanic activity, the rift spewed black basalt lava over the landscape as recently as 2,000 years ago. In places, trees that had been encased in lava and then decomposed have left behind hollow castings of rock. Dewdrop Cave and Indian Tunnel are lava tubes that were formed when molten lava flowed through an outer shell of the hardening lava.

By tracing the monument's convenient seven-mile loop drive, travelers will quickly understand why this was once the training ground for Apollo astronauts. The terrain is an unearthly fantasy of stringy lava loops, craggy towers of broken rock, and cinder cones of crunchy black-purple pumice. Big Cinder Butte is one of the largest basaltic cones in the world.

There is an abundance of life in this desolate terrain. A variety of bird species use the lava tubes as refuges from blistering summer heat, and more than 300 species of plants flourish here, mostly wildflowers, which carpet the black soil in the spring. Other local wildlife includes chukar partridges and great horned owls. At dusk long-eared bats and Townsend big-eared bats surge out of the lava tubes while coyotes prowl the ridge tops.

Driving west, and then south on Highway 75, travelers can visit another interesting lava tube, the Shoshone Ice Caves, located north of the small railroad town of Shoshone. Here, a block-long sheet of ice lies on the floor of a lava tube that is about 15 feet tall. A staircase leads into the tube, allowing visitors a close-up look at this natural ice rink.

South of Shoshone, the drive, now Highway 93, crosses the spectacular Snake River Canyon, which was cut into the high desert by the powerful Snake River. Just north of Twin Falls, several overlooks give visitors a chance to take in the canyon's sheer walls, colorful rock formations, bubbling springs, and waterfalls.

Before arriving in Twin Falls, a short detour leads to Shoshone Falls. Here the Snake River plunges for 212 feet over the precipice—making it 36 feet higher than Niagara's American Falls. The river displays its full ferocity during the snowmelt in early spring, when surging torrents spill unrestrained into the abyss and the rocky amphitheater fills with rainbows. Sightseers have been coming to the falls since the first trains stopped at Shoshone in 1882. Back then, the trip to the cataract was an overnight affair involving a dusty carriage

ride over the rough plain and camping in riverside tents. Today tour boats give visitors a memorable brush with the mist at the base of the falls.

Although much about the Snake River's evolution remains a mystery, one thing is certain: the Great Bonneville Flood transformed it forever. During the last ice age, Lake Bonneville was an immense body of water covering thousands of square miles to a depth of 6,000 feet. At least 14,500 years ago, the lake burst its banks at Red Rock Pass in southeastern Idaho and inundated much of southern Idaho. About 600 cubic miles of water roared through the Snake in a matter of weeks, churning truck-sized boulders that carved out the chasm and the plunge pool at the falls.

Heading west on Highway 30 from Twin Falls, drivers come upon a breathtaking apparition at Thousand Springs. Here, springwater tumbling from the rocky walls of the canyon has turned the cliffs into an opulent hanging garden. Geologists believe that the springs are the outlet for several subterranean sources, including Idaho's Lost River, which disappears underground some 150 miles to the east. The porous volcanic soil of the Snake River Plain allows the water to sink into the crust, where it forms vast underground lakes connected by networks of channels. The many roadside stops along the river beyond Thousand Springs may reward the patient observer with sightings of grebes, delicate avocets, and great blue herons.

| GEOLOGICAL WONDERS |

Next, the river route leads into Hagerman, a farm town that has capitalized on the area's booming tourist trade. The picturesque town's reputation as a prime fishing spot for sturgeon and trout has made it a mecca for anglers from all over the country.

The region is just as famous for its fossilized remains of creatures millions of years old. The ordinary-looking bluffs across the river have yielded some of the most significant fossils unearthed in North America. Local rancher Elmer Cook showed Dr. Harold Stearns, a geologist who was studying the Snake River Canyon, some fossils he had uncovered. In 1928 Stearns informed the Smithsonian Institution in Washington, D.C., about the find, and the institution sent a team of geologists to the site the following year. Their extensive excavation of the bluffs uncovered a cache of fossils that dates back approximately 3.5 million years.

The digs have revealed that in prehistoric times Hagerman was frequented by approximately 140 species that included mastodons, ground sloths, camels, and reptiles. An ancestor of the horse, *Equus simplicidens*, was especially prominent in the area. Twenty prehistoric horse skeletons and more than 120 horse skulls have been excavated at the site and are now on display in museums around the world. An observation post gives sightseers a panoramic view of the famed bluffs. From here, visitors look down into Hagerman Valley, where they are able to observe several trout hatcheries, the town, and a power station.

A short drive from Hagerman along the Snake River takes motorists to Malad Gorge State Park, hewed by the Malad River out of columnar basalt. Water dashes loudly through a widening chasm before diving 250 feet into the Devil's Washbowl. The gorge was a favored hunting camp for the Shoshone peoples for more than 7,000 years.

The route joins I-84 until it reaches Mountain Home, where it retraces a section of the famed Oregon Trail. The ruts of wagon wheels are carved indelibly in the arid plateau. Turning south onto Highway 51, travelers head toward Bruneau and the immense sand dunes that rise 470 feet above the Snake River. The dunes were created 13 million years ago by repeated volcanic eruptions on the Snake River Plain that exposed the riverbeds to the elements. Winds snatched up the bared sediments and deposited them into the Eagle Creek

TWISTED LIMBS

Adding to the eerie landscape of Craters of the Moon National Monument, two limber pines, below, reach for the September sky.

Flanked by soft, mounded snow, the gently curving Big Wood River, right, winds toward the rugged face of the Smoky Mountains.

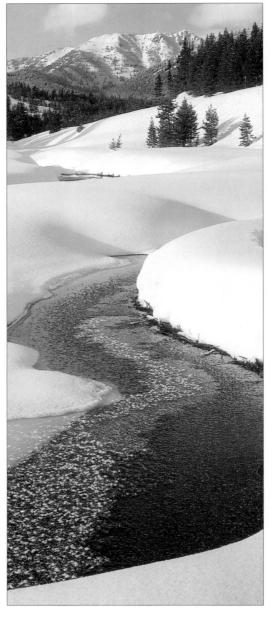

CAPITOL ARCHITECTURE
Like a giant, unblinking eye, the intricate dome of Idaho's capitol, below, located in Boise, seems to stare down at visitors.

Depression near Bruneau, where they formed dunes. The Great Bonneville Flood washed away these early sandhills, but after the raging waters had subsided, the process started all over again, and the present dunes were born. Some 14,500 years later, they constitute the tallest sand dune formation in North America.

The sand mountain actually consists of two dunes locked in a delicate embrace. Prevailing winds from opposing directions have kept the mountain in place for centuries; on either side, two smaller dune fields sneak slowly southward. From the crest of the dunes, the Snake River Plain looks like gently rising and dipping pavement punctured by cinder cones and scalloped by ragged escarpments where rivers have chiseled through the rock.

A late afternoon walk along the park's nature trail reveals a flurry of activity. Muskrats, weasels, and raccoons rustle through the marshes and sage flats, and elegant white-faced ibises and long-billed curlews pose in the mudflats. Mallards, pintails, and other winged visitors stop to rest on the lake, while kingfishers skim the surface for bluegill. The sunset sends tendrils of ocher light across the dunes, a last caress before the sands turn white against the evening sky. Every August the Boise Astronomical Society sponsors stargazing outings at the dunes, revealing a universe awash in luminous stars. Surrounded by the vastness of the volcanic plain and the whisper of tiny sand crystals, Bruneau Dunes is Idaho at its most haunting.

WHERE RAPTORS FLY Highway 78 offers tantalizing views of the cliffs in the Snake River Birds of Prey National Conservation Area. Travelers should keep watch for prairie falcons wheeling across the azure sky above the open road. Abruptly, their brown-tipped wings contract against the body and the birds change direction, rocketing earthward at 150 miles an hour. A ground squirrel is a fatal split second slow in reaching its burrow, and a falcon flies home with another meal.

The scenic roadway has entered the realm of the raptor. Encompassing 482,540 acres of land along the river and the sage-scrub hinterlands, the conservation area protects what might be the largest concentration of raptors in the world, as well as 250 other animal species. The geology of the Snake River is the key to its attraction for birds of prey: the torn and fractured faces of the 700-foot cliffs offer ideal nesting sites for both resident and migratory raptors, who use the area as a nursery. Some of the niches are big enough to accommodate golden eagle nests, which are eight feet in diameter. From here travelers can either continue on the highway until Boise, or strike out off the beaten path to the

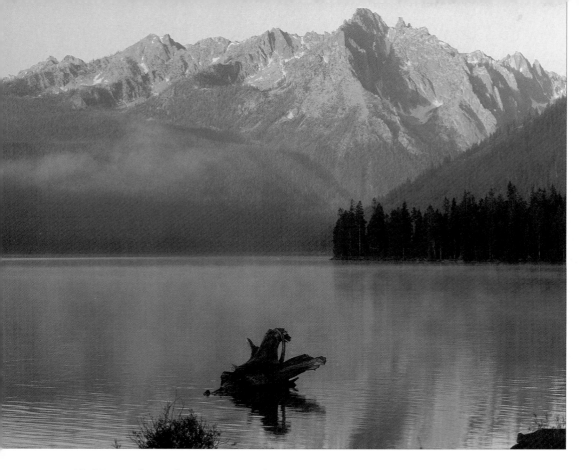

SOCKEYE SPAWNING WATERS
Deep in the heart of the Sawtooth Range, Redfish Lake, left, glows orange at sunrise. The lake is believed to be the only one in Idaho where sockeye salmon spawn.

raptors' habitat at the Snake River Birds of Prey National Conservation Area.

A side road to the town of Kuna leads to Swan Falls Road, which takes visitors to Dedication Point for expansive overlooks and the first good look at the birds' home. To the north, windblown sand has accumulated in thick mounds, providing habitats for an enormous population of burrowing animals, such as the Townsend ground squirrel, the eagles' chief prey.

From Dedication Point, sharp-eyed visitors may spot large ferruginous hawks cruising the updrafts, delicately spotted American kestrels hovering above a promising burrow, and ospreys plucking fish from the river. The farther afield one ventures—either on foot or by boat from the Swan Falls Dam, located just south of Dedication Point—the more likely one is to see the birds in flight.

Returning northward along Swan Falls Road, then heading east along Kuna Road, visitors arrive at the World Center for Birds of Prey, home to the prestigious Peregrine Fund conservation organization and the Velma Morrison Interpretive Center. Multimedia exhibits and live-bird presentations at the center instruct visitors of all ages in raptor biology and conservation. South Cole Road leads motorists from here into downtown Boise.

As they scan the sky, visitors may try to imagine what the terrain looks like to the falcon bobbing on an unseen breath of air: the Snake River flows across the sage-covered plain, the Sawtooths rise to the north, herds of elk and deer move across

alpine snowfields, rivers of spun silver lace the land—treasures such as these weren't meant to be seen from afar. Although visitors explore the region at ground level, they too experience nature's majesty on a journey that takes them from a lava-darkened land to snowcapped peaks and allows them to sample some of the best of Idaho.

WINDING WATERWAY
The Snake River coils through the Snake River Birds of Prey National Conservation Area, below. The river canyon and surrounding steppe are inhabited by more than 250 species of animals.

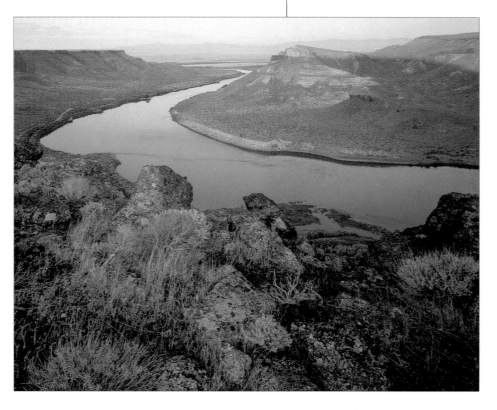

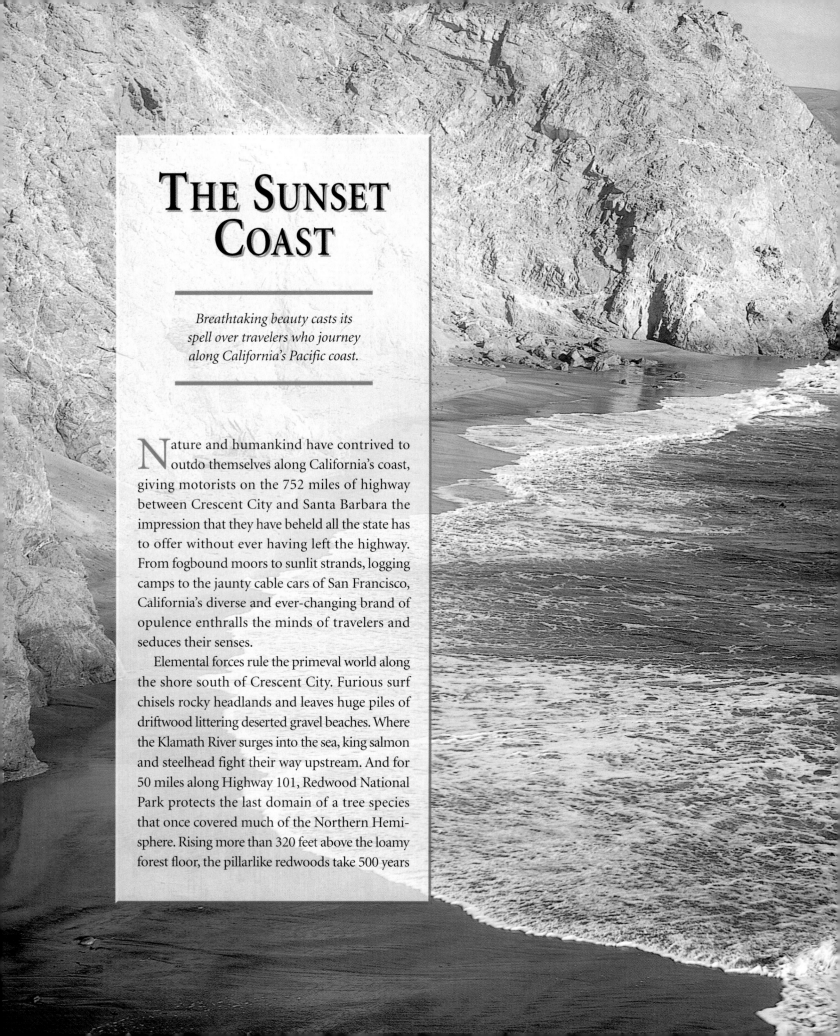

THE SUNSET COAST

Breathtaking beauty casts its spell over travelers who journey along California's Pacific coast.

Nature and humankind have contrived to outdo themselves along California's coast, giving motorists on the 752 miles of highway between Crescent City and Santa Barbara the impression that they have beheld all the state has to offer without ever having left the highway. From fogbound moors to sunlit strands, logging camps to the jaunty cable cars of San Francisco, California's diverse and ever-changing brand of opulence enthralls the minds of travelers and seduces their senses.

Elemental forces rule the primeval world along the shore south of Crescent City. Furious surf chisels rocky headlands and leaves huge piles of driftwood littering deserted gravel beaches. Where the Klamath River surges into the sea, king salmon and steelhead fight their way upstream. And for 50 miles along Highway 101, Redwood National Park protects the last domain of a tree species that once covered much of the Northern Hemisphere. Rising more than 320 feet above the loamy forest floor, the pillarlike redwoods take 500 years

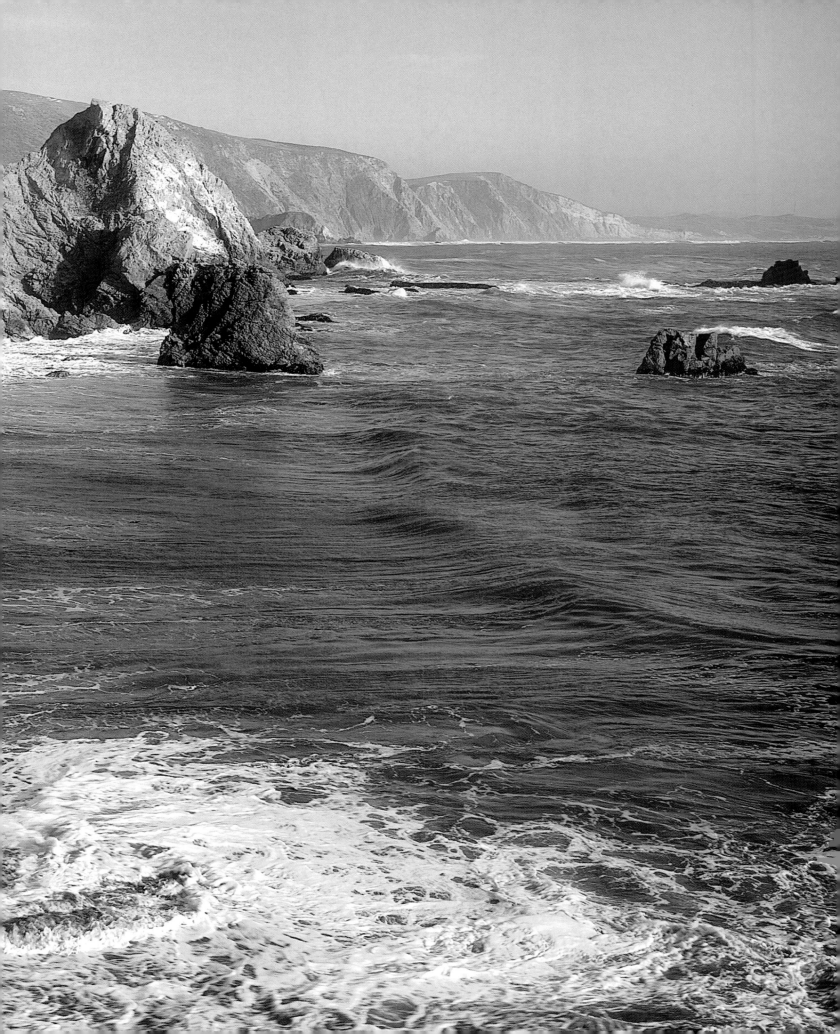

FAR FROM HOME

The Russian Orthodox chapel at Fort Ross, above, is one of several structures at the site that have been rebuilt to evoke the lives of the Russians, native Alaskans, and native Californians who hunted and farmed along this stretch of coast in the early 19th century.

SWEEPING VIEW

Overleaf: McClures Beach in Point Reyes National Seashore offers visitors expansive views of the rocky headlands and the Pacific Ocean.

to mature, and can live up to four times that long. Their wrinkled bark seems to signify old age; the trees are surprisingly limber, performing a balancing act on their root systems as they add mass to one side or the other in order to counteract any tendency to tip over. Continually sprouting new trees from their trunks and root systems, immune to disease or pests, and virtually fire-resistant, redwoods would be indestructible were it not for the ravages of climate and the chain saw. Weather patterns since the last ice age have confined the trees to this coastline, where the fog supplies the moisture they need to survive. The logging industry has further reduced their range to only a few protected areas along California's coastal highways. Here the redwoods display their dark, moody majesty amid ferns and flowering rhododendrons.

BOUNTIFUL EDEN

The forest gives way to marshlands and lagoons as the road approaches Eureka. In late fall and again in the spring, the skies teem with terns, ducks, and geese. Grasses and rushes provide shelter for young birds and fish, making the lagoons the most important nurseries along the coast. The bounty of this land sustained the Yurok, Hupa, and other native peoples for thousands of years before the arrival of Europeans.

The 1850 discovery of gold in the gravels of Gold Bluffs Beach, just north of Eureka, unleashed a wave of settlers who poured into northern

INFORMATION FOR VISITORS

The drive along California's Sunset Coast follows Hwy. 101 from Crescent City to Leggett, and then travels along Hwy. 1 from Leggett, southward through San Francisco, and on to Santa Barbara. Highways 101 and 1 are briefly united for several miles in southern Marin County, and again between Las Cruces and Santa Barbara. Motorists are advised to check local weather and road conditions before driving the coastal route, which is subject to fog and landslides. Headlights should be turned on at dusk and in foggy conditions in order to avoid accidents.

For more information: California Division of Tourism, 801 K St., Suite 1600, Sacramento, CA 95814; 800-862-2543.

San Francisco Convention and Visitors Bureau, 201 3rd St., Suite 900, San Francisco, CA 94103-3152; 415-974-6900.

BOATS FOR HIRE

Rowboats sit at the dock at Stow Lake, below, one of numerous artificial lakes within Golden Gate National Recreation Area, San Francisco's 1,017-acre oasis of lakes, woods, and lawns.

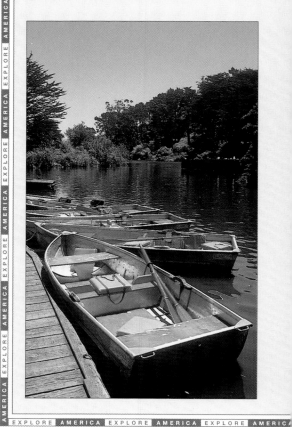

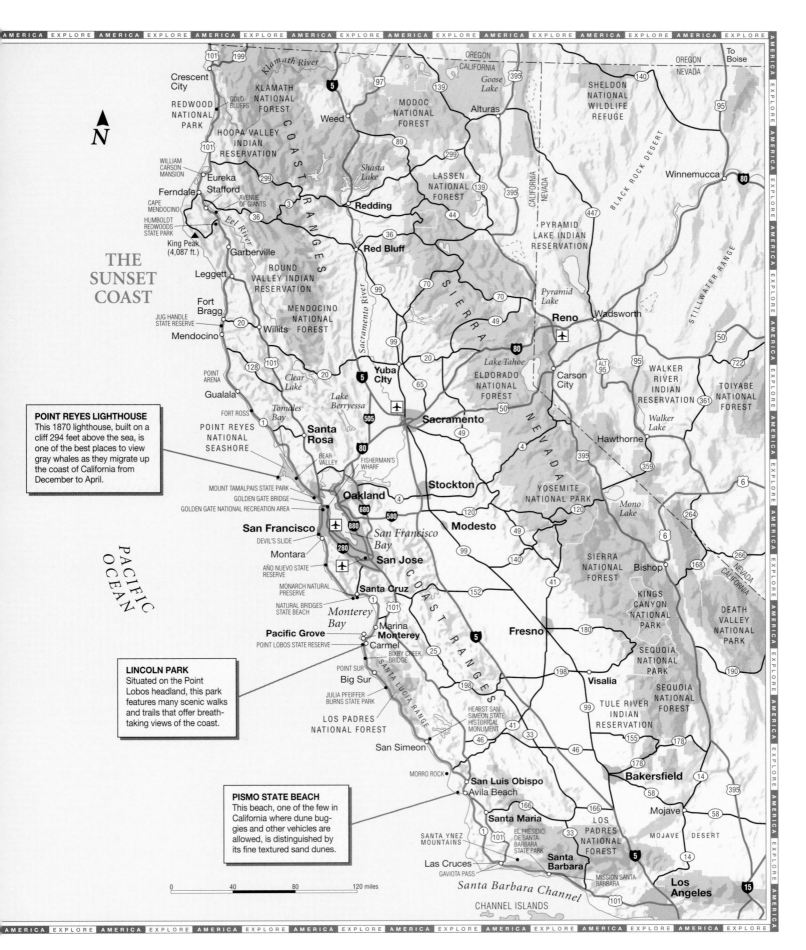

THE SUNSET COAST

POINT REYES LIGHTHOUSE
This 1870 lighthouse, built on a cliff 294 feet above the sea, is one of the best places to view gray whales as they migrate up the coast of California from December to April.

LINCOLN PARK
Situated on the Point Lobos headland, this park features many scenic walks and trails that offer breathtaking views of the coast.

PISMO STATE BEACH
This beach, one of the few in California where dune buggies and other vehicles are allowed, is distinguished by its fine textured sand dunes.

PACIFIC OCEAN

0 40 80 120 miles

AMERICA EXPLORE AMERICA EXPLORE AMERICA EXPLORE AMERICA EXPLORE AMERICA EXPLORE AMERICA EXPLORE AMERICA EXPLORE AMERICA EXPLORE AMERICA EXPLORE AMERICA EXPLORE

THE SUNSET COAST 83

TREE ORNAMENTATION

Rhododendrons wrap themselves around the grooved trunks of redwood trees in Lady Bird Johnson Grove, above, in Redwood National Park. Some of the trees are more than 300 feet tall and 2,000 years old. A mile-long loop trail takes visitors through the grove.

FAMED CYPRESS

Monterey Peninsula's stunning 17-mile drive passes a lone cypress, right, which is said to be the most photographed tree in the world.

California, bringing with them a short-lived boom. But it was lumber and its related industries that proved most valuable in the long run to the economic health of the area, and Eureka rode the crest of prosperity. The ornate Victorian homes on Hillsdale Street and the waterfront's restored Old Town display the fruits reaped by the town's citizens. One of the best-known landmarks is the 1886 mansion built by the brothers Samuel and Joseph Newsom for the lumber baron William Carson. Perched on a hill overlooking Eureka's broad harbor, the house boasts an intricate array of gables and towers that are constructed of durable redwood, a carpenter's dream.

South of Ferndale, the King Range rises 4,000 feet above sea level. A detour at Stafford takes motorists along the old Redwood Highway, which parallels Highway 101 on the eastern bank of the Eel River. In Humboldt Redwoods State Park, home to some of the tallest trees on earth, the Redwood Highway becomes the Avenue of Giants. Redwoods tower up to 300 feet above an understory of ferns and wildflowers that grow in more than 180 memorial groves scattered throughout the park.

At Leggett, Highway 1 leaves Highway 101 behind and heads for the coast. The road travels across coastal bluffs and mossy creeks to Fort Bragg, a

working lumber town and the terminus of the California Western Railroad—more popularly known as the Skunk Train. The skunks were foul-smelling gas engines that hauled logs and freight to turn-of-the-century lumber camps. Today a vintage steam engine pulls coaches eastward through 40 miles of lush rain forest to Willits, on the dry side of the coastal mountains.

South of Fort Bragg, at the Jug Handle State Reserve, a nature trail leads to trees that have succeeded in escaping the ax. They are dwarf trees, Bolander pines, and pygmy cypresses that grow only five to seven feet in height. Other plants here form a miniature understory. The explanation for this small-scale landscape can be found in the reserve's geological past. The northern coast of California is made up of a series of terraces created by wave action cutting into sedimentary rock, and then uplifted by tectonic forces as the North American continent rolled westward over the Pacific Plate. Each level of the stepped terrain contains a different soil type and is home to distinct species of plants. Coastal prairie yields to redwood forests fed by moisture-laden air and rich, loamy soils. At higher elevations the carnivorous sundew plants grow in wet sphagnum bogs. A pygmy forest dwells on the highest steps of the ecological stairway, where heavy rains over the millennia have leached minerals from the soil and produced an intensely acidic natural environment.

<hr>

DOG HOLE HARBORS

Up ahead lies the picturesque town of Mendocino with its weather-beaten Victorian residences, whose gables recall the 19th-century whaling villages of New England. Mendocino was one of numerous communities that grew up along the coast in the 1850's to serve one purpose: supply lumber to fast-growing San Francisco during the Gold Rush. The lack of a decent natural harbor did not deter some enterprising Californians from shipping lumber out of Mendocino. They used dog holes—rocky inlets that offered just enough room for a dog to turn around in. Small pocket schooners put into these dog holes and set up chutes that channeled the logs down onto their pitching decks.

As it snakes southward, Highway 1 clings to rocky cliffs and offers glimpses of the frothy surf through ragged rips in the mist. On a low promontory south of Gualala, pointed towers topped by iron crosses come into view announcing Fort Ross, whose name comes from "Rossiia," meaning czarist Russia. In the 18th century the hunt for sea otters brought Russians to Alaska, and in 1799 the Russian-American Company established outposts along the coast. The need for more fertile land that would feed the inhabitants of the forts sent the company in search of warmer climes. In 1812 they bought territory from the Kashaya Pomo Indians, who lived on the California coast, for the rumored fee of three blankets, three pairs of breeches, two axes, three hoes, and some beads. For the next 10 years or so the Russians farmed wheat and hunted sea otters, erecting a settlement of more than 60 buildings and marrying native Californian as well as native Alaskan women. But by the 1820's, the sea otters had been hunted to near-extinction and the Russians withdrew. The only original building at Fort Ross is Rotchev House, home of the last commander, Aleksandr Rotchev. The house, built of redwood, features remarkable joinery techniques.

WASHED BY THE TIDES
A tide pool, left, on the rocky shores of Point Lobos, creates a natural collage of different shapes, colors, and textures.

SEASIDE COTTAGE
A picture-book Victorian house, below, is found in Mendocino. After viewing the old lumber town's architectural treasures, visitors can go for a walk along the rugged Mendocino headlands.

BUTTERFLY CITY

As many as 150,000 monarch butterflies, right, migrate to Natural Bridges State Beach each fall and roost in a eucalyptus grove in what is now Monarch Natural Preserve. The butterflies spend spring and summer in regions west of the Rockies, where milkweed is plentiful. This is the only plant on which they can lay eggs and have their caterpillars feed.

SECLUDED WATERFALL

The McWay Waterfall, below, tumbles from a cliffside forest into the sea. It is located within the Julia Pfeiffer Burns State Park, named for the woman whose land formed the nucleus of the present-day park.

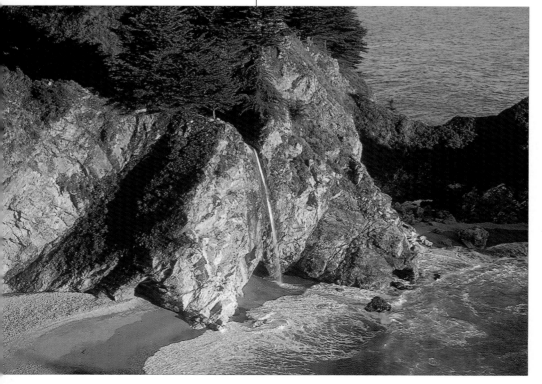

After leaving Fort Ross, Highway 1 descends to the sparkling waters of Tomales Bay. While cruising beside farms and fishing villages, it is hard to believe that this is one of the most geologically active places on earth: the waters of Tomales Bay cover part of the notorious San Andreas Fault.

A turnoff leads to the Bear Valley headquarters of Point Reyes National Seashore, a triangle of land that stands apart in many respects—including its basic geology. Although it seems stable, Point Reyes is in a constant state of motion because it lies on the Pacific Plate. Several million years ago, when the San Andreas Fault started slipping, Point Reyes lay nearly 300 miles to the south. During the 1906 earthquake that devastated San Francisco, the point moved 21 feet to the north, all in one push.

Visitors to the national seashore on Point Reyes can wander Earthquake Trail, an eerie walk along the fault. From Bear Valley, roads and walking trails branch out across rolling grasslands and lead to windswept beaches backed by chalky cliffs and to tidal inlets where egrets and avocets search the mudflats for tiny shellfish. During their 1579 circumnavigation of the globe, Sir Francis Drake and the weary crew of the *Golden Hind* dropped anchor in one of these bays to rest and make repairs. They stayed for five weeks and claimed the peninsula for Good Queen Bess before resuming their voyage. Even then the region was a paradise for birds and marine life. Now foamy seas wash tide pools filled with limpets and bat stars, and California quail scurry through the grasslands beneath the watchful eyes of red-tailed hawks and barn owls. The woodlands resound with the sharp hammerings of acorn woodpeckers and the ceaseless industry of crews of mountain beavers.

GOLDEN GATE BRIDGE

After leaving Point Reyes the road ambles south to Mount Tamalpais State Park before it rounds a corner and reveals San Francisco Bay and its engineering masterpiece—the Golden Gate Bridge. As the morning light turns the clouds to a buttery yellow, an orange tower materializes out of the fog. Far below, a ship heads for the open sea. The clouds part, unveiling the hills of San Francisco gleaming by the bay. San Francisco Bay, named the Golden Gate by John C. Frémont after the Golden Horn of Byzantium, is one of the world's great natural harbors.

For decades San Francisco's growing population relied on ferries to get around the bay. In the 1920's, when the city seemed destined to expand to the north, a bridge was thought to be impossible. The bay lies only 10 miles from the San Andreas Fault and is regularly washed by strong tides and buffeted by gale-force winds. Chief engineer Joseph

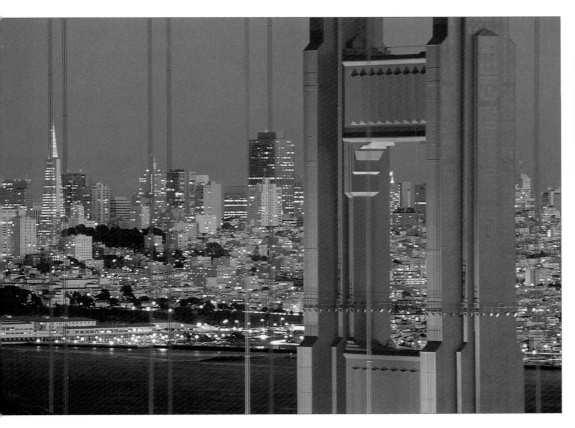

The Golden Gate Bridge offsets the glittering nighttime skyline of San Francisco, left. The Art Deco bridge has been an American landmark ever since cars first crossed it on May 28, 1937.

Strauss was confident, however, that a viable bridge could be built. He recognized that the task would demand a revolution in engineering. Strauss and his team worked on a plan for a lightweight suspension bridge that would adapt to the elements, rather than defy them. More than one mile long, 75 stories tall, and 220 feet above the water, the bridge was the largest such structure built at that time. San Franciscans were concerned that the bridge would spoil the beauty of the harbor, so consulting architect Irving Morrow made subtle refinements to it. He added streamlined Art Deco towers and painted the bridge in warm terra-cotta shades, making it a scenic attraction that adds to, rather than subtracts from, the surrounding landscape. The bridge is a work of art, symbolizing the confidence, dynamism, and style of this coastal city.

Highway 1 goes through the western portion of the city, within easy reach of the seafood restaurants at Fisherman's Wharf, a historic chocolate factory on beautifully preserved Ghirardelli Square, and the lively coffee houses of North Beach. The National Maritime Museum, with its flotilla of historic vessels, lies along the route, as does Fort Funston, on the outskirts of San Francisco, which is renowned among hang gliders for its updrafts. Visitors head for the observation deck for heart-thumping views of soaring hang gliders.

South of San Francisco, broad sandy beaches extend all the way to Devil's Slide, located between Pacifica and Half Moon Bay. The slide is a spectacular 800-foot fault line that reveals several million years of geological history. At the James V.

Fitzgerald Marine Reserve in Montara, giant green anemones, feather boa kelp, and spiny purple sea urchins can be seen living in the shale reefs of the tide pools. Sea life shows its boisterous side at Año Nuevo State Reserve. The coastal reserve is the largest mainland breeding site for northern elephant seals, whose populations have rebounded since the animals were nearly extinguished by overhunting. Each December males are seen on the dunes bellowing, blustering, and battling for dominance. The prize—a harem of females. Guided walks take visitors to the heart of the action.

ANTIQUE ARCADE

Beyond Año Nuevo, Highway 1 passes through Santa Cruz on Monterey Bay, a town that retains the bohemian feel of California beach towns of the past. The Loma Prieta earthquake of 1989 devastated the downtown core, but the historic boardwalk and its fanciful arcade somehow survived intact; the arcade is the last of its kind in the Mission Revival style on the West Coast. Riders on the park's 70-foot wooden roller coaster, known as the Giant Dipper, catch stunning views of beach and bay from on high before the vision gives way to the swoosh and rattle of pure acceleration. A 1911 carousel, with its elegant hand-carved horses, offers a more relaxing ride.

Surfers near Natural Bridges State Beach sometimes share the waves with playful sea lions. The sea continually carves dramatic arches from the sandstone cliffs along the Santa Cruz coastline and then gradually erodes them. Only one bridge stands

Elephant seals, like the one above at the Año Nuevo State Reserve, spend most of their lives at sea, coming ashore to give birth, breed, and molt from the months of December through March.

there now, but others are in the making. In a eucalyptus grove near the rocks, monarch butterflies paper the tree trunks in black and orange. For some unknown reason, Natural Bridges attracts one of the largest groups of monarch butterflies of any overwintering site in the United States. Some of the delicate-looking insects have made journeys of up to 3,000 miles, and all are here for the first and only time in their lives. It's a mystery how they pass on a knowledge of the route to their offspring.

MONTEREY PENINSULA

Across the shimmering bay and past the town of Marina's fields of dunes, the Monterey Peninsula curls into the sea. Adobe dwellings, Victorian mansions, and the clapboard and metal shacks of Cannery Row provide ample evidence of Monterey's varied history. Sebastián Vizcaíno, a Portuguese explorer sailing under the Spanish flag, was the first European to set foot on the peninsula, in 1602. He made friends with the native Ohlone people and named the site Monte Rey after the count who had financed his expedition. In 1770 the governor of Alta California (today the state of California), Don Gaspar de Portolá, and the Franciscan monk Junípero Serra—founder of Franciscan missions along California's coast—established the city of Monterey. It served as California's capital from 1777 to 1822, first under Spanish and later, Mexican rule. Today the 1835 Larkin House and other adobe structures with their generous wraparound porches recall the town's

ENTICING DETOUR
Travelers along Highway 1 can take the Panoramic Highway to Mount Tamalpais State Park in Mill Valley, above. The park offers miles of hiking trails, and visitors who reserve in advance can rent a cabin in the woods for the night.

MILLIONAIRE'S MANSION
A balustrade at Hearst Castle in San Simeon, right, flanks a staircase decorated with intricately designed tiles. The twin towers of La Casa Grande—the main house—hold water storage tanks and bedrooms, as well as carillons.

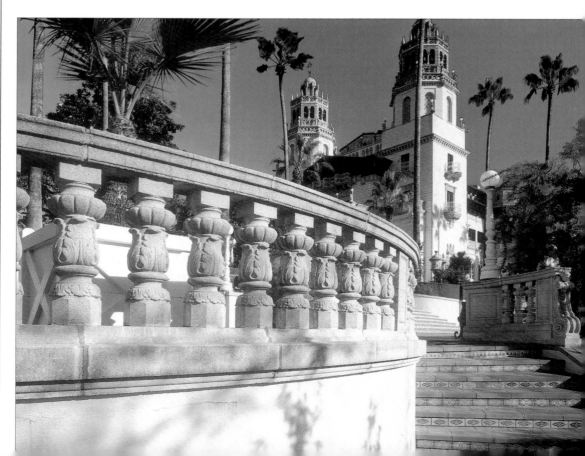

Spanish roots. In 1849 Monterey once again stood at the forefront of tumultuous events when the Constitutional Convention met at Colton Hall to draw up a blueprint for California statehood, which was achieved the following year. One of the convention's first acts was to move the capital to San Jose. Thus abandoned, Monterey turned from politics to the sea, capitalizing on the profits to be made from the sardine. John Steinbeck immortalized the gritty waterfront life in his novel *Cannery*

Elegant homes dot the coastal pine groves of the famous 17-mile drive that detours off Highway 1 south of Monterey. The private toll road winds past pocket beaches and noisy sea lion rookeries from Pacific Grove to Carmel-by-the-Sea, an artists' retreat established in the 1890's. Today Carmel numbers more art collectors than practitioners.

As Highway 1 climbs along the seaward flank of the Santa Lucia Range, it crosses the soaring 360-foot-long Bixby Creek Bridge, one of the longest

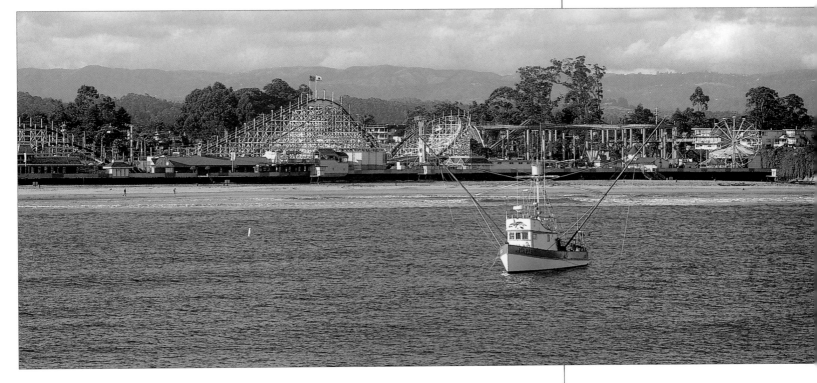

Row, which was published in 1945 when the sardine industry in Monterey was processing close to a quarter-million tons of fish in 18 canneries and 20 reduction plants. Overfishing destroyed the industry, but several refurbished canneries now boast floors of galleries and boutiques and have become popular tourist attractions.

The affiliation of these plants with the ocean is not over. At the end of Cannery Row lies the Monterey Bay Aquarium, which offers visitors a window on 10,000-foot-deep Monterey Canyon, an enormous submarine chasm the size of the Grand Canyon that extends more than 100 miles out to sea. The cold, nutrient-rich water of the canyon supports a vast diversity of life-forms, celebrated by the aquarium in innovative exhibits that range from a huge tide pool to a kelp forest, whose giant tenants are viewed in a 28-foot-tall glass enclosure. Visitors watch from behind an enormous 15-by-54-foot acrylic window in the new Outer Bay gallery as open-ocean species, including sea turtles and barracuda, glide by only inches away.

concrete arch spans in the country. Beyond the bridge lies the mystical realm known as Big Sur. This 90-mile stretch of coastal highway is blessed with groves of redwood trees and enchanting cliffside views. Built using convict labor between 1924 and 1937, this section of road replaced a tortuous wagon trail, becoming California's first scenic highway. A series of pullouts allow travelers to watch the play of clouds and light on the cliffs and water.

Highway 1 glides over coastal prairie past Hearst Castle, the architectural fantasy of media tycoon William Randolph Hearst, located on a 1,600-foot perch overlooking San Simeon and the Pacific Ocean. Farther south, Morro Rock rises from the sea where a volcano has eroded away, leaving behind a volcanic plug in the form of a towering 581-foot dacite monolith. Six more volcanic remnants line the road to San Luis Obispo, where Highway 1 rejoins Highway 101 and travels south to Avila Beach and Santa Maria—names that reflect the region's Spanish influence. (The two roads link up again at Gaviota Pass.) The landscape changes

BLUE ON BLUE
The Santa Cruz Beach Boardwalk, above, established in 1904, features an entertainment facility in a renovated 1907 casino and the Giant Dipper, which has been one of the country's most thrilling roller-coaster amusement rides ever since it was built in 1924.

as if the road has crossed a meridian into southern climes. Pines and cypresses give way to sun-baked pastureland and tall stands of California live oaks. After the highway emerges from the narrow, steep-sided Gaviota Pass, it bustles toward the sea, where the three northernmost Channel Islands seem to bob at anchor 20 miles offshore. Directly ahead, the town of Santa Barbara reclines lazily against the Santa Ynez Mountains.

Santa Barbara came to fame as a health spa at the turn of the last century. The city's palm-lined avenues, blazing bougainvillea that trail over tumbledown stone walls, and Mediterranean climate give it the feel of a lush garden. In 1925, when an earthquake devastated most of the town, civic leaders decided to use their restoration effort to return the city to its Spanish Colonial appearance. Since that time, red-tile roofs have been mandated by

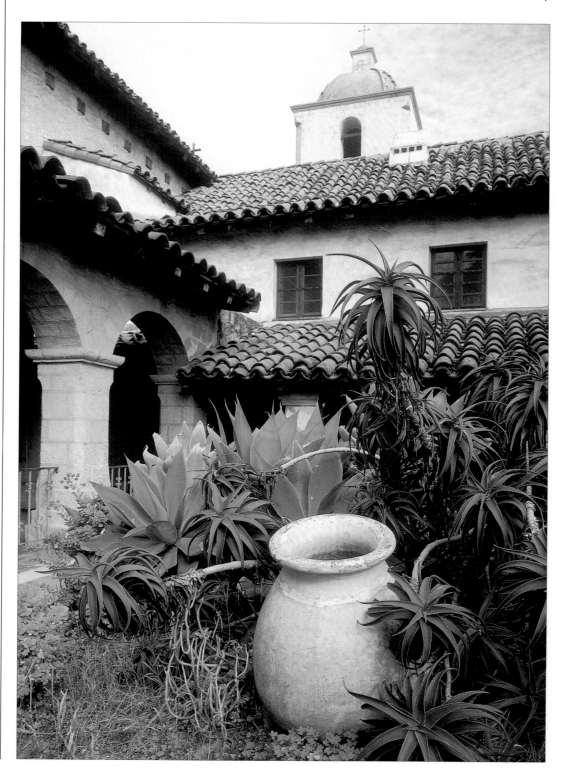

FULL OF GRACE
Native sandstone accentuates the harmonious proportions of Mission Santa Barbara, right, where wooden portals open to peaceful interior gardens and an overgrown cemetery. Ruins of the original aqueducts, reservoirs, and other outbuildings stand nearby in a lush grove of sycamore and olive trees.

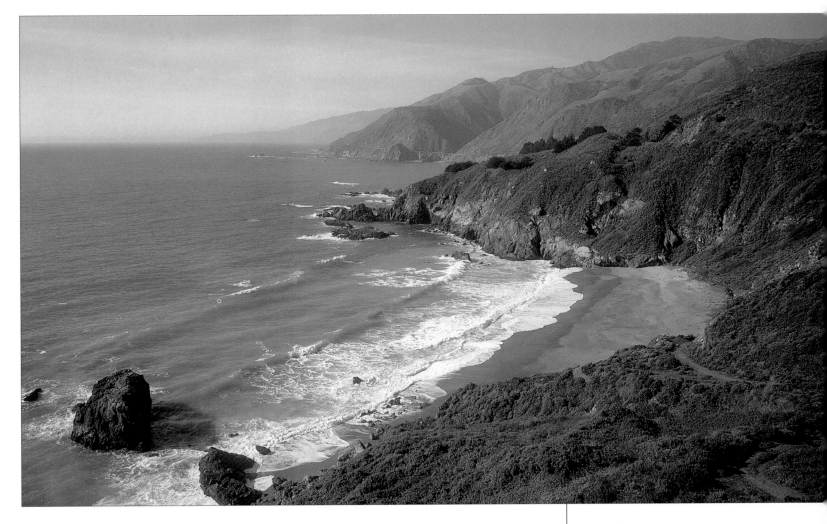

law in the city's old section. Before the arrival of the Spanish, Santa Barbara was the center of the Chumash civilization, the largest and most materially sophisticated of native California cultures. The Chumash lived along the beaches and estuaries and, unlike most other California peoples, were accomplished seafarers, at one time colonizing the offshore Channel Islands, which they reached in their distinctive pitch-covered plank boats. Santa Barbara's Museum of Natural History displays important relics of this lost way of life, including Chumash tools and a replica of one their boats.

| MILITARY PAST | El Presidio de Santa Barbara State Park re-creates the world of the Spanish presidios. The Santa Barbara site housed a |

substantial garrison from the 1780's until the 1830's. Today's reconstruction blends felicitously with the modern city. Skateboarders zoom past men and women making adobe bricks. Chapel walls that in the 18th century reverberated with the gentle voices of Franciscan brothers now echo with the soft shuffling of visitors' footsteps.

Tourists also come here to see the Queen of the Missions. Set on a rise overlooking rose gardens and the channel, Mission Santa Barbara was found-

ed in 1786 as the 10th in a chain of 21 missions set up to convert the California Indians to Roman Catholicism. It has been in continuous operation as a parish church ever since. The present structure, with its classical facade, was built in 1820.

Worlds away, at Stearn's Wharf, brown pelicans perch on pilings and warily eye passersby. As dusk advances and the blue water changes to fiery orange, a pod of dolphins leaps out of the water. The sight is an unexpected gift and a perfect ending to the journey along California's Sunset Coast.

OCEAN'S EDGE
A gentle tide rolls into a sheltered cove along Big Sur, above. One of the 32 bridges along Highway 1 can be seen in the distance.

DEEP-SEA DELICACY
Each year tons of crab, left, as well as salmon, shrimp, sole, and sea bass are offered for sale in Fish Alley at Fisherman's Wharf in San Francisco. The best time to buy crab is mid-November through June.

ROAD TO THE CRATER

*Maui's richly varied landscape is
revealed on the drive from Kahului
to the summit of Haleakala.*

High above the clouds on the island of Maui sleeps the volcano that ancient Hawaiians named Haleakala, meaning "House of the Sun." The Hawaiians regarded the mountain as a sacred place and climbed on foot up its steep slopes to worship their gods, quarry stone for adze heads, and hunt for birds. Now modern pilgrims drive to the summit in search of mystical experiences. Some people make the journey before the crack of dawn. Huddled in blankets, they crowd along the rail of the Red Hill Overlook in Haleakala National Park and watch the sun's rays creep over the jagged eastern rim of the crater and ignite the massive cinder cones in glowing amber, umber, ocher, celadon, and lavender light. Others travel up the mountain in the daytime, reaching the top at dusk to watch as the sun slips down behind the misty rim and disappears.

The pilgrimage is like no other experience. From the town of Kahului, at sea level, the Road to the House of the Sun spirals heavenward for 38 miles to the 10,023-foot-high summit. The route

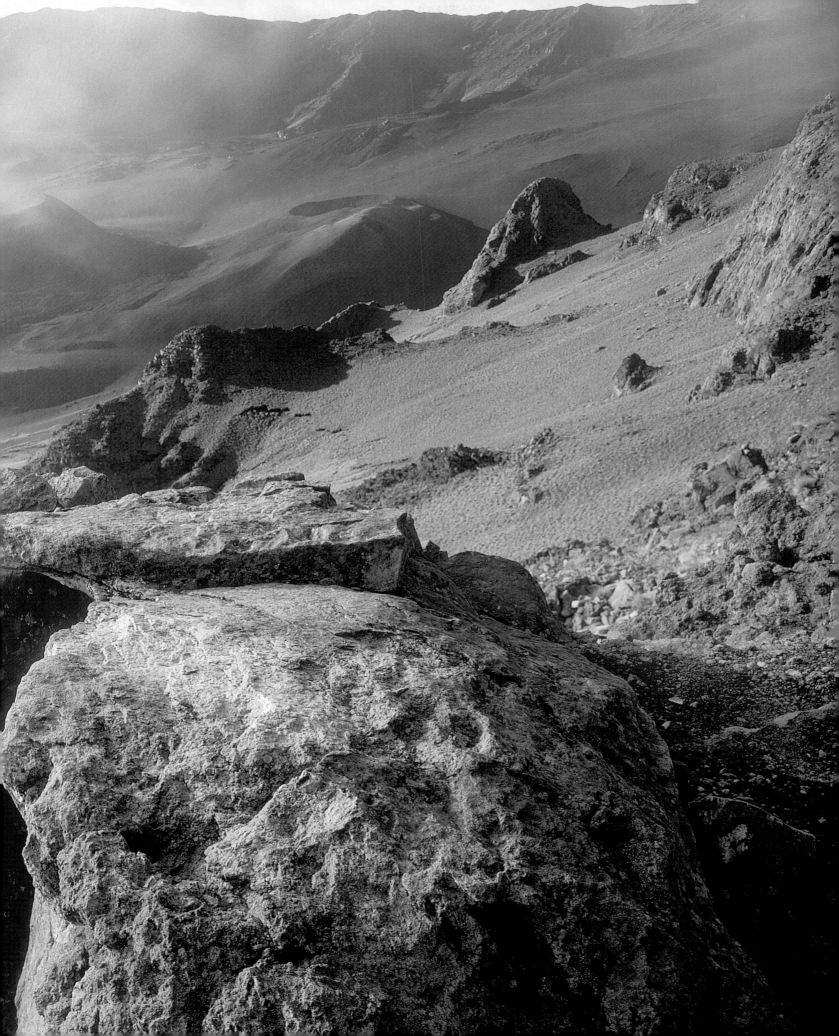

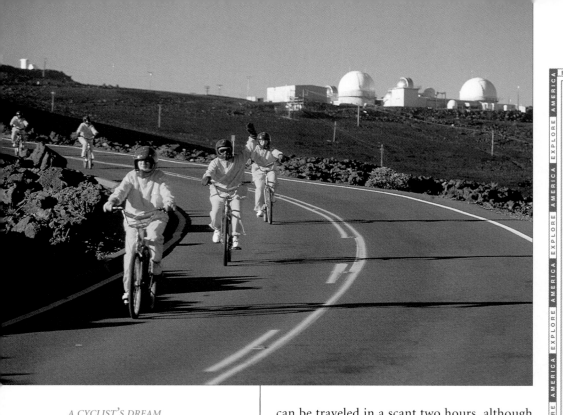

A CYCLIST'S DREAM
Bicyclists, above, coast down the road from Haleakala National Park to sea level on bikes equipped with oversized brakes that control their descent. Visible in the background are the Haleakala Observatories, a scientific research center.

VIEW FROM KALAHAKU OVERLOOK
Overleaf: Haleakala Crater is not, strictly speaking, a crater or a caldera since the volcano neither blew its stack nor caved in. Instead it is an eroded depression produced by the effects of rain and wind over the eons. Volcanic activity created the crater's lava flows and cinder cones. The last time Haleakala erupted, in 1790, it produced two lava flows at lower elevations that altered the contours of Maui's southwest coastline. Since then the volcano has been inactive.

can be traveled in a scant two hours, although visitors who wish to watch the sunset from the top often spend an entire day making their way up, detouring here and there on the way to see other sights in the region.

In the drive up to the summit of Haleakala the climate varies from the balmy latitudes of central Mexico to the mittened cold of Alaska. With every 1,000 feet of elevation, the temperature drops another 3°F—so if it's 80°F at the foot of the mountain, visitors should be prepared for temperatures of about 50°F at the peak.

BEGINNING THE ODYSSEY

Haleakala Highway makes up the first 13 miles of road to the summit. The highway begins amid a snarl of airport and shopping mall traffic, but once outside the coastal town of Kahului the route goes through an ever-changing terrain that shows the effect of the drop in temperature and the higher elevation.

Haleakala looms above the highway like an Aztec pyramid. Its statistics are impressive: at sea level the volcano is 33 miles in diameter, and it is a mile higher than any other mountain on Maui. Haleakala is the largest inactive volcano on the planet. Only about 7 to 10 percent of its entire mass rises above the ocean's surface—from the seafloor, Haleakala measures some 28,000 feet. As visitors travel up its enormous flanks, they may well forget that Maui is an island in the middle of the Pacific Ocean: Haleakala has a continental heft.

Outside Kahului the road passes through fields of emerald sugarcane that bend and toss their silver tassels in the trade winds. The highway climbs higher along the drier, leeward side of the volcano,

INFORMATION FOR VISITORS

The trip to the summit of Haleakala can be completed in about two hours. The road begins in Kahului and travels along Hwys. 37, 377, and 378. The crater is protected within Haleakala National Park, which extends from the summit of the volcano down its southeast flank to the Kipahulu coast near Hana. Restaurant facilities and lodging are available about 12 miles from the park entrance on Hwy. 377. The nearest service station is about 18 miles from the entrance to the park on Hwy. 37 near Pukalani. Because the weather near the summit is unpredictable, it is advisable to call the park for current conditions before setting out. Even in summer it can be cold, wet, and foggy at the summit, where the summer temperatures average in the mid-60'sF and the winter temperatures average in the mid-40'sF. The summit is usually free of clouds from sunrise to mid-morning and again in late afternoon and evening. The best light for taking photographs is in the afternoon.
For more information: Superintendent, Haleakala National Park, Box 369, Makawao, Maui, HI 96768; 808-572-7749.

GIGANTIC BLOSSOMS
The blossoms of the imported protea, below, average six inches in diameter. This popular flower favors the leeward slopes of Haleakala between 2,000 and 4,000 feet in elevation.

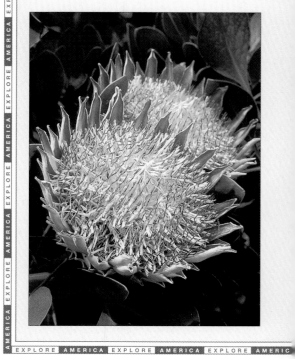

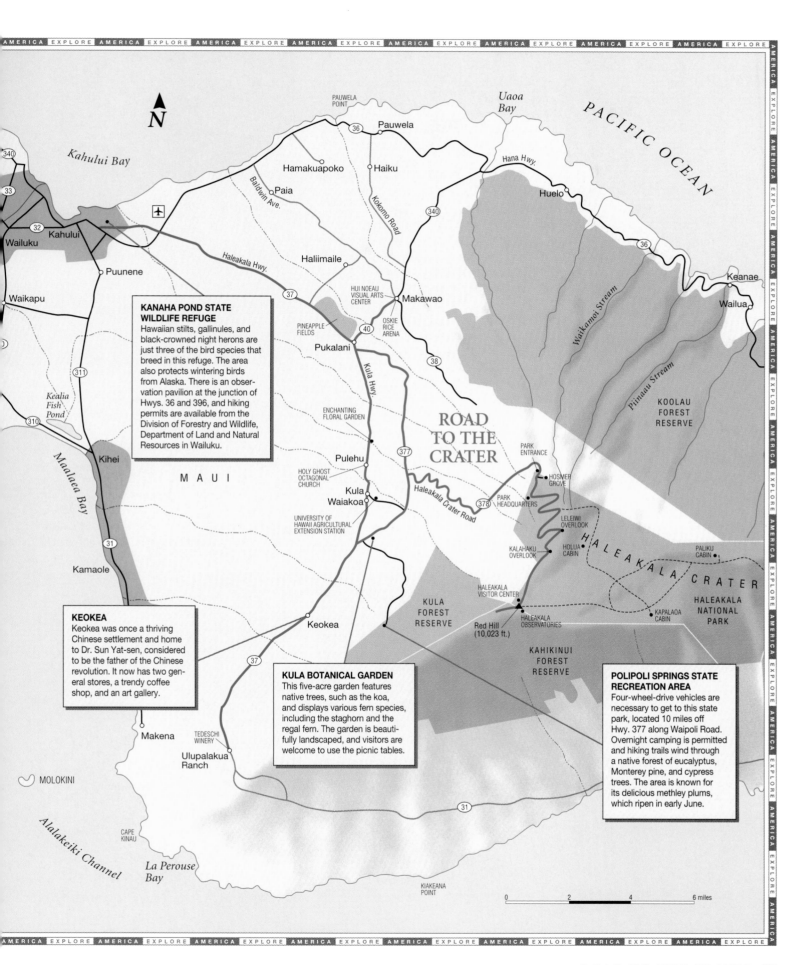

PACIFIC OCEAN

Uaoa Bay

PAUWELA POINT

36 Pauwela

Kahului Bay

340

33

Hamakuapoko Haiku

Paia

Hana Hwy.

32 Kahului

Huelo

Wailuku

36

Haleakala Hwy.

Haliimaile

Keanae

Puunene

340

Wailua

Waikapu

HUI NOEAU VISUAL ARTS CENTER

37 Makawao

KANAHA POND STATE WILDLIFE REFUGE
Hawaiian stilts, gallinules, and black-crowned night herons are just three of the bird species that breed in this refuge. The area also protects wintering birds from Alaska. There is an observation pavilion at the junction of Hwys. 36 and 396, and hiking permits are available from the Division of Forestry and Wildlife, Department of Land and Natural Resources in Wailuku.

PINEAPPLE FIELDS

OSKIE RICE ARENA

40

Pukalani

38

311

Kealia Fish Pond

ENCHANTING FLORAL GARDEN

310

ROAD TO THE CRATER

Kula Hwy.

377

PARK ENTRANCE

Kihei

Pulehu

HOLY GHOST OCTAGONAL CHURCH

Kula
Waiakoa

M A U I

Haleakala Crater Road

378 PARK HEADQUARTERS

HOSMER GROVE

UNIVERSITY OF HAWAII AGRICULTURAL EXTENSION STATION

31

LELEIWI OVERLOOK

Maalaea Bay

KOOLAU FOREST RESERVE

Waikamoi Stream

Piinaau Stream

KALAHAKU OVERLOOK

HOLUA CABIN

H A L E A K A L A C R A T E R

PALIKU CABIN

Kamaole

KULA FOREST RESERVE

HALEAKALA VISITOR CENTER

Red Hill (10,023 ft.)

HALEAKALA OBSERVATORIES

KAPALAOA CABIN

HALEAKALA NATIONAL PARK

KEOKEA
Keokea was once a thriving Chinese settlement and home to Dr. Sun Yat-sen, considered to be the father of the Chinese revolution. It now has two general stores, a trendy coffee shop, and an art gallery.

Keokea

KAHIKINUI FOREST RESERVE

Makena

37

TEDESCHI WINERY

KULA BOTANICAL GARDEN
This five-acre garden features native trees, such as the koa, and displays various fern species, including the staghorn and the regal fern. The garden is beautifully landscaped, and visitors are welcome to use the picnic tables.

POLIPOLI SPRINGS STATE RECREATION AREA
Four-wheel-drive vehicles are necessary to get to this state park, located 10 miles off Hwy. 377 along Waipoli Road. Overnight camping is permitted and hiking trails wind through a native forest of eucalyptus, Monterey pine, and cypress trees. The area is known for its delicious methley plums, which ripen in early June.

Ulupalakua Ranch

MOLOKINI

CAPE KINAU

Alalakeiki Channel

La Perouse Bay

31

KIAKEANA POINT

0 2 4 6 miles

AMERICA EXPLORE AMERICA EXPLORE AMERICA EXPLORE AMERICA EXPLORE AMERICA EXPLORE AMERICA EXPLORE AMERICA EXPLORE AMERICA EXPLORE AMERICA EXPLORE AMERICA EXPLORE AMERICA EXPLORE AMERICA EXPLORE AMERICA

ROAD TO THE CRATER 95

A woman picks baby's breath in one of Kula's numerous commercial flower gardens, right.

where the roadside sugar fields are interspersed with row upon row of pineapple plants. This spiky football-sized fruit grows plump and golden under the hot Hawaiian sun.

At Pukalani, meaning "hole in heaven," the road narrows to two lanes. According to one story, the town got its name from the eddies of air currents that sometimes sweep around Haleakala and blow away the clouds above the town, revealing the summit. Maui's Upcountry begins here where the heat of the tropics gives way to a temperate-zone nip. Smoke curls cozily from chimneys. Ranch properties and farmland quilt the countryside. Hibiscus plants and palm trees yield to hollyhocks, pines, and jacaranda trees laden with purple clouds of flowers in the spring.

FERTILE SLOPES

The climate and the rich volcanic soil on the midslopes of Haleakala are ideal for farming. The ancient Hawaiians grew taro and sweet potatoes here. When 19th-century Yankee whaling vessels began calling at Maui ports, the whalers would drop anchor in Lahaina or Maalaea Bay and raise a white flag, signaling the time for Hawaiians to barrel their crops and bring them down for trade. The whalers' demand for meat was the impetus for the island's first forays into cattle ranching.

During the California Gold Rush, Upcountry farmers added corn, cabbages, onions, apples, peaches, plums, and pears to their repertoire of crops and sent them across the Pacific Ocean to the goldfields. The farmers quickly grew more prosperous than most of the forty-niners, and Maui's Upcountry came to be known locally as Nu Kaliponi—New California.

Many of Upcountry's early farmers and plantation workers emigrated from China, Japan, and the Portuguese islands of Madeira and the Azores. Some of their descendants now raise crops and herbs for the gourmet chefs of Maui's hotels. The

HARD LABOR

A truck overflowing with sugarcane trundles along a dusty road on one of Maui's sugar plantations, below.

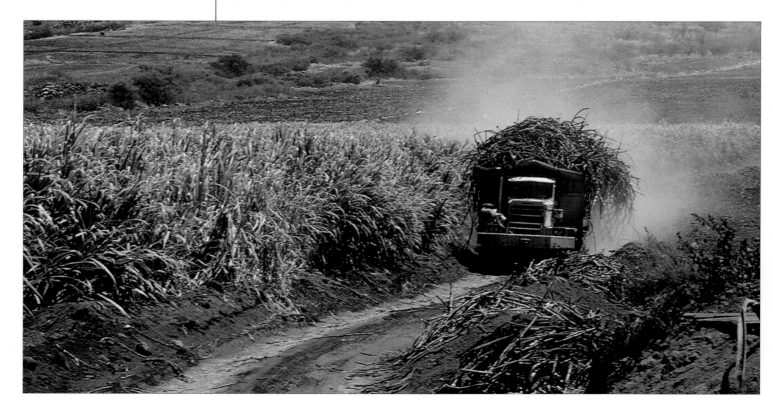

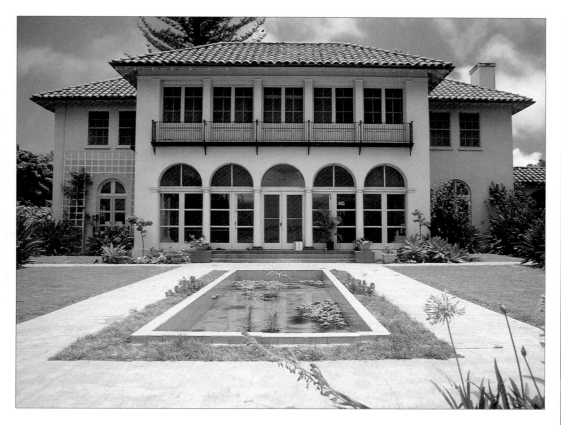

HOME FOR THE ARTS
The focal point for Maui's artistic community is the Hui Noeau Visual Arts Center, left, situated on the grounds of the gracious Makawao estate, Kaluanui, that once belonged to the Baldwins, wealthy Maui rice planters. The Hui, as the mansion is affectionately called, began as a ladies' club in 1934 for the island's society women to celebrate the arts. It has since become an educational institution, sponsoring juried art shows, classes, workshops, and lectures by acclaimed artists from around the world.

COWBOY PARADE
The Fourth of July rodeo, the biggest event in Upcountry, begins with a parade down the streets of Makawao, below.

Maui onion, especially, has earned an international reputation for its flavor, which is so sweet that it can be eaten like an apple—without eliciting a tear.

HAWAIIAN COWBOYS

Some of Upcountry is now used to raise cattle. This is cowboy country—America's westernmost West. The people who work the cattle are called *paniolos*, from the Spanish word *espaniola*. Hawaii's first cowboys were Mexican, brought here in the early 19th century to teach the Hawaiians the rudiments of the cowboy trade. In those days cattle drives would be held on nights with a full moon, so that the livestock would not lose weight while being driven to market in the tropical heat. The *paniolos* herded cattle down the mountain and across the lava flows to the beach. At the first light of day the cattle were driven—bawling and kicking—into the surf, lashed to whaling boats, and pulled by rope out to barges for shipment to market. It was a hazardous operation and sharks were a constant threat.

The *paniolos* of today show off their skills at the Fourth of July rodeo held at Oskie Rice Arena in Makawao, located on Highway 40. The town, settled by the Portuguese in the latter part of the 19th century, is characterized by false-front, two-story buildings that give it the look of a Hawaiian Dodge City. During World War II Makawao enjoyed a brief period of prosperity due to its close proximity to the military base in Kokomo. But by the

*A young boy has tucked feathers
in his hatband, below, mimicking
the cowboys who are sometimes
seen sporting flowers in their hats.*

1950's Makawao was well on the way to becoming
a seedy backwater. It earned the nickname Macho-
wow in keeping with its rough reputation. In recent
years, however, tourism has breathed new life into
the little Hawaiian town. Boutiques, espresso shops,
and art galleries have joined the older grain and
gun shops, and *paniolos* rub elbows with tourists.
Visitors rarely leave town without trying Makawao's
famous steaks and cream puff pastries.

Another detour takes travelers south along Kula
Highway (Highway 37), past flower farms where
fields of carnations perfume the air. Some farms
specialize in roses, lilies, camellias, baby's breath,
and hydrangeas. Many of the fragrant flower heads
are shipped to Honolulu and strung into leis. The
king of the floral crop, however, is the protea, a
flower of unearthly beauty. At 300 million years
old, the protea is one of the most ancient flora
species in existence. It is native to South Africa and
Australia and was introduced to Maui in 1965 at
the University of Hawaii's 34-acre agricultural sub-
station in Upcountry, when various flowers were
tested for viability and marketability. The protea
got a gold star and its production is now a multi-
million-dollar industry.

Many of the flower farms offer self-guided tours,
and visitors can arrange to have dried and fresh
bouquets and wreaths shipped to their homes. At
the Enchanting Floral Garden, across from the Kula
Highway's 10-mile marker, visitors can see 30 vari-
eties of protea, as well as 1,500 other species of
flowers. Travelers are welcome to wander the foot-

HAWAIIAN ORIGINAL
*The Hawaiian word for the beauti-
ful silversword, right, is* ahinahina,
which is derived from the word
hina, *for gray. The unusual-looking
plant belongs to the same family
as the sunflower.*

paths through the landscaped garden and picnic
on the grounds. They may even be offered chilled
cups of mixed fruit picked fresh from the garden.

LONG-
SUFFERING
ISLAND

Beyond the town of Keokea the
highway narrows and enters
ranch country. Herds of cattle
graze in vast emerald meadows
dotted with *panini,* or prickly
pear cactus, and divided by crumbling walls of lava
stone. The sea and the island of Lanai are visible
in the distance on the right. A little farther along,
motorists can see the tiny island of Molokini in the
Alalakeiki Channel and beyond it, the island of
Kahoolawe. In the mid-1800's European mission-
aries used the 45-square-mile island of Kahoolawe
as a penal colony. Ranching was introduced toward
the end of the century, causing untold destruction

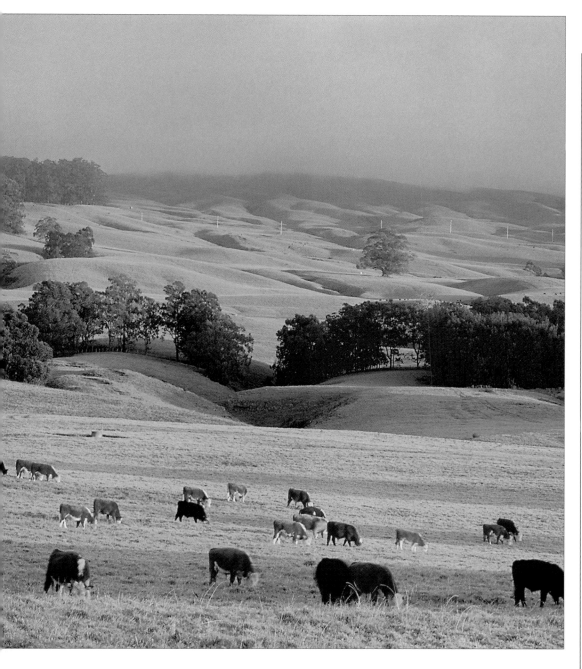

BUCOLIC SCENE
Cattle graze in the lush, rolling pastures of 100-year-old Haleakala Ranch, left, located along the Haleakala Crater Road. At this level several "cow crossing" signs have been posted along the road warning drivers to keep an eye out for cattle. Until the 1920's paniolos regularly drove cattle from the 35,000-acre ranch up the volcano's steep slopes and into Haleakala Crater where they grazed near the eastern side.

VOLCANIC HIGHWAY
Haleakala Highway winds across lava cinders above the tree line in Haleakala National Park, below.

on this, both the windiest and driest island in the Hawaiian chain. Cattle and sheep destroyed most of the sparse vegetation, and winds blew away as much as 15 feet of the island's topsoil. The War Department used Kahoolawe from 1941 until the early 1990's for target bombing and shelling practice. Today the island is uninhabitable and will remain so until the navy cleans up the last of the unexploded ordnance. This monumental task is expected to take generations—and an estimated $400 million—to complete.

Five miles from Keokea lies the headquarters of the 30,000-acre Ulupalakua Ranch, where Maui's only vineyard, the Tedeschi Winery, was established by Emil Tedeschi in the early 1970's. The climate here, similar to that of California's Napa Valley, is suitable for carnelian grapes (a cabernet hybrid). The winery is housed in the old ranch

PINEAPPLE POWER

Maui's pineapple crops, right, were among the island's economic main-stays until foreign competition forced the closure of many planta-tions. Pineapples are still grown on Maui between Paia and Makawao and on the coast north of Napili.

LUNAR LANDSCAPE

A cinder cone, below, takes on the crimson hue of the iron in the surrounding soil. The barrenness of the summit can be daunting, but hikers will discover 27 miles of marked trails on Haleakala main-tained by the National Park Service.

buildings and the tasting room occupies what was once the district's jailhouse, complete with a trap-door that leads to several holding cells.

The original owner of Ulupalakua Ranch was an American whaling captain, James Makee, who was put ashore on the island to recover from a hatch-et wound received at the hands of a mutinous sailor. Captain Makee stayed on to raise six daughters on a sugarcane plantation, called Rose Ranch, which also counted more than 1,600 head of cattle. He became a great friend of Hawaii's King David Kalakaua, who visited the ranch so frequently that Makee built a white cottage for him on the edge of the property. Local people claim that Makee's ghost has been spotted contentedly smoking a pipe by the ruins of the ranch's old sugar mill, about a quarter mile up the road from the winery.

Driving back along Kula Highway to the inter-section with Haleakala Highway takes only about 15 minutes. From that junction, the road to the summit climbs the 6 miles to Haleakala Crater Road and then pursues a zigzag path as it ascends 6,800 feet for the next 22 miles. Ranches and pas-turelands roll upward to fragrant eucalyptus and

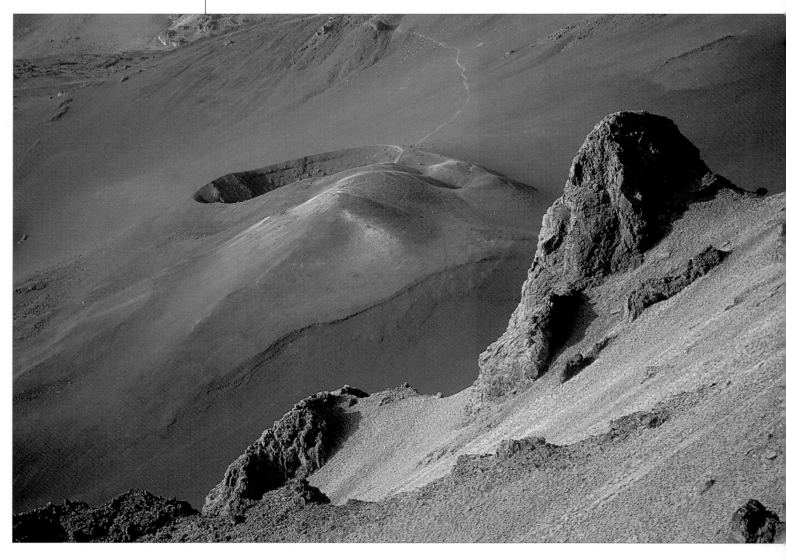

pine trees, and the lovely native ohia with its scarlet lehua blossoms. At higher elevations, the trees shrink to shrubs and finally disappear altogether as the road winds above the tree line.

At between 5,000 and 7,000 feet, the volcano is encircled by a lei of clouds. As the warm trade winds blow in and come into contact with the cooler air of the higher elevations, clouds form. At this level an unusual phenomenon known as temperature inversion occurs, forming a lid of cool air that traps the warmer cloud layer. The sun may be shining above and below this layer. Sometimes two or even three rainbows materialize above the road, appearing as luminous curtains of color, like scraps of celestial laundry hanging out to dry.

Bicyclists wearing helmets and brightly colored windbreakers emerge from the mist and cruise by. "Turn on Lights," a roadside sign reads. Bicycle tours from the top to the bottom of the volcano take about five hours. The descent is unexpectedly exhausting, although not nearly as arduous as Maui's annual footrace up the road to Haleakala's crater, billed as the Run to the Sun.

HALEAKALA NATIONAL PARK

The summit of Haleakala is protected within Haleakala National Park, which encompasses 28,655 acres of desert, dry forests, rain forests, and, at Kipahulu on Maui's eastern shore, a rocky shoreline. Along the road from the park entrance to the summit motorists should keep an eye out for the endangered nene, the Hawaiian goose. Seemingly aware of their status as a protected species, these birds often waddle down the middle of the road oblivious to danger. Tens of thousands of nene once inhabited the Hawaiian Islands. However, by the 1940's, only 50 wild nene were left alive in the world, their near-demise ascribed to the introduction of predators, such as the mongoose and the rat. The nene were reintroduced on Maui in the 1960's and now about 200 of them thrive here.

Just inside the park boundary there is a turnoff to Hosmer Grove, whose non-native trees are the result of Ralph S. Hosmer's efforts in the early 20th century to establish forest reserves of several fast-growing species that would safeguard Maui's damaged watersheds. Hosmer, the territorial forester with Hawaii's Board of Agriculture and Forestry, introduced pine, cypress, fir, juniper, cedar, and Australian shaggy barked eucalyptus. A half-mile nature trail winds through the grove.

The national park headquarters is located just beyond the 7,000-foot level. It provides information on Haleakala Crater, as well as the permits needed to camp at the two primitive campsites at Holua and Paliku in the wilderness area of the park.

Permits are not necessary for the campgrounds near Hosmer Grove and Kipahulu.

Park rangers at the headquarters are cultivating a cluster of silverswords. Browsing by goats and cattle—as well as human vandalism—rendered the plant nearly extinct in the 1920's. Now it is making a comeback. The silversword's stilettolike leaves are a pale ice-green color covered with silver down that helps the rare plant conserve moisture.

It takes up to 50 years to produce a flower stalk, which can grow to nine feet tall and opens up into hundreds of small, purple sunflowerlike blooms.

Above the tree line the landscape is devoid of the soft camouflage of verdure that brightens the lower elevations. The volcano reveals its true nature—stark, raw, and powerful. All around are sweeps of lava rock and cinder, a color somewhere between mud and bloodred. As the road snakes upward the air grows thinner and colder and the terrain becomes grimmer, almost alien in its raw magnificence. Clouds often obscure the checkerboard landscape below. In his travel book, *Roughing It*, Mark Twain described his visit to Haleakala and wrote of the clouds that seemed to sever the peak from the valley: "I felt like the Last Man, neglected of the judgment, and left pinnacled in mid-heaven, a forgotten relic of a vanished world."

HEAVENLY VIEWS Motorists can pull off the road at Leleiwi Overlook (8,840 feet) and Kalahaku Overlook (9,324 feet) for different perspectives of the crater. On the slope below the Kalahaku parking lot, there is another large cluster of silverswords. Visitors are cautioned not to walk within six feet of a silversword in order to avoid damaging the plant's shallow roots. Farther up the road, at 9,745 feet, another overlook offers a look into the crater. Nearby, the Haleakala Visitor Center has the best panoramic view of all, reaching from Kalahaku Pali to Haupaakea Peak. Immense cinder cones, ranging in color from gray to orange to red, rise from the crater floor. Visible in the distance is Mauna Kea, on the island of Hawaii.

Haleakala Crater Road terminates near the volcano's highest point, a cinder cone called Red Hill. The parking lot is located in the cone's shallow depression and a small shelter stands on its western rim. Early risers take advantage of the shelter's 360-degree windows to watch the arrival of dawn. If the weather is clear, all the major Hawaiian Islands except Kauai are visible from here.

The crater is an awesome sight at any time of day. Sunlight plays on the eerie cinder cones and galleons of clouds sail among the peaks. In 1866

Twain called Haleakala, "the sublimest spectacle I have ever witnessed." Modern-day visitors would likely agree with him: the crater is 21 miles in circumference and 3,000 feet deep. Thousand-foot-tall cinder cones that once spewed lava now lie sleeping inside their giant cradle, burnished gold by the sun and neatly sculpted by the wind.

MYTHIC GRANDEUR

The House of the Sun's beauty has long inspired the imagination. Hawaiians tell the story of Maui, the superman of Polynesian myth who wanted to stop La, the sun, from traveling too quickly across the skies. He climbed to the top of Haleakala and, with a net woven from the hairs of his grandmother, captured the rays of the sun as it peeked over the crater's rim at dawn. La begged for his freedom, but Maui refused to release him until he had promised to spend more time over Hawaii. In the end, man and sun reached a compromise whereby La would travel slowly across the sky for half the year and speed across during the other half.

People who greet the dawn from the rim of Haleakala and those who bid the light farewell in the evening would do well to remember that on these rarefied heights, a man confronted the powers of the heavens and made peace.

WINE-LOVER'S FANCY
Visitors to the tasting room at the Tedeschi Winery, left, near the end of Highway 37, have the opportunity to sample various wines, including Maui Brut, Maui Blush, Maui Nouveau, and Blanc de Noirs, the last, a dry white wine made from fermented pineapple juice.

A CITY-SIZED CRATER
Haleakala Crater is a subalpine desert of gray lava hills and cinder cones where the soil is so porous that it retains little water. The entire island of Manhattan would fit inside the enormous depression.

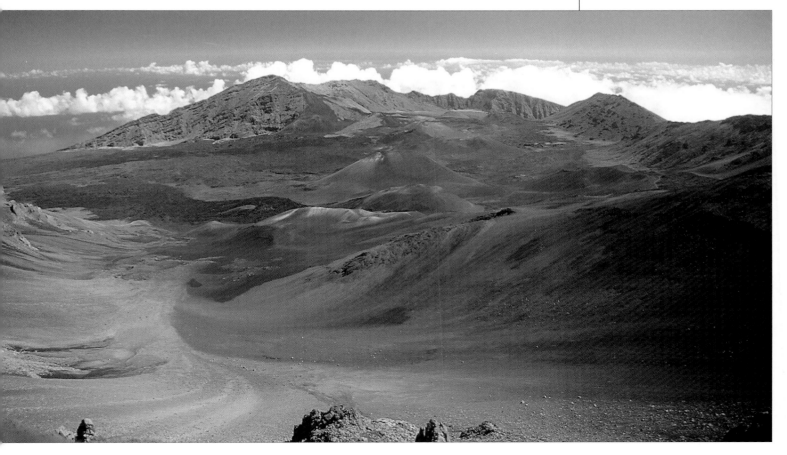

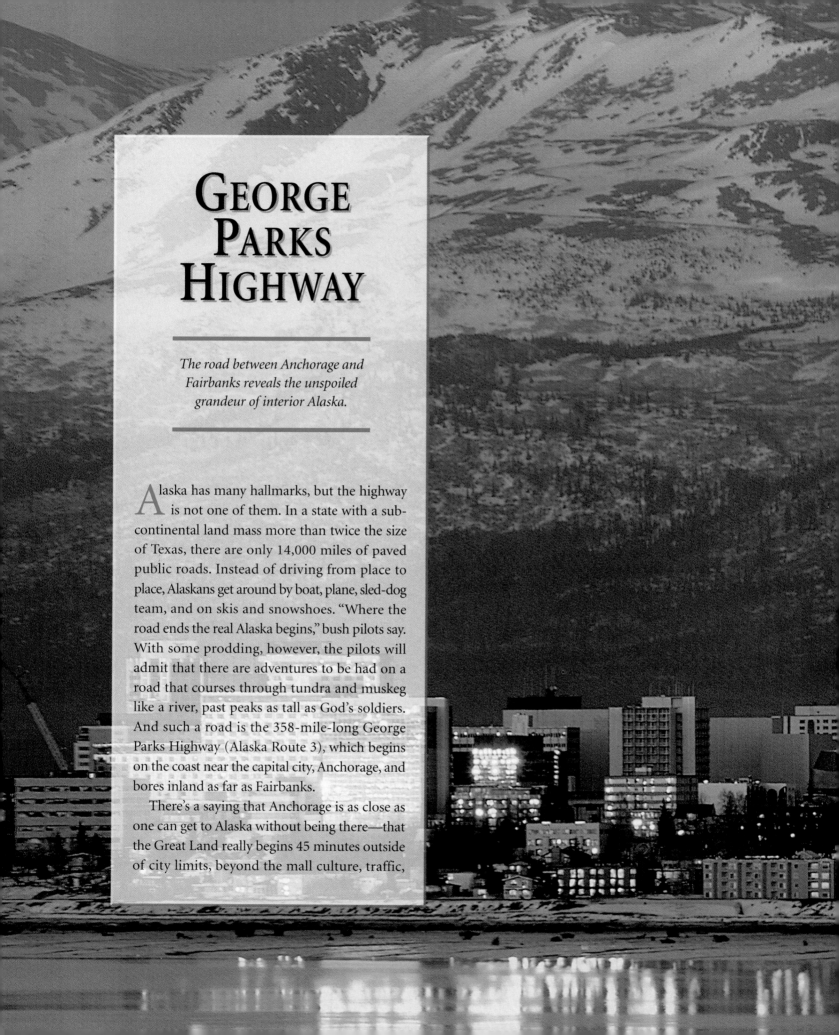

George Parks Highway

The road between Anchorage and Fairbanks reveals the unspoiled grandeur of interior Alaska.

Alaska has many hallmarks, but the highway is not one of them. In a state with a sub-continental land mass more than twice the size of Texas, there are only 14,000 miles of paved public roads. Instead of driving from place to place, Alaskans get around by boat, plane, sled-dog team, and on skis and snowshoes. "Where the road ends the real Alaska begins," bush pilots say. With some prodding, however, the pilots will admit that there are adventures to be had on a road that courses through tundra and muskeg like a river, past peaks as tall as God's soldiers. And such a road is the 358-mile-long George Parks Highway (Alaska Route 3), which begins on the coast near the capital city, Anchorage, and bores inland as far as Fairbanks.

There's a saying that Anchorage is as close as one can get to Alaska without being there—that the Great Land really begins 45 minutes outside of city limits, beyond the mall culture, traffic,

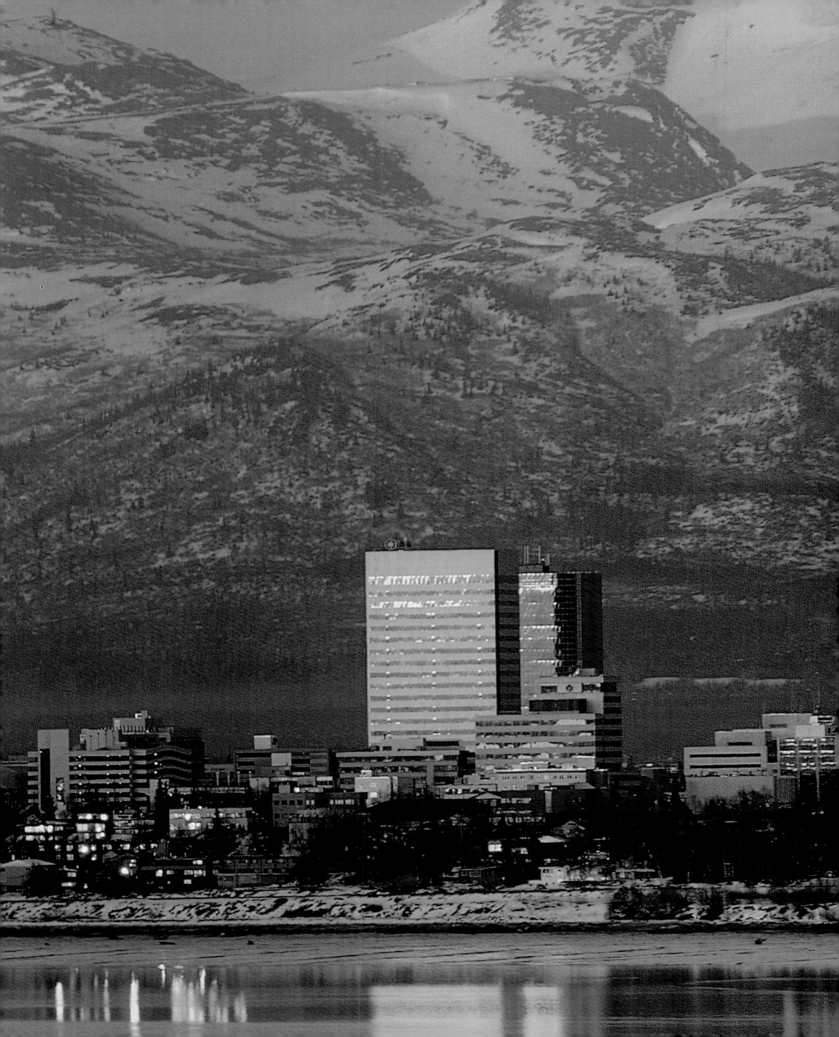

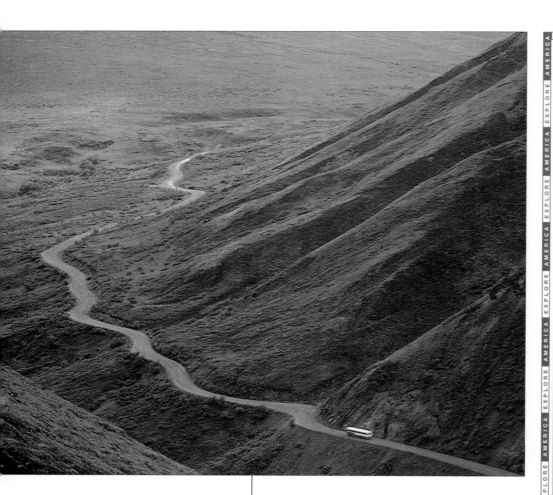

LONG AND WINDING ROAD
A shuttle bus in Denali National Park and Preserve, above, takes passengers from the visitor center to Wonder Lake, 86 miles away.

CITY LIGHTS, MOUNTAIN HEIGHTS
Overleaf: The twinkling lights of Anchorage are reflected in the waters of Cook Inlet at dusk. Behind the city rise the imposing slopes of the Chugach Mountains.

and crowding that plague this and other American cities. And yet, there is something unmistakably Alaskan about Anchorage, with its thick shawl of spruce and birch forest, and the occasional moose or bear that wanders its midtown streets.

Anchorage is a city reborn. In 1964 it suffered the most powerful earthquake ever recorded on the continent—8.6 on the Richter scale (later upgraded to 9.2)—a cataclysm that left it in shambles. Oil production has helped to resurrect the city, which now hums with the activity of nearly 260,000 people. Among Anchorage's glass-and-steel skyscrapers stand a performing arts center, 80 schools, 2 universities, and 200 churches, all within sight of the dramatic Chugach Mountains.

ON THE
ROAD

Anchorage is located at the southern end of the George Parks Highway, also the Glenn Highway at this point. The route heads to the northeast between the majestic Chugach Mountains and Knik Arm, a branch of Cook Inlet. After crossing the Knik and Matanuska rivers, the highways part company at mile 35.3, the Glenn striking northeast to Glennallen, near the volcanic Wrangell Mountains. The George Parks goes westward and then north, bordering Denali National Park and Preserve on its way to Fairbanks.

INFORMATION FOR VISITORS

Alaska's Hwy. 3, also known as the George Parks Highway, links Anchorage and Fairbanks and provides the most direct highway access to Denali National Park and Preserve. Mile posts mark off the miles from Anchorage. Motorists planning to drive this 358-mile highway should call 800-478-7675 for weather and updated road conditions before setting out. Heavy snowfalls begin in early September, and severe winter storms and extremely low temperatures sometimes produce hazardous driving conditions. Some facilities north of the Talkeetna turnoff (mile post A 98.7) and south of Nenana (mile post A 304.5) are closed in the winter. For emergency assistance between the Glenn Highway junction and mile post A 202.1, phone 911; between mile post A 174, at Hurricane Gulch Bridge, and mile post A 224, phone the state troopers at 907-768-2202; between mile post A 224 and Fairbanks, phone 911.
For more information: Alaska Division of Tourism, P.O. Box 11801, Juneau, AK 99811; 907-465-2012.

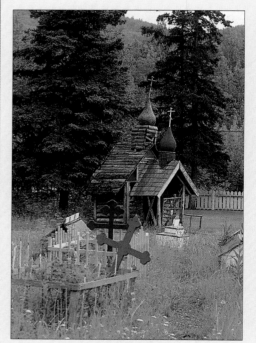

DOMAIN OF THE DECEASED
Athabascan Indians, who were converted to Christianity by Russian missionaries, built spirit houses for the souls of the dead in the cemetery of the St. Nicholas Russian Orthodox Church in Eklutna, above.

106

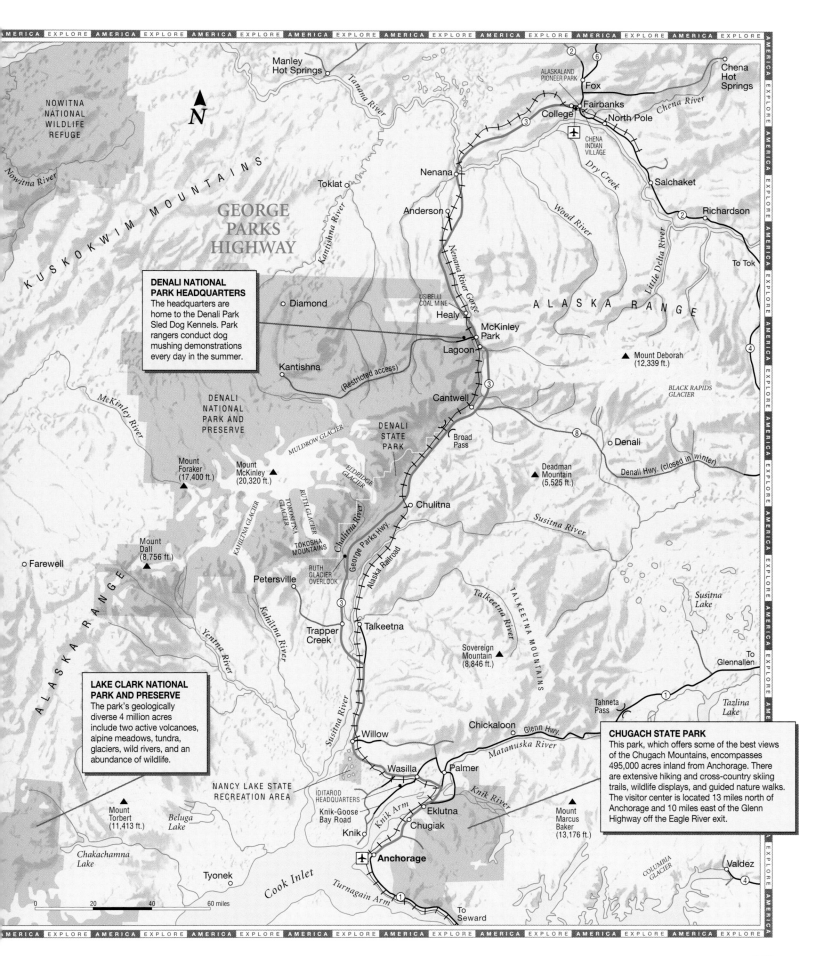

NOWITNA
NATIONAL
WILDLIFE
REFUGE

Nowitna River

Manley
Hot Springs

Tanana River

Chena
Hot
Springs

ALASKALAND
PIONEER PARK

Fox

Fairbanks

Chena River

College

North Pole

CHENA
INDIAN
VILLAGE

Nenana

Dry Creek

Salchaket

K U S K O K W I M M O U N T A I N S

Toklat

Anderson

Wood River

Richardson

GEORGE
PARKS
HIGHWAY

Kantishna River

Nenana River Gorge

A L A S K A R A N G E

To Tok

Little Delta River

**DENALI NATIONAL
PARK HEADQUARTERS**
The headquarters are
home to the Denali Park
Sled Dog Kennels. Park
rangers conduct dog
mushing demonstrations
every day in the summer.

Diamond

USIBELLI
COAL MINE

Healy

McKinley
Park

Lagoon

Mount Deborah
(12,339 ft.)

BLACK RAPIDS
GLACIER

Kantishna

(Restricted access)

Cantwell

Denali

McKinley River

DENALI
NATIONAL
PARK AND
PRESERVE

MULDROW GLACIER

DENALI
STATE
PARK

Broad
Pass

Denali Hwy. (closed in winter)

Mount Foraker
(17,400 ft.)

Mount
McKinley
(20,320 ft.)

ELDRIDGE
GLACIER

Deadman
Mountain
(5,525 ft.)

KAHILTNA GLACIER

TOKOSITNA
GLACIER

RUTH GLACIER

Chulitna

Susitna River

Mount
Dall
(8,756 ft.)

TOKOSHA
MOUNTAINS

Chulitna River

Susitna
Lake

Farewell

RUTH
GLACIER
OVERLOOK

George Parks Hwy.

Petersville

Kahiltna River

Alaska Railroad

Talkeetna River

T A L K E E T N A M O U N T A I N S

A L A S K A R A N G E

Yentna River

Trapper
Creek

Talkeetna

Sovereign
Mountain
(8,846 ft.)

To
Glennallen

**LAKE CLARK NATIONAL
PARK AND PRESERVE**
The park's geologically
diverse 4 million acres
include two active volcanoes,
alpine meadows, tundra,
glaciers, wild rivers, and an
abundance of wildlife.

NANCY LAKE STATE
RECREATION AREA

Susitna River

Chickaloon

Matanuska River

Glenn Hwy.

Tahneta
Pass

Tazlina
Lake

Willow

Wasilla

Palmer

CHUGACH STATE PARK
This park, which offers some of the best views
of the Chugach Mountains, encompasses
495,000 acres inland from Anchorage. There
are extensive hiking and cross-country skiing
trails, wildlife displays, and guided nature walks.
The visitor center is located 13 miles north of
Anchorage and 10 miles east of the Glenn
Highway off the Eagle River exit.

Mount
Torbert
(11,413 ft.)

Beluga
Lake

IDITAROD
HEADQUARTERS

Knik-Goose
Bay Road

Knik Arm

Knik River

Eklutna

Chugiak

Mount
Marcus Baker
(13,176 ft.)

Chakachamna
Lake

Knik

COLUMBIA
GLACIER

Tyonek

Anchorage

Valdez

Cook Inlet

Turnagain Arm

To
Seward

0 20 40 60 miles

MERICA EXPLORE AMERICA EXPLORE AMERICA EXPLORE AMERICA EXPLORE AMERICA EXPLORE AMERICA EXPLORE AMERICA EXPLORE AMERICA EXPLORE AMERICA EXPLORE

GEORGE PARKS HIGHWAY 107

Denali National Park and Preserve is home to 37 mammal species, including the red fox, right. The color of the fox's fur ranges from reddish brown to smoky gray.

Early trappers built food caches on stilts like one that is shown at Fairbanks' Chena Indian Village, below, to keep grizzlies and other wild animals at bay.

The highway is named after George P. Parks, who served as territorial governor from 1925 to 1933. It cost more than $150 million and was built over the 12 years from 1959 to 1971. Crossing some of the state's most rugged terrain, the route is well maintained year-round, though pavement breaks and frost heaves caused by the alternate freezing and thawing of the ground sometimes crop up.

The first leg of the highway traverses the broad Matanuska Valley—Alaska's breadbasket. In the spring, migratory waterfowl rest and feed in lakes and ponds en route to breeding grounds to the north in the Arctic. Wasilla, which lies in the fertile swathe of land between the Chugach and Talkeetna ranges, exploded with development after the completion of the highway. Many of the people who worked in Anchorage built homes here and started the daily commute.

Sound. When the race started out in 1973, it was strictly an Alaskan affair, treated more as an extended camping trip than a serious sporting enterprise. The person who won the first race took 20 days to complete the course and took home $20,000. Today the dog race is an international media event promoted by many sponsors and featuring state-of-the-art racing equipment. Most of the winners now finish the course within 10 to 12 days, weather permitting, and they earn a substantial $50,000 in prize money.

New fans of the sport are often surprised to learn that the best dogs for the race are neither purebreds nor large freight-hauling malamutes. Instead they are light-bodied mongrels known as Alaskan huskies. Fleet of foot and possessing a remarkably stable mental disposition, these marathon runners are descended from dogs bred in Athabascan

The riverboat Discovery III *waits out the winter in Fairbanks, right. During the summer the boat takes visitors on sightseeing tours along the Chena River.*

Wasilla is best known as the headquarters for one of Alaska's most famous events, the Iditarod Trail Sled Dog Race. The run takes place every March as the contestants make their way from Anchorage to Nome—a distance of about 1,200 miles. While the actual course and mileage differ from year to year, the basic route follows the old dog-team mail line blazed in 1910 and designated the Iditarod National Historic Trail in 1976. It crosses two mountain ranges, follows the Yukon River for about 150 miles, runs through several bush villages, and crosses the pack ice of Norton

Indian villages along the frozen rivers of interior Alaska. They are unusually tough animals, accustomed to running, eating, and resting in the relentlessly frigid conditions.

Garish development has grown up alongside the highway to Wasilla and beyond, but with each passing mile, the eyesores abate. At mile 67.2, a turnoff to the west leads to the 22,000-acre Nancy Lake State Recreation Area. Here the quiet is frequently interrupted by the fluted calls of nesting loons. Ducks and grebes also populate the park's 24 lakes, as do muskrats and beavers. Although there are miles of scenic roadway and 11 campgrounds in the Nancy Lake State Recreation Area, the best way to explore it is by following marked canoe trails.

After the small town of Willow, the highway parallels the mighty Susitna River through tall cottonwood, birch, spruce, and willow trees. The area provides an excellent habitat for moose, who like to browse on willow, of which there are 33 varieties in Alaska. Drivers should keep a sharp eye out for the gentle giants. Sometimes a mother moose and her calves will trot across the highway, or a large bull might be seen standing regally on the shoulder of the road, unperturbed by passing traffic until a thoughtless driver honks the horn and drives the animal back into the forest.

At mile 98.7 a spur road breaks away from the highway and runs up the east side of the Susitna River into the town of Talkeetna, home of the famous Denali Flyers. These pilots ferry mountaineers and sightseers into the Alaska Range in their small planes, typically single-engine Cessnas. The planes touch down on the enormous Kahiltna and Ruth glaciers, which range in elevation from 5,000 to 8,000 feet and spill over the south side of towering Mount McKinley—at 20,320 feet, the highest mountain in North America.

THE HIGH ONE

At Trapper Creek (mile 115)—located on the Susitna River's west bank, opposite the town of Talkeetna—Petersville Road branches off the George Parks Highway. From here visitors see Mount McKinley and the icy peaks of the Alaska Range reaching up like great white fangs to bite the azure sky. Alaskans often refer to the mountain as Denali, which means the "High One" in Athabascan. Veteran mountain climbers do not consider the soaring peak to be the most technically difficult to scale. However, thin air, fierce winds—which hit speeds of more than 150 miles an hour—and temperatures below -95°F make the mountain an irresistible challenge. In the early years of this century seven attempts were made to reach the summit of this icy colossus. It was finally conquered in 1913 by a four-man party organized by

Hudson Stuck, archdeacon of the Yukon, and led by horse-packer and guide Harry Karstens. "There was no pride of conquest," wrote Stuck about reaching the summit, but "the feeling that a privileged communion with the high places of the earth had been granted."

Every spring and summer as many as 1,000 climbers test their mettle on the mountain. Even those who are best equipped and trained might fall prey to sudden storms that can pin them down, tent-bound for days at dangerous elevations. In a good year roughly half of the climbers who try reach the top; in a bad year a dozen may die.

RECORD HIGH
Alaskans flock to the shore of Wasilla Lake, below, when the mercury reaches an unusually warm May reading of 75°F.

Mount McKinley continues to dominate the highway as the road steers northward beside the Chalitna River, a tributary of the Susitna River. At mile 135.2 the Ruth Glacier Overlook offers an extraordinary view of the peak, as well as the jagged Tokosha Mountains and the great white rivers of ice formed by the Ruth and Tokositna glaciers. Clear summer days are a rarity here, but stormy days can be absolutely stunning as angry clouds whip across the wind-lashed mountain summits.

The awe-inspiring mountains hold sway over the area, but visitors should not overlook its smaller wonders. White-crowned sparrows, Wilson's

BEYOND THE TUNDRA

The mammoth hulk of the Alaska
Range darkens the horizon behind
the George Parks Highway, right,
as it winds through the taiga—a
Russian word for the stunted spruce
forest that blankets much of the
northern quarter of the earth.

warblers, and other songbirds trill from their alder
and willow perches during their breeding season
in Alaska. Unfortunately, this happy chorus has
thinned somewhat in recent years. Songbird pop-
ulations are declining worldwide, especially in
regions where tropical and subtropical rain forests
have been severely clear-cut, though relatively lit-
tle of their habitat has been destroyed in Alaska.

The highway climbs in elevation as it turns north-
east and, at mile 200, leaves the forest behind to
enter a breathtaking tundra landscape at Broad
Pass. The Alaska Range looms to the north and the
Talkeetna Mountains to the south. The handsome
arrangement of lakes, spruce trees, and open tun-
dra here indicates it is an ecotone, a transitional
area between forest and tundra. In summer the
terrain is covered in a quilt of variegated greens;
in early fall, a splash of russets and reds; and in
winter, a blanket of snow. Cold and windy the win-
ter may be, but not lifeless. Part of the Nelchina
caribou herd—one of 13 major caribou herds in
Alaska—usually feeds then. These members of the
deer family move as they eat to avoid overgrazing
an area. Yet when the mercury dips to -40°—the

same temperature on both the Celsius and
Fahrenheit scales—they can be seen standing stone-
still to conserve energy.

ANCIENT RIVER

Beyond Broad Pass the George
Parks Highway turns northeast
as it proceeds past Cantwell.
From Cantwell to Healy the
highway hugs the banks of the Nenana as it cuts
through the rocky ramparts of the Alaska Range.
Each mile of road discloses unforgettable scenes
of the river and surrounding landscape. In the dis-
tance the serrated mountains push their shoulders
against the sky. Moose, grizzlies, and even wolves
sometimes cross the highway. White-water kayak-
ers and rafters slice through Nenana's clear waters
as they make their way downriver. The Nenana is
an antecedent river, meaning it predates the geo-
logical uplift that created the mountains some 65
million years ago. The river carved through the
rocks at a faster rate than the uplift and thus main-
tained its original course.

A left turn at mile 237.3 takes travelers into Denali
National Park and Preserve—the famed subarctic

sanctuary. A road penetrates the park for 90 miles, but to reduce traffic and give visitors plenty of opportunities to view the wildlife, only the first 15 miles of the road are open to private vehicles. Transportation beyond that point is provided only by public shuttle bus.

The Denali park road quickly leaves the visitor center and the park headquarters behind and forges through a forest of spruce, birch, and aspen. Several packs of wolves live in the park, one of them near the headquarters. Spotting them is a matter of being in the right place at the right time—and keeping an eye out. In winter they usually hunt in packs; in summer they are more solitary.

Unlike moose, who must emerge from the woods to be seen, caribou wander the open tundra. A herd of 50 or more is sometimes visible from the park road. Grizzlies come and go wherever they please and often patrol the deep forest in early summer to prey on newborn moose calves. Autumn finds them on the tundra, feeding and fattening on berries before their long winter sleep. The snowy white Dall sheep inhabit the high slopes of the surrounding mountains and are occasionally seen around Savage River, the lambs gamboling over the tundra on spring-loaded legs. The rams sport magnificent curled horns, whereas the ewes have smaller spiked horns. Dall sheep have a special significance to Denali National Park and Preserve, for it was the threat of overhunting them in the early 1900's that prompted Vermont-born Charles Sheldon to fight for the creation of a national park, a battle that he won in 1917. Sheldon, a hunter and naturalist, explored much of the central Alaska Range in the company of Harry Karstens, who later climbed Mount McKinley's South Peak. Karstens also became the national park's first ranger.

The willow ptarmigan, the state bird of Alaska, is also commonly sighted along the park road. A member of the pheasant family, the ptarmigan lives in Denali year-round. It exhibits brown plumage in summer, white in winter, and a mix of colors in spring and fall. The bird's Latin name, *Lagopus lagopus,* refers to its feathered feet, which help insulate it from winter's extreme cold.

This far north, the temperature drops to -50°F in winter. Frigid weather was just one of the challenges faced by the builders of the Alaska Railroad, the northernmost railroad in North America, when construction on the line between Anchorage and Fairbanks began in 1915. A tent town of 2,000 workers sprang up on the shores of Cook Inlet, where Anchorage stands now. Eight years later Pres. Warren G. Harding drove in the golden spike at Nenana in a ceremony commemorating the railroad's arrival at Fairbanks. From the highway it is possible to see the blue-and-gold trains as they

UNEARTHLY SIGHT
Residents of Fairbanks can enjoy the spectacle of the aurora borealis, or northern lights, left, an average of 240 nights a year. The gossamer curtains of light are also known as merry dancers and chèvres dansantes—*French for dancing goats—because of their frolicking motion in the dark sky.*

GUESS WHO'S COMING TO DINNER?
An enormous bull moose pays a surprise visit to a house in downtown Anchorage, below.

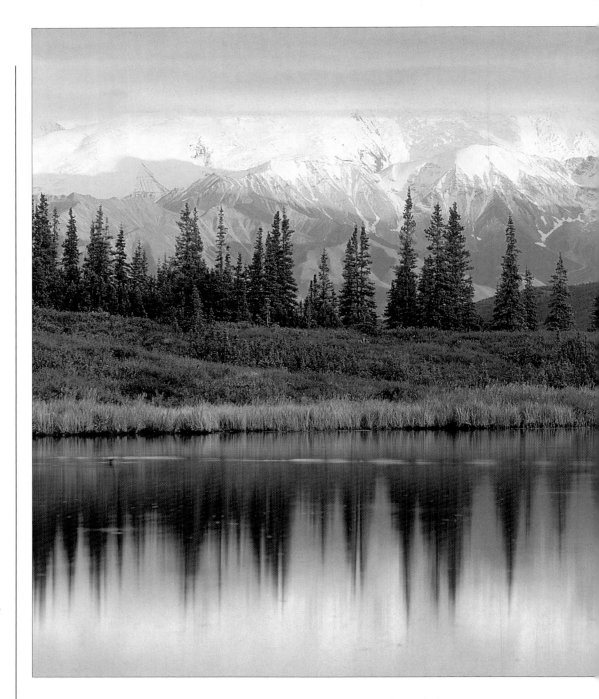

The headquarters for the Iditarod Trail Sled Dog Race, below, located a short distance south of Wasilla on the Knik–Goose Bay Road, houses a museum with various exhibits and information on dog mushing and sled-dog lore. The race follows the Iditarod Trail, famous for its role in 1925 as the highway used by dogsleds bearing lifesaving serum to diptheria-stricken Nome.

chug their way through the Nenana River Gorge on the other side of the river.

As the highway drops down a long hill into the town of Healy, the large machinery of the Usibelli Coal Mine appears on the horizon. It is the only coal mine in the state; half of the 1.5 million tons it extracts annually is burned in Alaska.

INTERIOR ALASKA

North of the mountains, the land transforms into alluvial terraces and gentle hills covered in boreal forests. This is interior Alaska. It is warmer here than by the coast in summer, and colder in winter. At the town of Nenana, the Tanana River joins the Nenana, and the water flows north on its journey toward the mighty Yukon. The town takes center stage every

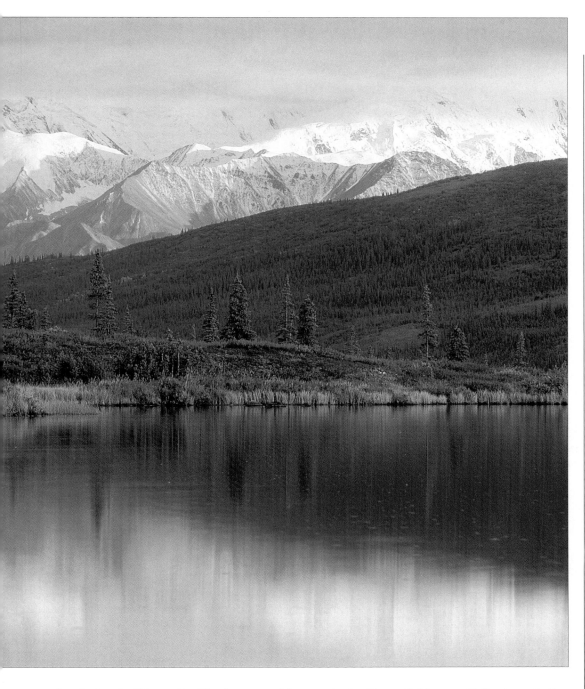

spring during the Nenana Ice Classic, a statewide betting event to guess the precise day, hour, and minute the ice will break. A tripod set on the frozen river becomes dislodged when the ice begins to surge, tripping a wire that stops a clock in town. The ice usually cracks sometime between April 28 and May 12. The betting pool, which was first established in 1917, offers upward of $250,000.

GOLDEN HEART

Between Goldstream Valley and Tanana River valley, the final stretch of highway climbs a forested ridge and looks out on vast sweeps of forested riverine land backed by the shining white peaks of the Alaska Range. Then the highway turns east and heads into Fairbanks, Alaska's Golden Heart. The 1902 discovery of gold ore in the Upper Goldstream Valley by an Italian prospector named Felix Pedro helped establish Fairbanks. But travelers to the valley are quick to discover a natural phenomenon of more lasting value than gold: the night skies put on an astonishing display known as the northern lights, or the aurora borealis. Scientists say that the celestial show is produced when electrons and protons, released through sunspot activity, strike gas particles in the earth's upper atmosphere, causing them to emit electromagnetic energy in the visible portion of the color spectrum.

This heavenly display is a dramatic finale to the exploration of America's last frontier. The drive offers travelers the opportunity to experience a unique blend of urban vitality and fierce, unconquered arctic wilderness.

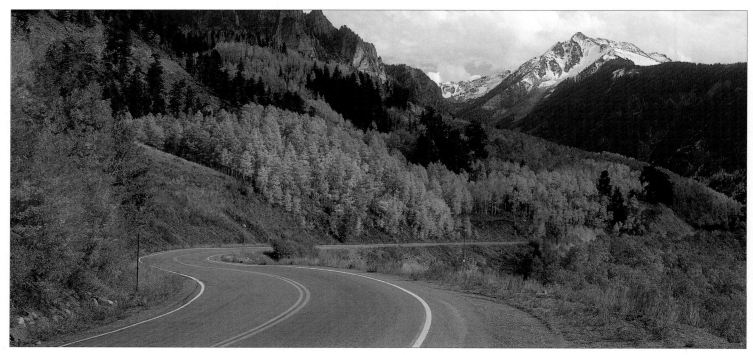

The snowcapped peaks of the San Juan Mountains dominate the San Juan Skyway.

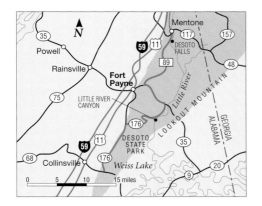

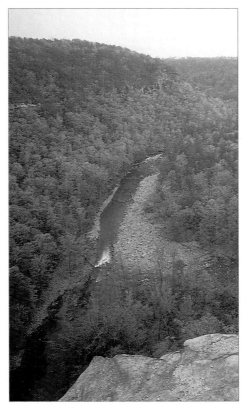

A s it meanders from Mentone to Collinsville, this drive through northeastern Alabama passes by pine-fringed mountains, deep river gorges, and peaceful Appalachian communities. Lush, green parklands wrap around the 43-mile section of Highways 176, 89, and 35, luring hikers, swimmers, paddlers, rock climbers, and nature photographers.

The drive begins on Highway 89 in the rustic hamlet of Mentone, which is nestled in the slopes of Lookout Mountain. Antique stores and curiosity shops line the town's main street, where visitors can shop for collectors' items, handmade quilts, needlework, and rugs. The most prominent building in town is the three-story Mentone Springs Hotel. Dormered and turreted, this 1890's structure, which no longer operates as a hotel, is a remnant of the days when stylish vacationers flocked to the area's mineral springs, two of which are located on the hotel grounds.

Large boulders line the highway as it weaves through the forested uplands and gentle valleys of DeSoto State Park. The highlight of this 5,067-acre park is the Little River. A geographical fluke, the river is the only one in the nation that flows almost entirely atop a mountain. Fed by underground springs, this serpentine waterway defines the landscape: cascades and waterfalls tumble down craggy ledges, and tributary streams branch off in a multitude of capillaries. The park counts 15 waterfalls, including 104-foot-high DeSoto Falls.

During spring the valleys bloom with a succession of flowers: pink rhododendrons are followed by bursts of Queen Anne's lace, wild azalea, mountain laurel, honeysuckle, and black-eyed Susan. Forest and meadow are stitched together with hiking trails and a series of bridges.

Rustic cabins are found in the northern section of the park, where a 20-foot boulder serves as the rear wall of the Sallie Howard Memorial Chapel—a tiny church made of stones from the Little River. One of the

area's earliest settlers and developers, Milford Howard, erected the structure in memory of his deceased wife. The pulpit is also constructed of stone.

Deer, turkeys, and other wild animals roam freely on the east side of the river. Elsewhere in the park, fortunate visitors may spot bald eagles, peregrine falcons, and ruby-throated hummingbirds.

Travelers passing through the southern section of the park cross into the 14,000-acre Little River Canyon National Reserve, where the Little River has carved a deep scar into the sandstone. Dubbed the Grand Canyon of the South, the chasm extends for 16 miles and reaches depths of 700 feet.

LAND OF WATERFALLS
Highway 176 overlaps the Little River Canyon Rim Parkway, which parallels the west rim of the Little River and its offshoot at Bear Creek Canyon. The road follows the canyon for 22 miles, offering views of 60-foot Little River Falls gushing over rugged cliffs. Roadside overlooks provide vistas of rocky outcroppings and waterfalls, including Grace's High Falls—a cascade that is torrential in spring and early summer. Rock climbers come here to scale the sheer walls of the canyon, and river runners tackle world-class white water. Other visitors swim in the reservoir or picnic near a historic dam at DeSoto Falls.

With an average depth of 400 feet— 700 feet at its lowest point—the Little River Canyon, left, is one of the deepest canyons east of the Mississippi River.

Pressing on to Collinsville, visitors who arrive on Saturday and most holidays can participate in Trade Day, an occasion that draws some 30,000 bargain hunters and browsers. In operation since 1950, the event features ducks, swans, rabbits, geese, goats, and other animals for sale, giving it a country fair atmosphere. Local treats such as corn dogs and boiled peanuts can be sampled, and vendors sell local crafts, antiques, and bric-a-brac.

FOR MORE INFORMATION:
Alabama Bureau of Travel and Tourism, Suite 126, 401 Adams Ave., P.O. Box 4309, Montgomery, AL 36103-4309; 334-242-4169.

Water crashes down Little River Falls, below, at DeSoto State Park.

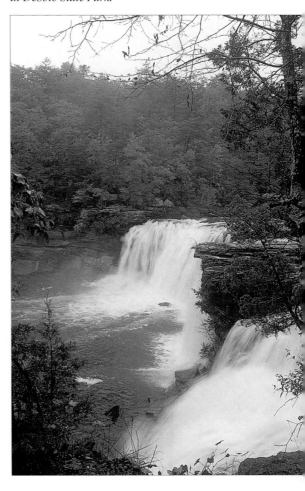

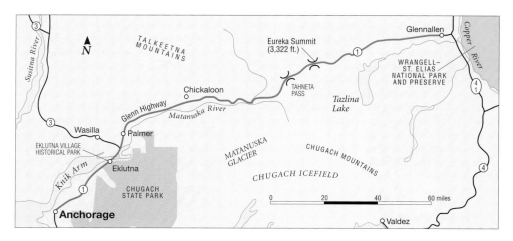

significant, the park is built on the site of an abandoned gold-mining camp. The visitor center displays objects relating to the various gold rushes in the region. Guides offer walking tours of Palmer.

Although travelers are treated to breathtaking views around every bend of the Glenn Highway, few sights can compare to that of the Matanuska Glacier. The road first passes Monument Glacier, an expanse of debris carved by a glacier on its way to Matanuska Glacier. This river of ice coils down the mountains from the Chugach ice fields, some 13,000 feet above. The glacier's statistics are impressive: it is 1,000 feet deep and 27 miles long, and its base is 3 miles wide. The glacial meltwater feeds the Matanuska River, upon which the farmers of the valley depend.

The highway skims through wide fields of alpine forget-me-nots (Alaska's state flower). As the road approaches 3,000-foot Tahneta Pass, it rolls past bleak stands of blue spruce trees, which struggle to maintain a foothold in the sodden muskeg.

Eureka Summit, at 3,332 feet, is the highest point along the highway. From here travelers are afforded outstanding views of the surrounding terrain. Gazing downward, visitors can see the Matanuska, Susitna, and Copper river systems divide and branch off from each other. The Wrangell Mountains loom to the east, and hundreds of kettle lakes sparkle on the ridges of the Chugach Mountains to the south.

As the highway approaches the town of Glennallen, situated at the junction of the Glenn and Richardson highways, visitors can peer across the expansive Copper River valley and catch glimpses of the steaming, semidormant volcano Mount Wrangell. Glennallen sits at the foot of the impressive mountain range, which includes some of the highest peaks in the Wrangell–St. Elias National Park and Preserve. Covering 13.2 million acres—six times the size of Yellowstone National Park—this is the largest national park in the United States.

The park's boundaries encompass the largest ice fields on the continent, as well as giant glaciers, an intricate braiding of rivers and streams, and wave after wave of snowcapped mountains. With few roads and very limited facilities, the park demands strong survival skills of those who would conquer it.

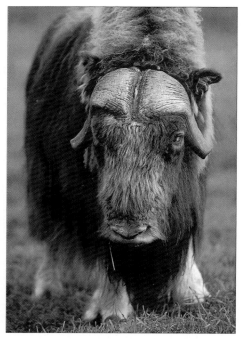

A musk ox bull, above, grazes at the Musk Ox Farm in the Matanuska Valley. The tips of the bulls' horns are removed to keep them from injuring one another.

A journey along Alaska's Glenn Highway is without equal. The 189-mile route reveals a kaleidoscope of changing landscapes—soaring, snow-capped mountain ranges and broad meadows of wildflowers, gleaming glaciers and lush, fertile farmlands, deep, dark forests and sun-streaked lakes.

Leaving the urban sprawl of Anchorage, the highway begins its journey across south-central Alaska, slicing between the towering Talkeetna Mountains north of the highway and the jagged Chugach Mountains to the south. Practically abutting Anchorage's doorstep are the almost 500,000 acres of Chugach State Park. The park's numerous trails offer breathtaking views of shimmering lakes, icy pinnacles, and wide, wild valleys that were sculpted by the glaciers that moved through the region thousands of years ago. The high country wilderness teems with animal life. Moose, grizzly and black bears, snow-white Dall sheep, lynxes, and wolves roam the terrain, and bald eagles and hawks soar in the sky overhead. The rivers and streams run thick with salmon and trout.

The highway heads northeast in the shadow of the Chugach Mountains and skirts Knik Arm, a fjord of Cook Inlet, to Eklutna Village Historical Park. The park's Athabascan spirit houses, and its Russian Orthodox churches and shrines—traces of czarist Russia's attempt to colonize the region and exploit the natural riches of the North Pacific—are testaments to the cultural and historic diversity of Alaska.

FERTILE FARMLAND

As the road loops inland it enters the Matanuska Valley, where rich farmland provides a sharp contrast to the towering ice-crusted peaks. During the Great Depression, farm families from the Dust Bowl of the Midwest settled in the valley and established towns such as Palmer, now a ghost town. The region is an agricultural success in a state that does not have a significant farming history.

A close-up view of a different kind awaits visitors who stop at Musk Ox Farm, located just outside of Palmer. As many as 200 of these shaggy ice-age survivors now roam the 75-acre property. Hunted to near extinction in the 1800's, musk oxen are now bred for their ultralight underwool, called *quiviut*, which is knitted into garments by local Native Americans.

While in the Palmer area visitors might also consider a side trip to Independence Mine State Historical Park, near Hatcher Pass. Visually stunning and historically

FOR MORE INFORMATION:

Alaska Division of Tourism, P.O. Box 110801, Juneau, AK 99811-0801; 907-465-2012.

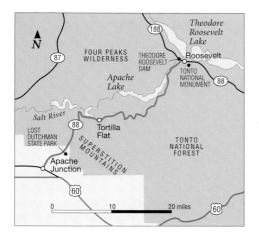

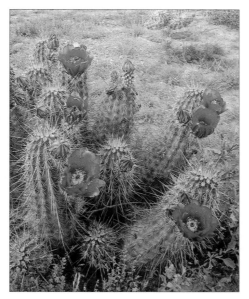

The bright blossoms of hedgehog cacti, above, dot the Superstition Mountains.

E dging along the sheer-walled cliffs of a rugged desertscape, a portion of Highway 88 called the Apache Trail retraces a route used by Indians for hundreds of years. Brooding mountains with slopes blanketed in cacti dominate this sublime landscape, which whispers tales of lost civilizations and rich veins of gold. But motorists beware—the byway is notorious for its steep switchbacks, blind corners, and a steep descent that plunges 1,500 feet in just three miles.

This 44-mile section, which begins east of Apache Junction on Highway 88, once served as a supply line for construction crews building the Theodore Roosevelt Dam. The road strings together a necklace of sapphire lakes as it meanders through Tonto National Forest. The Superstition Mountains also ripple through the 3-million-acre forest. Here, in the shadow of a 4,553-foot rock spire called Weaver's Needle, legend says that German prospector Jacob Waltz began to mine for gold; but the mythical mine has never been found. Modern-day travelers will enjoy discovering some of the natural treasures offered by Lost Dutchman State Park, where the wealth of desert flora includes mesquite, paloverde, ironwood, and cholla, saguaro, and prickly pear cacti.

Continuing eastward, the road sweeps through eroded lava flows and brushes Canyon Lake at several points. Travelers can see the 10-mile-long reservoir from the deck of the *Dolly Sternwheeler*—a 100-foot replica of a double-decker steamboat.

Tortilla Flat, the only town along the trail, was named for a cluster of boulders resembling stacks of tortillas. There is a restaurant and a store in this old stagecoach stop, where travelers can sample prickly pear ice cream or dine in a saloon furnished with horse-saddle seats and surrounded by walls that are papered with dollar bills.

A SERIES OF SWITCHBACKS

Five miles past Tortilla Flat, the pavement ends and Highway 88 continues as a gravel road. It cuts through sharp canyon walls composed of pink arkosic rock speckled with quartz and feldspar. A series of steep descents and hairpin turns culminate in a 1,500-foot plunge into Fish Creek Canyon, where an old-fashioned one-lane bridge traverses Fish Creek.

Following the highway northeastward, visitors come upon Apache Lake Vista, which overlooks the water. A side road descends to a cove studded with saguaro, barrel, and cholla cacti. The road also provides glimpses of the Painted Cliffs of Four Peaks Wilderness across the lake.

The last few miles of the byway run high above Apache Lake as it narrows on the way to Theodore Roosevelt Dam. Completed in 1911, the 280-foot dam and water system helped Phoenix become one of the world's largest desert cities. The hand-hewn masonry stones of the original dam rest inside the newly renovated structure, which now stands 357 feet high.

Though the Apache Trail ends here, travelers continuing eastward on Highway 88 to Tonto National Monument can explore the area's prehistoric cliff dwellings. The Salado Indians migrated to the Salt River area from northeastern Arizona in the early 14th century and built pueblo structures of native rock and adobe mud in natural caves.

Relics of the Salado culture are on display in the visitor center, including pottery, woven cotton fabrics, jewelry, and stone tools. A self-guiding trail leads to the ruins of a 19-room cliff dwelling. Visitors can make reservations for a ranger-led hike to the impressive Upper Ruins and a 40-room pueblo built into the cliff. These artistic and industrious pueblo people thrived in the area until their mysterious disappearance in the mid-15th century.

FOR MORE INFORMATION:
Tonto National Forest, 2324 E. McDowell Rd., Phoenix, AZ 85006; 602-225-5200.

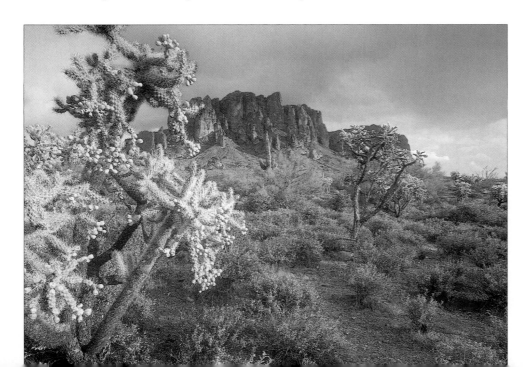

The dark bulk of the Superstition Mountains looms behind a cholla cactus, left, in Lost Dutchman State Park.

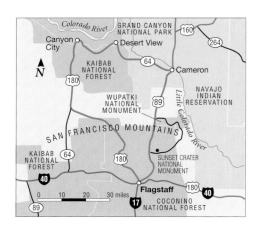

Skirting Arizona's highest mountains and deepest chasms, this paved loop through Grand Canyon Country gives new meaning to the word sublime. Beginning in Flagstaff, the drive rolls past the lofty San Francisco Mountains, brushes past the South Rim of the Grand Canyon, then cuts through a sprawling lavascape before arriving back in Flagstaff.

On it heads west through Coconino National Forest, Highway 180 traverses the high rangelands of the San Francisco Mountains. A maze of hiking trails weaves through forests of ponderosa and piñon pine, juniper, and quaking aspen, leading to alpine meadows abloom with wildflowers. Visitors can hike to the mountaintops and glide up from 9,500 to 11,500 feet on the

Agassiz Skyride during the summer, which offers bird's-eye views of northern Arizona and southern Utah.

The byway turns northward and gradually descends to an arid basin forested with juniper and piñon pine. Past the boundary of Kaibab National Forest, Red Butte—a vestige of an ancient lava flow—juts up 7,324 feet from the ground beside the road.

CHANGING TERRAIN

Beyond the forest, the landscape becomes a rolling carpet of fragrant sagebrush. The drive heads east on Highway 64 at Canyon City, then skirts the Grand Canyon along pine-wooded plateaus that rise almost a mile above the Colorado River. Desert View, at 7,438 feet the highest lookout on the South Rim, reveals the tiered sandstone mesas and multihued cliffs that frame the tremendous chasm.

From Desert View, Highway 64 crosses into the Navajo Indian Reservation about eight miles east of Grand Canyon National Park. Overlooks peer into the steep-walled gorge of the Little Colorado River. Roadside stands sell crafts made by the Navajo.

Heading south along Highway 89 at Cameron, drivers will come upon a well-marked side road that leads through the 56-square-mile Wupatki National Monument. Here, in the parched landscape, sit the ruins of some 200 structures built by the Sinagua Indians during the 12th and 13th centuries.

A stand of ponderosa pines, above, rises from a blanket of snow on the South Rim of Grand Canyon National Park.

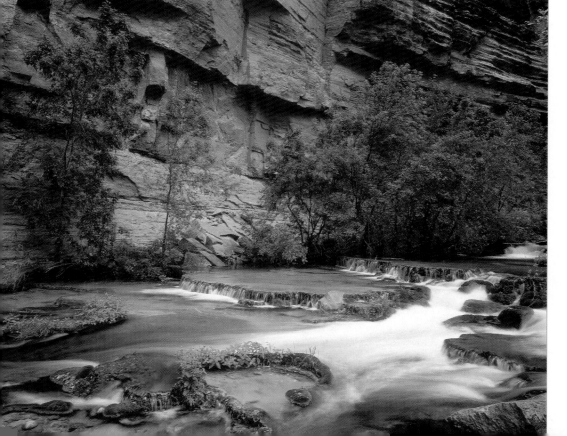

Before rejoining Highway 89 and heading into Flagstaff, drivers can continue through the ash-covered hills surrounding Sunset Crater National Monument. Formed by volcanic activity roughly 800 years ago, this landscape is named after Sunset Crater, a cinder-cone volcano that emerged when molten rock spewed into the air.

Just 35 miles east of Flagstaff on Highway 180, visitors can see a crater that was dug into the earth 50,000 years ago when a 150-foot meteor struck at 40,000 miles an hour. The impact left a gouge three-quarters of a mile across and 60 stories deep.

FOR MORE INFORMATION:
Arizona Office of Tourism, 1100 W. Washington St., Phoenix, AZ 85007; 602-542-8687.

Cardinal monkeyflower and box elder crowd the banks of Havasu Creek, left, where it churns through Grand Canyon National Park.

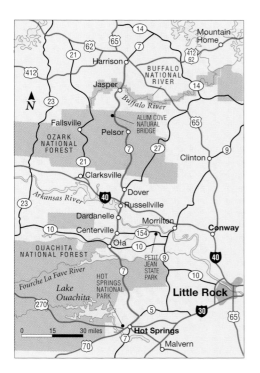

Scenic Byway 7 winds through charming rural countryside, hugs high mountain ridges, and cuts through dense forest, providing an unforgettable introduction to a vast and unspoiled part of Arkansas. The road boasts overlooks and a string of impressive sites, some of which are located just a few miles off the highway.

The Buffalo Ranger Station in Jasper, near the northern part of the route, provides visitors with information on the Ozark National Forest and nearby Buffalo National River, with its high limestone bluffs. The river is a prized fishing spot. During the spring the currents churn with mountain runoff, and white-water enthusiasts take to the river to ride the rapids.

The highway passes through a stretch of meadows, hollows, and coves, and then crosses Highway 16. A detour onto Route 16 for a mile west, then to Forest Road 1206 for another three miles northwest, arrives at the Alum Cove Natural Bridge. This striking 130-foot-long rock span was created over the centuries by the combined erosive forces of wind and water. The area is shaded by beech trees, magnolias, and dogwoods, and a short interpretive trail provides visitors with access to the caves and rock formations along the bluffs. Travelers can also take advantage of the area's various picnic spots.

Continuing south on Route 7, drivers begin the steep climb into the mountains. The road offers outstanding views of the valleys and ridges to the west on the way to the quaint village of Pelsor. After leaving this tiny town, the road intersects with the 165-mile-long Ozark Highlands National Recreation Trail, a scenic wonderland of limpid streams and brooks trickling through a tranquil hardwood forest.

From here the road grows increasingly crooked and steep as it enters the Ozark National Forest. Surrounded by some of the most rugged mountains in the region, the area is forested with stands of oak and hickory. Clearings along the way provide panoramic views of deep valleys and mountains that stretch to the horizon.

Five miles beyond the southern boundary of the national forest is the small village of Dover, where shoppers may enjoy perusing the local handicrafts and antiques that are offered for sale. From here the road descends through fields and forested hills and enters a more populated region dominated by the bustling towns of Russellville and Dardanelle. A historic river port, Dardanelle's north shore remains a busy shipping center where river barges are loaded with grain and soybeans for the voyage up the Arkansas River.

After crossing the river, the byway intersects a series of roads that lead to several state parks. One of the most beautiful of these is Petit Jean State Park, situated 16 miles east of Centerville on Highway 154. The park got its name from a local legend about a young French girl who followed her fiancé, an explorer, to America because she couldn't bear to be far from him. She disguised herself, even from her sweetheart, as a boy and called herself Jean to get a job on the explorer's ship. Petit Jean's true identity was discovered only when she fell ill and died just months after arriving in Arkansas. Highlights of the park include several lookout points and 95-foot-high Cedar Falls.

The byway now weaves through pine woods and gentle farm fields and pastures, providing views of Nimrod Lake and the surrounding hills. Once over the Fourche La Fave River, the road cuts through steep rock walls and forests as it climbs up and down the gentle slopes of the Ouachita Mountains. Wildlife lovers who pitch their tents at the South Fourche Campgrounds will be lulled to sleep at night by the songs of frogs, whippoorwills, and owls.

HISTORIC HOT SPRINGS
Scenic Byway 7 arrives at its southern terminus at Hot Springs National Park. Thousands of years before the first

A brick path known as the Grande Promenade, right, leads visitors behind Bathhouse Row in Hot Springs National Park.

European explorers set foot in the region, the hot springs were considered sacred to Native American tribes. This was neutral ground, where warriors of different tribes could put aside their weapons to bathe in the cleansing waters in peace.

With the purchase of the Louisiana Territory from France in 1803, the Valley of the Vapors, as it was then known, became part of the United States. Interest in the region was sparked by a publicized report of it as a place where steam rose like smoke from pools and drifted along a lush, green valley floor.

Increasing numbers of people came to soak in the waters, many of them convinced, as Native Americans had been before them, that the mineral-rich springs were beneficial to their health. In the 1870's private bathhouses, from the plain to the luxurious, were built under the supervision of the federal government. The popularity of Hot Springs as a vacation spot and destination for water therapies reached a peak in the 1920's, when palatial bathhouses were built along Bathhouse Row. Today one of the establishments there operates as a traditional bathhouse and some others have been restored—giving visitors a chance to sample some of Arkansas' history.

FOR MORE INFORMATION:
Arkansas Division of Parks and Tourism, 1 Capitol Mall, Little Rock, AR 72201; 501-682-7777.

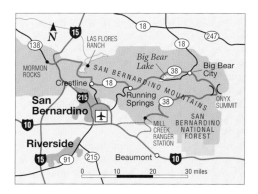

The stark white dome of the Big Bear Solar Observatory rises above Big Bear Lake, California. Operated by the New Jersey Institute of Technology, the observatory was built on this site because it receives a high percentage of sunlight and because the atmospheric conditions here are steady.

The Rim of the World Scenic Byway unveils more than 100 miles of natural and historic treasures as it winds its way through the San Bernardino Mountains. Following many of the routes used by Native Americans and Mormon settlers, and later placer miners and lumberjacks, the road takes visitors through a terrain featuring great geological diversity.

The trek begins at Mormon Rocks Fire Station on Highway 138, where travelers should take the time to hike the short, half-mile trail to Mormon Rocks. The rocks, formed when massive beds of pinkish tan sandstone were thrust upward from the earth, mark the approximate spot where a party of Mormon pioneers passed in 1851 on their way to settle what is now San Bernardino. Joshua trees, piñons, and holly-leafed cherry trees grow amid the rocky outcroppings.

Five miles east of Mormon Rocks, at Cajon Pass Overlook, travelers are given another glimpse of the past. Three historic routes intersect here: the Old Spanish Trail, the Santa Fe–Salt Lake Trail, and John Brown's Toll Road. The transcontinental Santa Fe Railroad's original tracks can still be seen stretching into the distance.

On its journey eastward, the byway dissects Horsethief Canyon. In the 1830's the parched canyon served as the main route for Ute Indians driving stolen Californian horses into New Mexico and Utah. At Summit Valley, the road passes Las Flores Ranch—the oldest operating cattle ranch in the region, which has been raising livestock since 1862.

The byway sweeps southward and begins to climb to higher elevations. Clumps of California junipers across this landscape signal that the desert is being left behind. From the Silverwood Lake Overlook, travelers gaze down upon pristine waters that serve both as a state recreational site and a vital reservoir. The Mojave Indian Trail—used in 1826 by Jedediah Smith, the first American to cross the San Bernardinos—wound past this site.

As the road gets steeper, the air cools and the surrounding vegetation undergoes another transformation. Sparse scrubland quickly gives way to stands of incense cedar, white fir, pine, and black oak trees that seem to swallow up the road. Steller's jays flit in the tree branches overhead, keeping a sharp eye out for tasty picnic morsels left unguarded by travelers.

REMNANTS OF A VOLCANIC PAST

The scenic byway heads east on Highway 18 at the growing mountain community of Crestline. Hugging the side of the sheer mountain flank, the road affords spectacular views of the San Bernardino valley. To the southeast, the San Jacinto Mountains claw at the sky, while to the southwest it is the Santa Ana Mountains that dominate the view. Nearby Baylis Park offers picnic sites that feature the occasional granite outcropping—remnants of the violent upheaval that shaped the region some 60 to 200 million years ago.

Visitors who wish to learn more about the region's plant life should stop at the Heaps Peak Arboretum. By following a self-guided trail, nature lovers can learn about some of the important trees and plant species of the region.

A side trip leads to Keller Peak Lookout, where travelers can climb an observation tower for a view of 53,000 acres of forest and chaparral that were destroyed by a massive fire in 1970—a catastrophe caused by an illegal campfire. Not far from the tower, the National Children's Forest—which was replanted using funds raised in part by children—has started to take root.

Water-sports enthusiasts will enjoy Big Bear Lake, where waterskiing and boating are permitted. After a refreshing interlude, motorists take to the road again, following the lake's graceful shoreline along Highway 38. A side trip to Holcomb Valley leads to the scene of a gold rush that was sparked in 1860 when a prospector named William Holcomb hit pay dirt.

The road begins to climb again until it reaches 8,443-foot Onyx Summit, the highest point on the drive. From the summit travelers gaze into the San Gorgonio Wilderness. In the distance stands 11,500-foot Mount San Gorgonio, the tallest peak in Southern California.

As the scenic byway passes Barton Flats, it comes to Landslide Overlook, which reveals the gouged face of Slide Mountain, created when part of the slope gave way. The final leg of the journey slices past the north branch of the infamous San Andreas Fault and ends at the Mill Creek Ranger Station.

FOR MORE INFORMATION:
California Division of Tourism, Suite 1600, 801 K St., Sacramento, CA 95814; 916-322-2881.

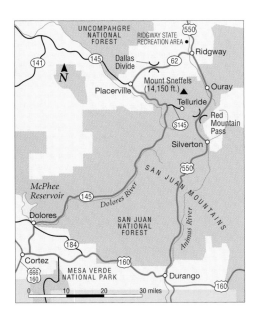

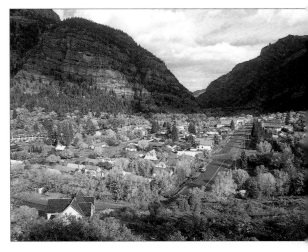

The town of Ouray, above, is nestled in a valley of the San Juan Mountains. Ouray's historical district includes the 1886 Beaumont Hotel, where Theodore Roosevelt once stayed.

C harting a bold route through jagged mountains, the San Juan Skyway clings to the ridges of peaks that rise more than 11,000 feet. Red gravel streams trickle into sharp gorges, and overhead, the misty skies are streaked with rainbows. Starting from Ridgway, this 236-mile loop excursion weaves through high desert and red-rock canyons, and past old mining villages and regions once inhabited by the Anasazi, or "the Ancient Ones," and now known as the Ancestral Pueblo.

The southbound journey begins along Highway 550, below the snowcapped crests of the San Juan Mountains. Skirting the base of 14,150-foot Mount Sneffels, the road follows the Uncompahgre River to Ouray, a village nestled in a ring of peaks rising 5,000 feet from the valley floor. Established in 1875, the picturesque town features Victorian buildings such as Saint Joseph's Hospital, an 1887 structure that contains exhibits on the area's mining and railroading history.

Outside of Ouray, Highway 550, here known as the Million Dollar Highway, negotiates the seemingly impossible 11,000-foot Red Mountain Pass. The drive, which is named for its surface of gold-bearing gravels, shadows the switchbacks and hairpin turns of an old mining road that was built to transport rich ore from the Ouray-Silverton area in the late 19th century.

Silverton allegedly got its name when a miner remarked, "We may not have gold, but we have silver by the ton." Established in 1871, the mining town's historic district includes notorious saloons, brothels, and more than 50 Victorian buildings. The restored 1882 Rio Grande Depot serves as the ticket office of the Durango & Silverton Narrow Gauge Railroad, a coal-burning train that travels through gorges on its 45-mile run in the San Juan National Forest.

The southern terminus of the railroad is Durango, a railroad town founded in 1880. The downtown area is lined with elegant stone and brick Victorian buildings, and is dominated by the four-story, red-and-white brick Strater Hotel, built in 1887.

FROM ANCIENT TO MODERN

From Durango, Highway 160 leads to Mesa Verde National Park, a World Heritage Site that preserves the architecture of the Ancestral Pueblo. The structures range from sunken pit houses and aboveground pueblos, to cliff dwellings. The Ancestral Pueblo settled the piñon-covered plateau some 1,400 years ago; in the late 13th century they mysteriously abandoned the area.

Trails through the 53,000-acre park lead visitors to remarkable archeological sites, such as the ruins of Balcony House, a 45-room cliff dwelling; Far View Ruin, a mesa-top community surrounded by 16 satellite villages; and the four-story Cliff Palace, whose 217 rooms are painted with intricate designs.

Heading north on Highway 145, visitors arrive in the resort village of Telluride, where Victorian homes and condominium complexes line the floor of a box canyon. The alpine region features world-class ski slopes, including a vertical drop of 3,165 feet—one of the longest in the state.

From Telluride, the skyway picks up Highway 62 at Placerville to complete the loop back to Ridgway. In the summer the emerald meadows are dappled with blue columbine, crimson paintbrush, and cow parsnip. Rising 3,000 feet above the road, sharp ridges seem to reach for the sky.

The tour ends in Ridgway, a quiet railroad and ranching town established in 1891. Travelers can cap the journey with a trip to Ridgway State Recreation Area, where a 1,000-acre reservoir on the Uncompahgre River beckons swimmers and boaters to savor its beauty.

FOR MORE INFORMATION:

Colorado Tourism Board, Suite 1700, 1675 Broadway Ave., Denver, CO 80202; 303-592-5510.

An old mill, left, is one of the few remaining structures in the ghost town of Sneffels, situated within the Uncompahgre National Forest.

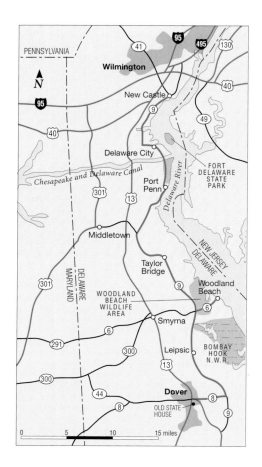

Setting off from historic New Castle, this drive through the marshlands of Delaware follows the sinuous curves of the Delaware River, then veers inland and heads toward the state capital of Dover. The route takes in wayside villages steeped in Colonial history, and, to the delight of bird-watchers, broad fields speckled with migratory waterfowl.

The tour begins with a stroll through the cobblestone streets of New Castle, which was established as a Dutch fort in 1651. After falling into British hands in 1664, the town served as Delaware's Colonial capital until 1777. Once a stagecoach stop, the port town thrived as a rail center until the mid-19th century. New Castle contains many fine examples of Colonial and Federal architecture, including the 1732 Old Court House, one of nation's oldest public buildings. A large courtroom has been restored to its 18th-century appearance.

Just south of town, Route 9 crosses a high bridge over the Chesapeake and Delaware Canal, which runs in an east-west direction across the state and into Maryland. The bridge offers motorists a sweeping view of the Delaware River, the New Jersey shoreline to the east, and the narrow ribbon of canal and marshlands to the west.

CIVIL WAR PRISON

Farther south, Delaware City serves as the departure point for ferries to Pea Patch Island, a swatch of marshlands and mudflats on the Delaware River. The island's Fort Delaware State Park features a granite-and-brick fortress built in 1859 that was used to house rebel prisoners during the Civil War. Visitors can tour the fort and climb observation towers for a view of a huge bird sanctuary a quarter mile away at the northern end of the island. Here nine species of wading birds, including herons, egrets, and ibises, build large nests in the treetops and marsh grass.

At Port Penn, visitors have the chance to learn more about the terrain they've been driving through. Trails into the marshlands begin at the Port Penn Interpretative Center, where exhibits describe the ecological significance of wetland environments.

Beyond Port Penn the waysides are quilted with fields of corn and soybeans, alternating with marshy refuges such as those at the Augustine and Cedar Swamp wildlife areas. The drive veers east onto Highway 6 and leads to the Woodland Beach Wildlife Area, a 4,794-acre sanctuary for migratory waterfowl. Feather grass and salt hay in the tidal marshes are prime feeding grounds for great blue herons and snowy egrets.

Farther south off Highway 9, at Bombay Hook National Wildlife Refuge, birds once again rule the roost. This 15,122-acre refuge is a stopover on the Atlantic Flyway, and a veritable blizzard of some 75,000 snow geese descends on the area each fall.

In early October roughly 30,000 Canada geese honk noisily amid the tall grasses, accompanied by the chirps and warbles of ducks, stilts, and other wading birds, songbirds, and sandpipers. Roads and boardwalks here are equipped with platforms for observing the sanctuary's 314 bird species.

Back on the byway, travelers drive past pastures and farmlands before the road arrives at the junction with Highway 8, the last leg of the journey to Dover.

Established in 1717, Dover retains its Colonial flavor. Restored buildings include the 1792 Old State House, a gambrel-roofed Georgian structure that contains period furnishings and antique photographs. The Hall of Records displays original documents, such as the colony's 1682 charter. The three buildings of the Delaware State Museum house exhibits to commemorate historic events, including the 1787 ceremony in which Delaware became the first state to ratify the U.S. Constitution.

FOR MORE INFORMATION:

Delaware Tourism Office, 99 Kings Highway, P.O. Box 1401, Dover, DE 19903; 302-739-4271.

Light and shadow play on the exterior of the Rising Sun Tavern, below, in New Castle.

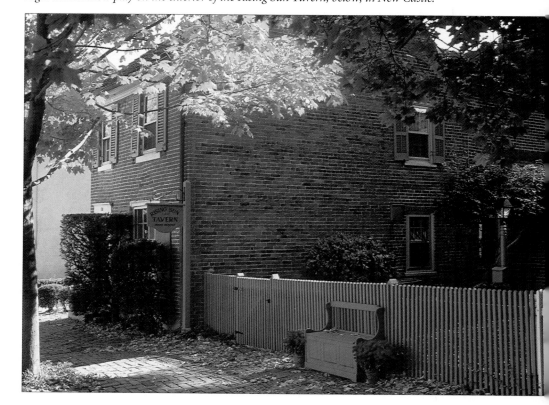

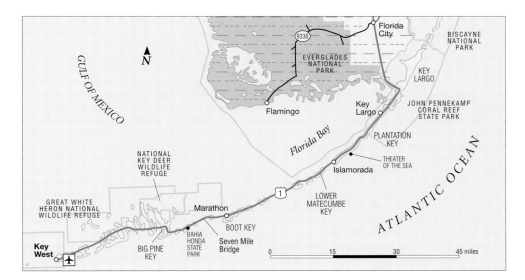

botanists opportunities for close-up views of spider lily and satinwood plants.

As the road reaches Big Pine Key, signs urge motorists to Drive Deer-fensively. The signs refer to a herd of endangered Florida Key deer, which stand less than three feet high. Encompassing 7,900 acres of shoreline and slash pine forest, the National Key Deer Wildlife Refuge preserves the last stronghold of this diminutive species.

The refuge also administers the adjacent 7,407-acre Great White Heron National Wildlife Refuge, which harbors egrets along with mangrove cuckoos, roseate spoonbills, black-whiskered vireos, frigate birds, and endangered Shaus' swallowtail butterflies.

The marine highway reaches its southern terminus in Key West. Spiked with a dash of Caribbean flavor, the semitropical isle is a writers' enclave, celebrity retreat, and vacationers' haven. The Key West Historic District boasts 3,100 buildings within its 190 blocks. Palm-lined streets feature gingerbread Victorian mansions, Spanish Colonial–style buildings, and white-frame conch houses. The conch houses are constructed with dovetail joints and trimmed with wrought-iron railings, carved figureheads, and thick louvered shutters.

Ernest Hemingway's muse seemed to have favored Key West. He penned *For Whom the Bell Tolls* and *A Farewell to Arms* while residing in an 1851 Spanish Colonial building, known as Hemingway House. The home contains the furnishings of the author and his wife, Pauline.

FOR MORE INFORMATION:
Florida Keys Visitor Center, 106000 Overseas Hwy., Key Largo FL 33037; 305-451-1414 or 800-822-1088.

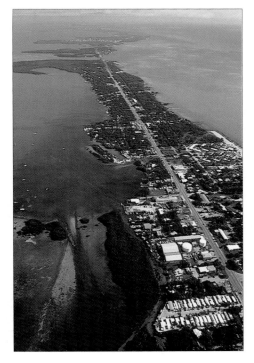

World-renowned as a deep-sea fishing center, Islamorada, left, is a popular destination for travelers along the Overseas Highway.

Offshore, John Pennekamp Coral Reef State Park preserves a section of the only living coral reef to be found in the continental U.S. The reef can be explored by snorkeling, diving, or glass-bottom boat. Mollusks, sponges, 500 species of fish, and 55 varieties of coral thrive in the delicate and unique ecosystem.

Crossing Plantation Key, the highway arrives at 1 of 42 bridges that weld the keys together. The road passes former pineapple and banana plantations on its way to the Theater of the Sea in Windley Key, where dolphins, sharks, and sea lions swim in spacious aquariums.

INTO THE GULF OF MEXICO
Boat tours off Lower Matecumbe Key go to the Lignumvitae Key State Botanical Site, where gumbo-limbo, pigeon plum, and poisonwood trees grow in a rare virgin tropical hardwood forest. Indian Key, another satellite isle, preserves the ruins of an 1830's wrecking village established to salvage sunken vessels. The foundations of buildings and a cistern are still visible amid the tropical foliage.

Past the middle isles, the causeway leapfrogs over the Conch, Grassy, and Marathon keys, then soars along the majestic Seven Mile Bridge, a marvel of engineering. The bridge provides stunning views of the jade and aquamarine waters of the Atlantic Ocean and the Gulf of Mexico.

Easing into Bahia Honda State Park, travelers can take advantage of the area's white sandy beaches; there are also camping facilities. Silver Palm Trail gives amateur

Reaching into the Gulf of Mexico, the Overseas Highway links a chain of small keys located off the tip of Florida. Motorists glide over graceful arches of concrete and steel along the 126-mile drive, which overlaps the former route of the Florida East Coast Railway. Surrounded by sparkling waters, the keys offer visitors pristine beaches, coral reefs, wildlife refuges, and Key West, the southernmost city in the continental U.S.

Mangrove swamps give way to azure seascapes as Highway 1 cuts through the southern Everglades to Key Largo. Thirty miles long, Key Largo is a lively tourist spot that offers everything from dive shops to boat rental outlets and restaurants.

The African Queen, *below, the very boat used in the film starring Humphrey Bogart and Katharine Hepburn, is berthed in Key Largo.*

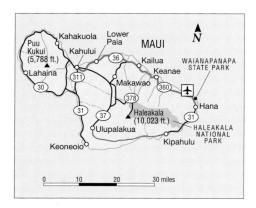

The road to Hana is an obstacle course of 56 one-lane bridges and 600 spine-tingling bends. But the drive is redeemed by the exotic beauty of Maui. Inching along at speeds under 10 miles an hour, travelers can revel in the scenery and aromas of the island's lush valleys, tropical flower groves, silvery waterfalls, and misty azure seascapes.

The journey on Highway 36 departs from Kahului and travels past sugarcane fields and wave-lapped shores, giving no hint of the grueling road conditions ahead. The road enters the town of Lower Paia, the last place to stock up on gas and picnic items before Hana. The nearby Mantokuji Buddhist Temple pays homage to the sun by striking its gong 18 times at sunrise and sunset. Just past the town, high grassy dunes mark the beginning of Hookipa Beach Park, a showcase for the daring aquabatics of windsurfers.

The Hana Highway officially begins about seven miles down the road. Carved out with pick and shovel in 1927, the narrow road leaves Kailua and zigzags through an emerald jungle, winding past pineapple fields, guava trees, and mountain apples.

Farther along, the roadway is lined with groves of bamboo, paperbark trees, rainbow and robusta eucalyptus, and the odd rubber tree. Twisting beside a string of creeks and waterfalls, the road eventually reaches Kaumahina State Wayside Park, where the ocean and the black sand of Honomanu Bay beckon from the fern-laced cliffs. The waysides blaze with the fiery orange blossoms of African tulip trees as the road makes its way along the cliffs.

In the Honomanu Valley travelers can learn about tropical vegetation at Keanae Arboretum, where trails lead to growths of native and exotic plants such as taro, ti,

The town of Hana, right, seen from the pier of the Hana Beach Country Park, is the picture of peace and prosperity.

breadfruit, bamboo, ginger, papaya, and native rain forest vegetation.

Keanae Peninsula—a jagged appendage of black lava that grew out of a lava flow from Haleakala—juts into the water far below the road. The dormant volcano looms above eastern Maui. A roadside lookout allows motorists to gaze down upon the tidy taro patches that surround the rustic hamlet of Keanae. Here native Hawaiians pound poi and tend their fields using traditional methods. Shimmery cascades spill from the slopes as the road climbs into the foothills of Haleakala. At Puaa Kaa State Park, travelers can wade in pools fed by small waterfalls.

TEMPLE OF VOLCANIC ROCK

Along the descent to the Hana Coast, the tang of roadside ginger spices the air. A muddy side road along the lava coastline passes Phiilanihale Heiau, the largest temple of its type in Hawaii. Built by a 15th-century Maui chief, the lava structure rises 50 feet and covers more than an acre.

The road to Waianapanapa State Park is lined with breadfruit trees that yield head-sized fruit. A hiking trail weaves through the foliage of a hala grove, takes visitors into a lava tube, and ends at a black sand beach fronted by clear green waters. Waves of tiny red shrimp periodically rush into the lava tunnels and turn the water scarlet, a phenomenon that may have inspired the Hawaiian legend that says the waters were stained with the blood of a slain princess.

The Hana Highway ends in the resort town of Hana, but motorists may wish to continue to follow the road to Oheo Gulch, where a series of glassy pools collect along Palikea Stream as it slithers down the flank of Haleakala, providing a welcome respite from the heat of the sun.

Leaving the gulch, intrepid motorists may navigate the bumpy road to Kipahulu to visit the grave site of Charles A. Lindbergh. Having lived here for many years the aviator chose this sublime headland as his final resting place. The Lone Eagle sponsored the restoration of the Palapala Hoomau Church that now watches over his grave.

FOR MORE INFORMATION:
Maui Visitors Bureau, 1721 Wili Pa Loop, Wailuku, HI 96793; 808-244-3530.

Deep red lobster-claw heliconias, below, brighten the roadside on the way to Hana.

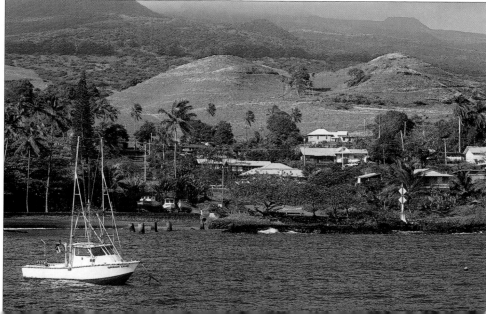

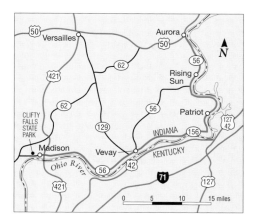

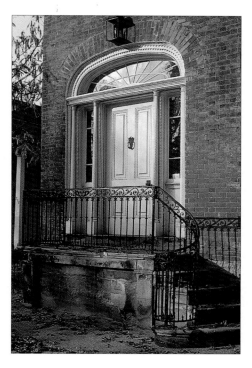

By any standard, the Ohio is one of the world's great rivers. Draining most of the eastern United States, its broad curves sweep through a dramatically hilly landscape that rivals the Rhine River valley in scenic beauty.

But the Ohio is more than just visually stunning; its powerful waters run deeply through the course of American history. The river served as the main route for the early pioneers heading west.

The Northwest Ordinance of 1787, an act granted to prepare the region for statehood status, not only opened the Midwest to settlement, but also excluded slavery from the new territories north of the Ohio. The river became the guiding passageway for countless African-Americans seeking freedom from slavery. Many early 19th-century structures along the river route have connections to the Underground Railroad.

The Ohio River also played an important role in the Civil War as a firm boundary between the North and South, and as an important artery for the movement of Union troops and supplies in Gen. Ulysses S. Grant's Western campaigns.

Steamboat traffic brought great prosperity to the Ohio Valley. The river is still a hardworking waterway, carrying more freight than the Panama Canal. But the very hills that provide the valley's visual drama were formidable obstacles to large-scale agriculture and to the construction of the emerging railway network.

By the late 19th century, towns that had sprung up along the river were no longer growing, and the focus of development moved to the flatter lands in the north. As a result of this shift, the route along the Indiana–Kentucky border boasts an extensive stretch of relatively intact pre–Civil War townscapes—a virtual museum of a vanished way of life. The drive roves wild and cultivated landscapes and provides views of the historic architecture that has survived along the river.

The route begins in Aurora, whose downtown area is a National Historic Register district. The town's pride is the Hillforest Mansion, built in the 1850's by riverboat magnate Thomas Gaff. The house borrowed some of its design features from Gaff's riverboat fleet—including its rounded front porticoes and suspended interior staircase—making it an unusual example of the Steamboat Gothic architectural style. From the mansion's observatory, visitors can look down upon the Ohio River.

As the road leaves Aurora, it crosses Laughery Creek and winds through fields of corn, soybeans, and tobacco to the town of Rising Sun—so named, according to local legend, for the blazing sunrises that pour down on it from the Kentucky hills across the river. Visitors can take a trolley tour of this picturesque town that includes a stop at the courthouse. Built in 1846, it is the oldest courthouse in continuous use in Indiana.

Leaving Rising Sun behind, travelers soon enter a changing landscape of farmlands, wooded hillsides, and windswept bluffs. The road provides many glorious overlooks of the big river and its varied boat traffic: pleasure boats cruise beside enormous diesel-powered towboats that pull strings of barges loaded with coal, oil, and sulfur around the river bends.

The *Delta Queen,* a luxurious reconstruction of a 19th-century stern-wheeler, will sometimes come into sight as it plies the waters between its home port, Cincinnati, and New Orleans.

Farther on down the highway is the town of Vevay (pronounced "vee-vee"), where Swiss vintners established the first commercial winery in the United States in 1802. Eventually wine-making gave way to more profitable crops such as wheat and tobacco, but the town's Swiss heritage is still very much in evidence in this region called Switzerland County. The town has more than 300 buildings that date to the 19th century, many of which display distinctly Swiss architectural details.

LEAVING THE RIVER

Continuing westward, the road climbs the lower slopes of Big Cedar Cliffs and offers travelers spectacular riverside views. The Ohio River parts company with the highway just west of Madison and continues its course for hundreds of miles.

Once the largest and most important town in Indiana, Madison was an industrial center and an important hub for riverboat, wagon, and rail traffic. Although it has since faded in importance, Madison's Historic District encompasses 133 city blocks that offer many fine examples of 19th-century architecture. Among the highlights of the district are the Greek Revival Shrewsbury House Museum, with its freestanding spiral staircase that towers three stories in height, and the J.F.D. Lanier State Historic Site, also a Greek Revival edifice, which looks out onto the river and the beautiful green Kentucky hills beyond.

Travelers can end their tour of the Ohio River on a high note just west of town, with a side trip to the river's tributary, Clifty Creek, in Clifty Falls State Park. The creek has cut a canyon in the rocky terrain that is so deep, sunlight penetrates only at noon. At high-water time in the spring, the resounding roar of the creek's waterfalls—which include the 60-foot high Big Clifty Falls—fills the air. Park staff can direct visitors to the remains of an uncompleted railway tunnel, which reveals the engineering challenge faced by those who labored to conquer southern Indiana's rugged terrain.

FOR MORE INFORMATION:
Indiana Department of Commerce, Tourism and Film Development Division, Suite 700, 1 N. Capitol Ave., Indianapolis, IN 46204-2288; 317-232-8860 or 800-469-4612.

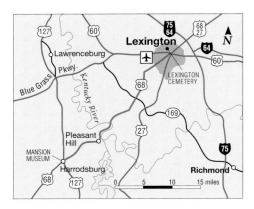

Although it is a little over 27 miles in length, the stretch of Highway 68 that connects Lexington and Harrodsburg in Kentucky is rich with treasures—so many of them, in fact, that it has come to be known as one of the most scenic routes in the state.

The trip begins in Lexington. Founded in 1775, Kentucky's second-largest city has managed to establish itself as a major center of commerce while maintaining the grace and charm more often seen in smaller Southern towns. Here visitors can see several notable homes from the nation's past, including the Mary Todd Lincoln House, the childhood home of Abraham Lincoln's wife, and Ashland, the magnificent estate of famed statesman Henry Clay. Clay's role in negotiating the Missouri Compromise of 1820—which maintained the balance between free and slave states in the union by admitting Missouri and Maine at the same time—contributed to his being nicknamed the Great Compromiser. Clay is buried in the Lexington Cemetery, as are several notable Civil War soldiers, including Confederate brigadier general John Hunt Morgan and Union general Gordon Granger. Also buried here is suffragette Laura Clay, who was the daughter of the abolitionist Cassius Clay and the first woman to be nominated for U.S. president.

Heading south toward Harrodsburg, travelers pass some of the horse farms that have made Kentucky famous. Whitewashed four-board fences divide the gentle swells of land into paddocks and pastures. Long driveways lined with trees lead up to stately houses and sturdy barns. It was on such a farm in nearby Paris that Secretariat, winner of horse racing's Triple Crown, was conceived and where he later retired from racing to sire more than 300 offspring.

It is only evident in early May why this lush, green countryside is called Bluegrass Country. Each spring, if allowed to grow tall enough, the blades of grass reveal their blue hues when the wind blows. The seeds for Kentucky's bluegrass, brought over by English settlers, originally came from Eurasia, but the grass has adapted well to the rolling hills of central Kentucky.

The sweeping splendor of the horse farms gives way gradually to equally impressive, but less manicured, crop farms. As they pass by wide fields of tobacco, travelers will notice large clusters of trees that were absent from the well-groomed landscape of the horse farms. These clusters of blue ash, burr oak, and sycamores—remnants of Kentucky's original savannah woodlands—are now among the sole survivors of an ecosystem under threat from the farmer's plow.

STONE WORKMANSHIP

Thick stone walls run across the undulating terrain along the road here. Made from native limestone, these walls were constructed in the mid-1800's by Irish stonemasons who came to Kentucky as road builders. Many of the walls were erected without the use of mortar. That they haven't toppled after more than 100 years of exposure to the elements is a testament to the skill of their builders.

Near the midway point in this scenic drive, the highway crosses the Kentucky River, whose olive green waterway flows through an ancient gorge. More than 100

million years ago, the river carved this jagged chasm out of limestone.

The road twists upward and then parallels the sinuous course of the tree-lined river. In the spring delicate baby's breath and pink stonecrop blossom on the rock outcrops, and wild blue phlox and saxifrage sprout from the sides of the deep ravines.

In Pleasant Hill, a restored Shaker village, motorists can pause and take a look at 33 carefully preserved, authentic 19th-century buildings. The village provides glimpses into the daily lives of these devout church members. The village, which was established in 1805 by three converts, displays artifacts and furniture highlighting the simple charms of Shaker design. Of particular interest are the elegant twin spiral staircase inside the 1839 Trustees House and the Centre Family Dwelling, whose 40 rooms are stocked with more than 1,600 artifacts. The site offers demonstrations of broom making, weaving, spinning, and coopering techniques employed by the Shakers.

The final stop along this wonderful stretch of blacktop is Harrodsburg. Established in 1774 by a young adventurer from Pennsylvania named James Harrod, the town is the oldest permanent settlement in the state. Harrodsburg's history is commemorated at the 28-acre Old Fort Harrod State Park, which is based on the original design. Old Fort Harrod features two-story blockhouses in three of its corners. The fourth corner is built around a freshwater spring that flows within the stockade walls.

Travelers can stroll through the shaded grounds of the Pioneer Cemetery and view the graves of 500 settlers. The Lincoln Marriage Temple, also located within the park grounds, is a brick building enshrining the simple log cabin in which Thomas Lincoln and Nancy Hanks—the parents of Abraham Lincoln—were wed on June 12, 1806. President Lincoln himself is memorialized at the Mansion Museum, located in Harrodsburg. Included among the museum's artifacts are a life-sized painting of Kentucky's favorite son and plaster molds of his face and hand.

FOR MORE INFORMATION:
Kentucky Department of Travel, Suite 22, 500 Mero St., Frankfort, KY 40601; 502-564-4930.

A powerful young horse, left, frolics in a farm pasture near Lexington—a common sight throughout the region known as Horse Country.

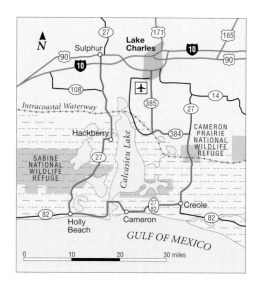

Shells and seaweed, above, are washed ashore on a stretch of the Gulf Coast beach.

The Creole Nature Trail in southwestern Louisiana takes travelers on a 105-mile loop that begins in the city of Sulphur and ends at Lake Charles, five miles east of Sulphur on I-10. En route, the trail crosses tidal marshes, rolls past oil fields and shipping channels, and travels through rich grasslands. The trail circles much of 19-mile-long Calcasieu Lake and brings travelers within throwing distance of the Gulf of Mexico.

The first leg of the Creole Nature Trail, on Highway 27, departs from Sulphur, which was named for the mineral deposits found in a nearby salt dome. The highway heads south, crosses the Intracoastal Waterway, and enters the 120,000-acre marsh of the Sabine National Wildlife Refuge. This basin of wetlands, which includes both fresh- and saltwater, provides a sanctuary for waterfowl, shorebirds, and alligators, as well as fish.

It takes about two hours to walk the mile-and-a-half-long refuge trail through the ever-changing marsh environment. Tall stands of roseau cane and the ubiquitous salt-meadow cordgrass partially conceal the activities of the refuge's 250 species of birds, which include egrets, common moorhens, mottled ducks, and blue-winged teals. Also protected within the refuge are marsh rabbits, raccoons, coyotes, muskrats, and muskratlike nutrias. Visitors to the refuge may well come away with soothing memories of pink-plumed roseate spoonbills winging across the sky to their nightly resting places, or the spine-tingling sight of an alligator—any 1 of 40,000 that dwell here—slipping silently into the brackish water.

BEACHFRONT CAMPGROUNDS

Approximately seven miles past the refuge is Holly Beach, on the Gulf of Mexico. The beach, called the Cajun Riviera, lives up to its name. By day, visitors take to the water to swim, fish, go crabbing, collect shells, and bird-watch, whereas at night they can stay at one of the 525 campsites along the Gulf Coast beach.

From Holly Beach the trail swings north along a highway lined with oaks, cedars, and tallows that have been bowed by winds from the Gulf. Where the road crosses the Intracoastal Waterway a second time, travelers can pull off at the Cameron Prairie National Wildlife Refuge. The marshes and prairies of the refuge host a resident population of songbirds, bobwhite quail, and mourning doves. Wigeon, mallard, and shoveler populations can reach 60,000 in fall and winter. In late fall, tens of thousands of geese fly into the area, including as many as 20,000 snow geese who stop at

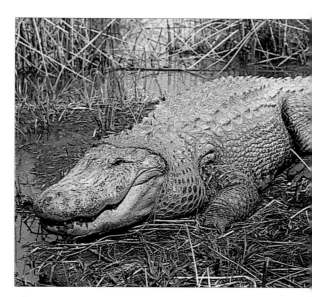

About 40,000 alligators lurk in the Sabine National Wildlife Refuge. The 14-foot animal above is a prime example.

the refuge on their migration south. Dainty white-tailed deer forage in upland fields, nutrias and otters swim in the water, and coyotes are occasionally seen prowling along the edges of the fields. Endangered peregrine falcons have been spotted searching the southern sky for prey. In the spring the refuge's shrubby areas come alive with warblers and other songbirds, while wading birds, such as snowy egrets and great blue and tricolored herons, preen themselves at the water's edge. A bird checklist is available at the visitor center.

From the Cameron refuge, Highway 384 travels westward through five miles of rice fields. Motorists turn north at the turnoff for Highway 385 and continue to the end of the trail, in the waterside community of Lake Charles, which was settled by the French in the mid-18th century.

Until the early part of this century, no architects lived in Lake Charles; therefore, the unique sensibility of each carpenter in this period is reflected in his work. These creative and bold builders combined an imaginative variety of architectural elements taken from pattern books. A walking tour of the Charpentier District reveals the city's fascinating collection of Victorian and early 20th-century buildings, of which the Walter Goos House is a prime example.

FOR MORE INFORMATION:
Louisiana Office of Tourism, P.O. Box 94291, Baton Rouge, LA 70804-9291; 504-342-8100.

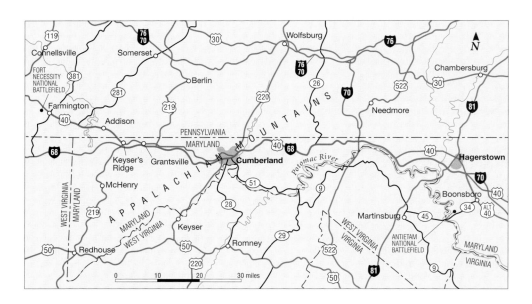

As America's first federally funded highway, the National Road paved the way for settlement of the fertile lands west of the Appalachian Mountains. Construction of the highway started in Cumberland, Maryland, in 1811 and eventually extended to Vandalia, Illinois. Motorists can retrace this part of the fledgling nation's lifeline along Highways 40 and 40A. Waysides are dotted with old villages, historic inns, and battlefields dating from pre-Independence to the Civil War period.

The tour begins in Boonsboro, once a major stopover for westbound pioneers. In 1827 residents of Boonsboro erected the country's first monument to George Washington. Located just outside town, the restored 34-foot tower is the centerpiece of Washington Monument State Park.

A side trip along Highway 34 leads to Antietam National Battlefield, scene of the bloodiest single-day battle of the Civil War. On September 17, 1862, some 87,000 Union troops led by Gen. George B. McClellan clashed with 41,000 Confederate soldiers under Gen. Robert E. Lee. By day's end more than 23,000 soldiers lay dead or wounded. Visitors can tour the battlefield's strategic points, including a road called Bloody Lane, where 5,000 soldiers fell.

Farther along the highway lies the city of Hagerstown, which was a wilderness when Jonathan Hager settled the area in 1739. Hager House is positioned over two springs and has 22-inch-thick stone walls. It displays period furnishings and artifacts.

WARTIME MEMENTOES

The road connects with Highway 68 en route to Cumberland, a town named for Fort Cumberland, the 1755 headquarters of Gen. Edward Braddock and Lt. George Washington during their campaigns against the French in the Revolutionary War. Washington's cabin, the only remaining structure of Fort Cumberland, was moved to Riverside Park in 1921 and restored.

Just west of town, a small, octagonal, brick building is one of the last surviving tollhouses along the historic route. Other relics of the Old National Highway include the stone arch of Clarysville Bridge and the Clarysville Inn, built in 1807 as a stopover for weary wayfarers. Near Grantsville, visitors may pass horse-drawn buggies driven by Mennonites who live in the area.

The drive enters the rolling Pennsylvania countryside, where Fort Necessity National Battlefield commemorates the skirmish that triggered the French and Indian War. After the French refused to leave the Ohio Valley early in 1754, George Washington and a group of soldiers were sent in to force them out. The Colonials routed a small French reconnaissance party at Jumonville Glen. The French quickly retaliated by sending 700 men to attack Fort Necessity, compelling the 22-year-old Washington to sign a surrender document stating that he had assassinated a French lieutenant, Sieur de Jumonville. The document outraged the leaders of the world and fueled tensions between the French and the English.

The 900-acre battlefield preserves reconstructed Fort Necessity and Jumonville Glen, as well as the Mount Washington Tavern, a stagecoach stop along the Old National Highway. Built in the late 1820's, the brick tavern displays period furnishings and a Conestoga wagon, a primary mode of transportation during that period.

FOR MORE INFORMATION:
Maryland Office of Tourism Development, 9th Floor, 217 E. Redwood St., Baltimore, MD 21202; 410-767-3400 or 800-634-7386. Pennsylvania Travel Council, 902 N. Second St., Harrisburg, PA 17102; 717-232-8880.

Wilson Bridge, below, was built across Conococheague Creek in 1819 as a step in extending the Old National Highway west from Hagerstown to the Ohio River backcountry.

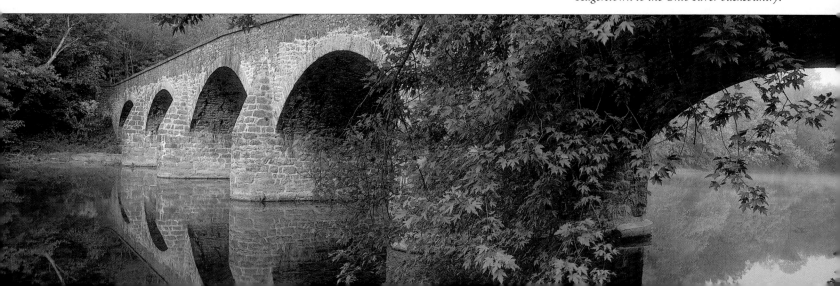

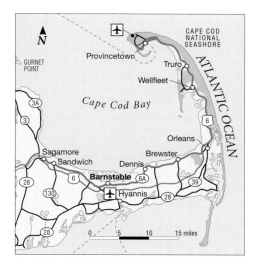

Typical of the area, a weathered cedar-shingled house on Cape Cod, above, is hemmed in by luxuriant growths of crimson and pink rosebushes.

America's oldest road follows the curl of the Cape Cod peninsula from Sagamore to Provincetown. Made up of portions of Highways 6A and 6, which parallel each other along the Upper Cape, the route was the Cape's mainstay in the first days of European settlement, and Highway 6 continues to serve as the region's main artery. The route of the Old King's Highway meanders through historic villages and then through the heart of the Cape Cod National Seashore.

After Sagamore, the first town Highway 6A meets is Sandwich, the oldest settlement on the Cape, founded in 1637. The town became famous in the 19th century for the manufacture of colorful handblown glass, some examples of which are on display at the Sandwich Glass Museum. The town's historic district is a showcase for early American architecture, with 47 structures ranging from clapboard churches and Cape Cod cottages to Georgian-style houses and Greek Revival buildings. Hoxie House, a restored 1637 saltbox built of rough-hewn timbers, is the oldest house on the Cape.

Farther along the road lies Barnstable, which was settled by early farmers who grazed their livestock in the salt hay marshes. Villagers in the late 1600's learned to capitalize on the stranded whales that washed up on the barrier beach of Sandy Neck by cutting them up and boiling the blubber in try-pots set up on shore.

In the summer crimson-hued berries brighten the roadside on the drive between Barnstable and Brewster. Pioneers near Dennis developed the first method for cultivating cranberries in bogs in the early 1800's. Dennis residents also initiated commercial salt extraction from seawater, a vital Cape industry in the late 18th century. Six miles east of Dennis stands the resort town of Brewster, once the home of wealthy sea captains. Their names are inscribed in the pews of the 1834 First Parish Church, a white clapboard structure known as the Church of the Sea Captains.

CAPE COD NATIONAL SEASHORE

Routes 6A and 6 meet the Mid-Cape Highway two miles past Nickerson State Park, a 2,000-acre campground of pine forest and kettle-hole ponds. Beyond Orleans, Highway 6 cuts through the middle of the Cape, flanked on the right by the Cape Cod National Seashore, which extends along the Outer Cape's narrow forearm and into its fist. The 43,500-acre oceanside domain offers variations on a

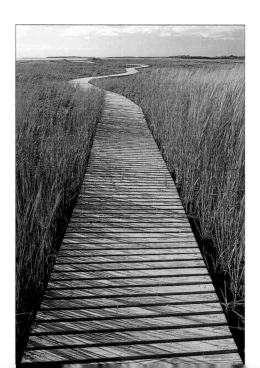

coastal theme of whitecapped breakers, beaches with high dunes, glacial cliffs, cedar swamps, and salt marshes.

Wellfleet, situated on the bay side of Highway 6, has the only clock in the world that strikes ship's time once every half-hour; the clock is housed in the First Congregational Church. Acclaim came to the seaport in 1985 when salvagers raised a bronze bell, 5,000 coins, and a cannon from the *Whydah*, a pirate ship that sank off its shore in 1716. Shipwrecks were common in these waters until 1797, when the Cape Cod Light in Truro was built, followed by a string of beacons along the coast. The existing tower, rebuilt in 1857, was moved 450 feet back from the eroding cliff in 1996.

The journey ends in Provincetown, whose heather-blanketed moors have changed little since the Mayflower Pilgrims landed here in 1620. The 253-foot-tall Pilgrim Monument houses a museum that displays a diorama of the *Mayflower,* ship models, whaling equipment, and scrimshaw.

FOR MORE INFORMATION:
Massachusetts Office of Travel and Tourism, 13th Floor, 100 Cambridge St., Boston, MA 02202; 617-727-3201.

A boardwalk plunges into the tall grasses of the Wellfleet Audubon Sanctuary, left. The sanctuary's marshy terrain attracts thousands of waterfowl annually.

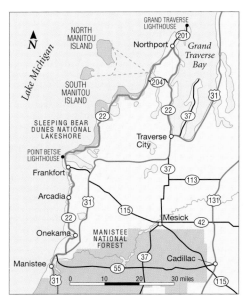

While motoring along Lake Michigan's northeastern shoreline, travelers rarely lose sight of the vast, shimmering lake. The 62-mile drive from Manistee to Traverse City follows the contours of the lake along Highway 22. It winds through a coastal region of apple and cherry orchards, small ports and villages, and historic lighthouses.

Manistee was once a prosperous 19th-century lumber and salt-producing town that locals say boasted more millionaires per capita than any other city in the United States. Razed by fire in 1871, Manistee was rebuilt soon after using brick. The town's surviving structures include opulent mansions, painted to highlight their Victorian architectural features, and the 1869 Our Savior's Evangelical Lutheran Church, which served the local Danish immigrants.

Highway 22 heads north through the coastal hamlets of Onekama and Arcadia to Frankfort, which has a marina that harbors more than 300 slips. Sweeping past the 1858 Point Betsie Lighthouse, the drive enters the Sleeping Bear Dunes National Lakeshore. The area takes its name from a Chippewa legend about a mother bear and her two cubs who were drowned when they tried to swim across the lake to escape a forest fire. A massive mound of dark sand at the highest point of the dunes along the lakeshore represents the mother waiting for her cubs, who became the two islands offshore. The Pierce Stocking Scenic Drive, an eight-mile route, allows visitors to sample a portion of the 71,000 acres in Sleeping Bear Dunes National Lakeshore. The road winds past 400-foot-high dunes, clear lakes, and a beech-maple forest. Scattered throughout the national lakeshore park are the ruins of sawmills and docks, where the wood-burning ships that sailed the Great Lakes in the mid- to late 1800's once docked to take on fuel.

TURBULENT WATERS

A lifesaving facility was established at Sleeping Bear Point in 1901 in response to Lake Michigan's sometimes fierce storms. The facility was moved to Glen Haven in 1930 when migrating sand dunes threatened to bury it. Today it houses the U.S. Coast Guard Station Museum and offers visitors exhibits on the history of Great Lake shipping and salvage techniques.

Farther along the lakeshore lies the town of Leland, departure point for ferries to South and North Manitou islands. Continuing north to the tip of the Leelanau peninsula, travelers reach Northport, which once boasted the world's largest cherry orchard. From there, a short side trip leads to the 1864 Grand Traverse Lighthouse.

From Northport, the highway veers south, weaving through vineyards and more orchards en route to Traverse City. Large Victorian buildings, such as the 1891 red brick City Opera House, speak of the city's glory days as a prosperous lumber town. The harbor in the resort town is the home port of the tall ship *Malabar*. Visitors can climb aboard the two-masted schooner at sunset and cruise across the glistening waters of Lake Michigan.

FOR MORE INFORMATION:

Michigan Travel Bureau, Dept. of Commerce, P.O. Box 30226, Lansing, MI 48909; 517-373-0670.

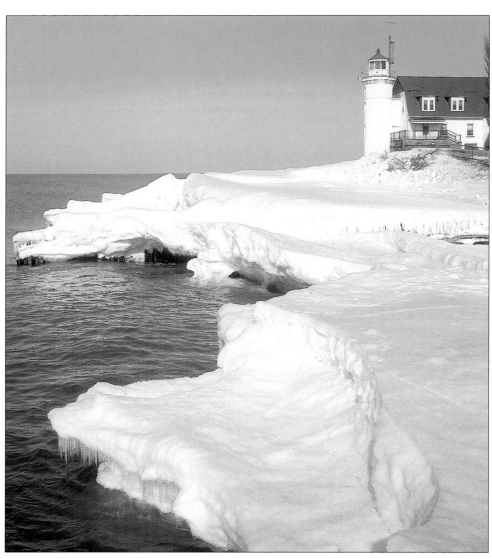

Point Betsie Lighthouse, above, stands on the ice-packed shoreline of Lake Michigan, not far from Sleeping Bear Dunes National Lakeshore.

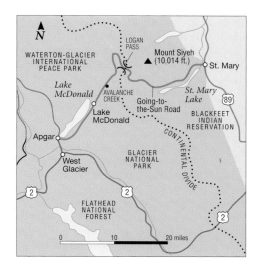

The powerful waters of Avalanche Creek, left, carve their way between moss-covered rocks in Glacier National Park.

In the ice-carved realm of Glacier National Park, horn-shaped mountains reign over wide valleys dotted with turquoise lakes. Venturing through the rocky kingdom, Going-to-the-Sun Road passes dazzling wildflowers and iridescent waterfalls along a 3,000-foot climb to the Continental Divide. Completed in 1932, the east-west route through the enormous natural kingdom of this 1,538-square-mile park traverses an area once crisscrossed by vast rivers of ice. About 10,000 years ago the ice sheet began to melt, revealing deep valleys and sharp ridges.

The 50-mile drive, open during summer and fall, begins at the east end of St. Mary Lake, then follows the azure basin for 10 miles through a glacier-gouged trench. The road is bordered by aspens and lodgepole

Thick growths of wildflowers, below, blanket the deep valleys of Glacier National Park during the spring and summer months.

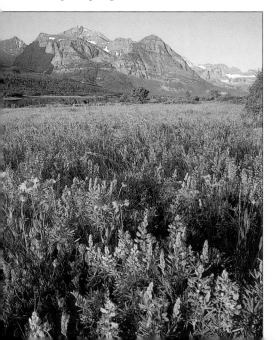

pines and fields ablaze with goldenrod, Indian paintbrush, and silky lupine. At Sun Point, a nature trail leads to an overlook of St. Mary Lake, and a chart that helps visitors identify the nearby peaks.

The road climbs through a thick layer of bloodred mudstone to the head of the lake, where trails branch off toward three spectacular cataracts: St. Mary Falls, Virginia Falls, and Baring Falls.

At Jackson Glacier Turnout, travelers can glimpse one of the park's few active glaciers above the treetops. The ice mass has shrunk to a quarter of its 19th-century size. Black bears prowl the subalpine forest of Engelmann spruce and fir, sharing their habitat with porcupines, weasels, and great horned owls.

The road breaks out of the trees and ascends a broad slope ringed by jagged peaks. A stop at an overlook provides a neck-crimping view of 10,014-foot Mount Siyeh and 9,642-foot Going-to-the-Sun Mountain. According to a Blackfoot legend, Napi, the creator, climbed this mountain up to the sun after having spent time on earth helping the Indians.

The road clings to the side of Piegan Mountain on its way to 6,646-foot Logan Pass, where mountain goats are often seen browsing along the upper slopes. On the descent from the windswept summit, the road hugs the side of the Garden Wall, a razor-edged ridge that knifes along the Continental Divide. The Blackfeet called the part of the divide that is within the park "the backbone of the world," although the entire divide zigzags through the Rocky Mountains from Canada to Mexico. Separating the watersheds of the Pacific and Atlantic oceans, the divide also forms a climatic barrier: tree species east of the Continental Divide are typical of the northern Rockies, whereas the western side harbors Northwest rain forest vegetation.

The road descends along the western slope through an area recovering from a 1967 lightning fire. For the next five miles, silver snags of dead trees litter hillsides dappled with fireweed, mountain maple, young lodgepole pine, and berry bushes. After it takes a sharp left turn, the road parallels McDonald Creek, a ribbon of sapphire that tumbles over a bed of green and vermilion pebbles.

AVALANCHE CREEK
Motorists can stop and stretch their legs on the Trail of Cedars, a half-mile loop path that arcs through a forest of giant western red cedar, hemlock, and black cottonwood trees. The trail also passes the mouth of Avalanche Creek, where glacier-blue waters swirl incessantly through a narrow gorge composed of red mudstone.

The highway continues through a thick forest of cedar, larch, white pine, and birch en route to Lake McDonald Lodge, a timbered 1913 structure with Old West appeal. The lake itself stretches 10 miles and fills a 472-foot-deep basin. Fringed by dense forest, Lake McDonald is barely visible from the road, but nearby trails lead to the wide coves along its shore. The journey ends at the base of Lake McDonald in the village of Apgar, which affords a magnificent view up the lake to the ice-capped ridges formed by the continent's rocky spine.

FOR MORE INFORMATION:
Glacier National Park, West Glacier, MT 59936; 406-888-7800.

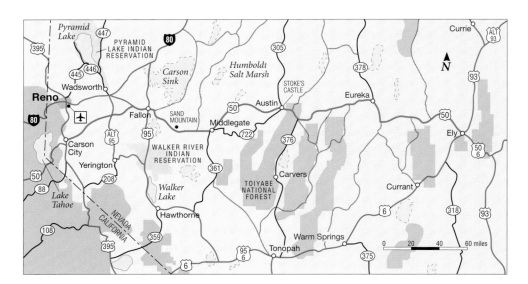

Legend has it that in 1862 a Pony Express horse kicked over a rock in the area, uncapping the mouth of a silver-laden cavern. The town sprang up and within two years its population had topped 10,000 as bullion poured from its 11 ore-reduction mills.

A striking reminder of Austin's glory days is found at Stoke's Castle, built of hand-hewn granite slabs in 1897 for Anson Phelps Stoke, an eastern financier who held considerable mining interests in the region. The castle's three-story tower can be seen for miles around. Visitors to the Lander County Courthouse can examine the second-floor hanging post used to mete out frontier justice.

More history awaits visitors 70 miles down the road in the town of Eureka. One of Nevada's best-preserved mining centers, the town boasts numerous brick buildings that date back to the 1870's. The Eureka Sentinel Museum, housed in the town's original newspaper offices, displays a selection of photographs and reproduced front pages that provide visitors with a dramatic account of the compelling history of this once-vibrant region.

FOR MORE INFORMATION:
Nevada Commission on Tourism, Capitol Complex, Carson City, NV 89710; 702-687-4322 or 800-638-2328.

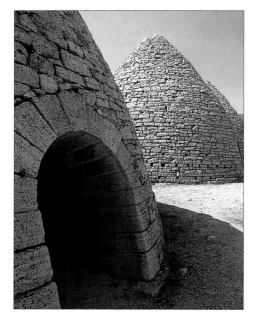

Resembling giant beehives, Ward charcoal ovens in Ely, left, attest to the city's mining past. In marked contrast to these structures is the elegant state capitol building in Carson City, below.

I n 1986 *Life* magazine dubbed Highway 50 the loneliest road in America, a designation Nevada soon adopted and now proudly proclaims on its official highway signs. This length of blacktop across Nevada's vast salt flats, parched basins, and rugged mountain ranges roughly follows the route of the Pony Express. Much of the road passes through a desolate and haunting landscape of muted grays, greens, and browns, but on a 318-mile section between Carson City and Ely the human history of the area comes alive.

Carson City transports visitors back to the 19th century. Founded in 1858, the town was named after Kit Carson, and became the state capital in 1864. The capitol building, complete with silver dome, and later additions, has been restored and is still in use today. In 1869 the U.S. Mint was opened in Carson City and it eventually produced $50 million in gold and silver coins before it closed its doors in 1893. The mint building now houses the Nevada State Museum, where various artifacts, including an authentic Gatling gun—an early machine gun—and gambling wheel, are on display.

HISTORY AT EVERY TURN

As the road head east, it rolls down some of the straightest, flattest road in the nation. Gray-green sagebrush grows close to the roadside, and tumbleweed blows across the range. Fallon is renowned for its award-winning "Heart of Gold" cantaloupes. From here, interesting detours lead to a 600-foot-tall sand dune called Sand Mountain, and to Grimes Point, where one of the state's most extensive collections of Native American petroglyphs is found.

After passing through the historic Pony Express stops at Middlegate and Cold Springs, the road leads straight to Austin.

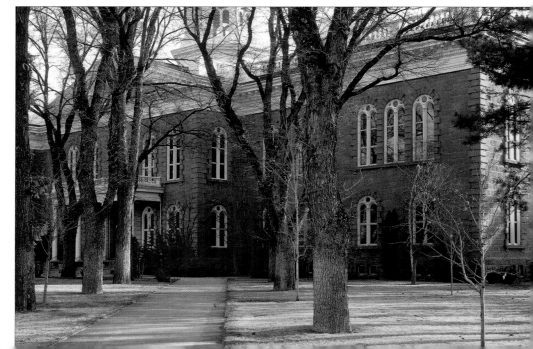

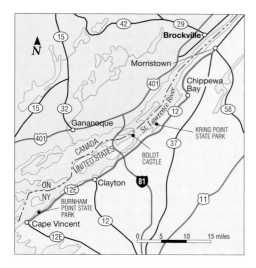

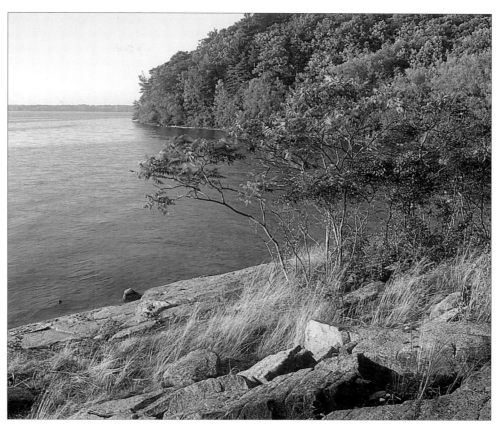

The windswept shore of Wellesley Island State Park, above, is characteristic of the coastlines of the more than 1,700 islands that dot the Thousand Island archipelago.

Stretching from Cape Vincent north to Morristown, this section of the Seaway Trail borders a deep channel dredged from the St. Lawrence River in the 1950's to open up the route to international ships. Vistas along the drive reach far into the Thousand Island archipelago, a constellation of 1,793 isles ranging from a few acres of grass and trees to islands populated by busy villages.

The journey begins in Cape Vincent, where Lake Ontario flows into the St. Lawrence River toward the Atlantic Ocean. Towering above the cerulean waters, the historic Tibbets Point Lighthouse offers spectacular views of the region. A world-renowned sportfishing center, the cape's waters run thick with prize lake trout, chinook and coho salmon, smallmouth bass, muskellunge, and walleye.

Cape Vincent was settled by the French, and its former residents include Napoleon Bonaparte's brother, Joseph, who lived here in the early 1800's to establish a safe haven for his exiled brother. The village's ties to French culture are shown at the Cape Vincent Historical Museum, which once housed soldiers during the War of 1812.

Following Highway 12E from Cape Vincent, the drive meanders through quiet farmlands toward Burnham Point State Park, whose lightly wooded campground borders the river. Strollers ambling along the shore often enjoy the sight of ocean-going freighters and 700-foot lakebound vessels traversing the seaway.

More than a century ago, trade goods were floated downriver to eastern markets on rafts made in lumber centers such as Clayton, roughly 10 miles east of the park. Settled in 1822, the city preserves vestiges of its shipbuilding past in the Antique Boat Museum, which houses an impressive collection of freshwater craft that ranges from Native American dugout and birch-bark canoes to St. Lawrence skiffs and early 20th-century speedboats. The Thousand Islands Craft School and Textile Museum celebrates early American crafts such as decoy carving and hand-weaving with displays of antique looms, textile tools, and wood carvings.

CROSS-BORDER HOPPING

Seven miles past Clayton, motorists can take a jaunt along Thousand Islands International Bridge, a slender 1938 construction that goes from Wellesley Island across the river to Canada. Between the spans of the bridge, a 395-foot observation tower affords a splendid view of island clusters and massive cargo vessels plying the waterway. Dewolf State Park, located on Wellesley Island, is a good place for motorists to unwind as they walk along streets flanked by Victorian cottages.

Back on the mainland, Alexandria Bay caters to enthusiasts of a wide array of recreational activities ranging from boating and hot-air ballooning to horse-and-buggy carriage tours. Settled in 1818 as a vital station for St. Lawrence steamboats to take on wood for fuel, the town became a resort spa for wealthy vacationers in the late 19th century. The breathtaking homes that sprang up here include the Boldt Castle, a magnificent granite edifice on Heart Island begun by hotel magnate George C. Boldt in 1900 for his wife, Louisa. Decorated with carved cherubs, heart-shaped motifs, and medieval-style towers, the six-story, 120-room Rhineland castle was abandoned when Louisa died suddenly in 1904.

The next inlet along the drive, Goose Bay, offers waterfront campsites and docking facilities at Kring Point State Park. Boaters can approach a great blue heronry on nearby Ironside Island, where nests as wide as six feet perch in the treetops.

Highway 12 hugs the shoreline as it continues downriver to Chippewa Bay, which arcs around the easternmost island. As the seaway tapers to a narrow channel, the drive ends at the junction with Highway 37, near the waterfront village of Morristown.

FOR MORE INFORMATION:
Seaway Trail, 109 Barracks Dr., Sackets Harbor, NY 13685; 315-646-1000 or 800-732-9298.

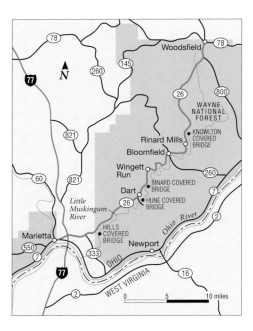

F ew man-made structures combine the elements of romance and fancy quite like a covered bridge. A quaint link to a bygone era, the "kissing bridges" go back to the days when lovers would steal a tender moment in their horse and buggy under cover of a bridge. It is also said that travelers who hold their breath when they cross a covered bridge will be granted a wish.

Near the turn of the 20th century, Ohio must have been the favorite state of lovers and wish-seekers, as some 2,000 covered bridges spanned its waterways. While many bridges have succumbed to the forces of time and the elements, today the 48-mile Covered Bridge Scenic Byway offers travelers a chance to experience the enduring magic of these historic structures.

The drive begins in Marietta, a town settled in 1788 by 48 pioneers under the leadership of Revolutionary War veteran Rufus Putnam. Marietta was named in honor of France's Queen Marie Antoinette. The museum of Campus Martius re-creates the founding of this first permanent settlement in the region at the Putnam House, which features pioneer artifacts and original furnishings. The town's attractive waterfront area boasts red brick streets and a paddlewheel boat that takes visitors on cruises along the Little Muskingum and Ohio rivers during the summer.

A NARROW TWO-LANE ROAD
Highway 26 heads north from Marietta to a forested ridge top that offers panoramic views of rolling hills and deep ravines. Descending to the river valley floor, the two-lane road follows the muddy Little Muskingum River with its four covered bridges. The river is also a popular canoeing site and attracts anglers fishing for smallmouth bass, bluegill, and crappie.

For most of its length, the road dissects the Marietta Unit of Wayne National Forest. The 200,000-acre forest contains about 200 miles of trails for hikers, horseback riders, mountain bikers, and off-road vehicles. Visitors are rewarded by the sight of waterfalls set amid delicate ferns, clearflowing streams, and rugged outcroppings of shale and sandstone. In spring the forest is fragrant with blossoms of dogwood and redbud, and the chill autumn air creates a blazing palette of reds and oranges.

A half-mile detour on County Road 333 leads to Hills Covered Bridge, a sturdy span that has been shouldering a constant stream of traffic since 1878. The North Country Scenic Trail is accessible from here.

Back on the byway, drivers wend their way through a forested terrain punctuated by modest farms and tiny crossroad towns. Painted advertisements for Mail Pouch Tobacco adorn weathered barn walls. Many barns in the area were painted by Harley Warrick, who began working for Mail Pouch Tobacco in 1946 and only retired in the 1980's. These unique landmarks are considered historically and artistically significant. Now and then a solitary oil well is visible—some of them still operate even though they are among the oldest rigs in the country.

Passing through Dart, the byway leads to Hune Bridge Recreation Area and its campsites, picnic areas, and canoe launch. The Covered Bridge Trail, which connects to the North Country Scenic Trail, can be reached from here. Just over four miles in length, the well-kept path leads past Wingett Run to Rinard Covered Bridge, which was built in 1876, after the original bridge was washed out and its wreckage drifted downstream past the Hune Farm.

Continuing north toward the town of Woodsfield, travelers come upon the last bridge along the Covered Bridge Scenic Byway. Built in 1860 to cross the Little Muskingum River, Knowlton Bridge was swept off its moorings at the turn of the century and hauled by local workers, with the help of a team of strong horses, back to its position and secured. Repeated restoration efforts have preserved this picturesque relic of Ohio's history, a silent witness to the kisses and wishes it has inspired down through the years.

FOR MORE INFORMATION:
Ohio Covered Bridge Scenic Byway, Wayne National Forest, Athens District, 219 Columbus Rd., Athens, OH 45701; 614-592-6644.

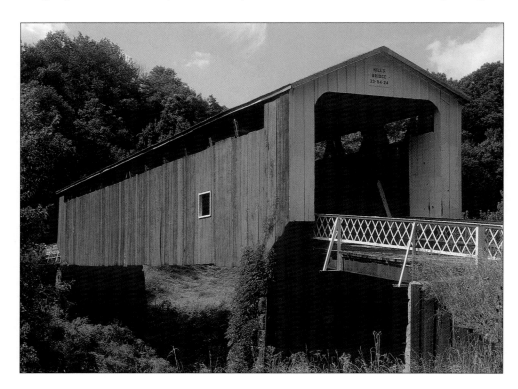

Hills Covered Bridge, left, was built in 1878 to span the Little Muskingum River at a point just east of Marietta.

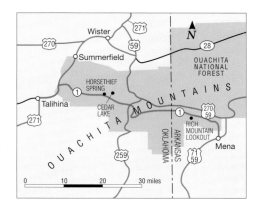

Tiger lilies, above, bloom in secluded corners of Ouachita National Forest.

Tracing the backbone of the wooded Ouachita Mountains, the Talimena Scenic Byway stretches for 54 miles along Highway 1 across the border of Oklahoma and into Arkansas. The road, built in the 1960's, winds through the Ouachita National Forest, which is the oldest and largest national forest in the South. Ouachita is a Choctaw word meaning either "Good Hunting Grounds" or "Hunting Trip." Today the woods are home to deer, opossums, foxes, bobcats, and squirrels, as well as warblers, finches, and owls.

Talimena is taken from Talihinia, Oklahoma, and Mena, Arkansas, the two communities at either end of the byway. It is a splendid drive, encompassing sites of historical and natural interest. The town of Talihina, which means "Iron Road" in the Choctaw language, was established as a missionary settlement when the Frisco Railway first carved a path through the mountains in 1888.

About seven miles east of Talihina, a visitor information station marks the official start of the byway. The first of many spectacular lookout points along the route is reached at Choctaw Vista, just down the road. From this vantage point on Winding Star Mountain, visitors gaze across the region's dark blue hills and deep valleys. The Ouachita National Recreation Trail runs parallel to the byway and can be reached at a number of access points. Hikers will find the trail steep and hard-going in places.

The Ouachita Mountains themselves are among America's oldest landmasses and the only mountains in the country to stretch in an east–west rather than a north–south direction. This configuration has resulted in different plant communities evolving on opposite sides of the range. Generally, the rich soil of the northern slopes supports a wide variety of hardwood trees, including oak, hickory, elm, maple, cherry, and black walnut. The south side, however, is characterized by shortleaf pine, mixed hardwoods, and flowering shrubs such as dogwood and redbud. The wide variety of tree and plant species makes the area particularly colorful during the autumn and in spring.

Horsethief Spring, a reminder of a very different time, lies about 16 miles after the start of the byway. In the late 1800's and early 1900's the spring was a popular stopover for horse thieves transporting stolen horses from Arkansas to market in Texas and Missouri. The thieves became so common in the region that a local group organized the Anti–Horse Thief Association, which operated until World War I, when the last gang of thieves was captured near Horsethief Spring.

TAKING A SHORT HIKE

Travelers on the road will want to stop and explore the rolling hills of Ouachita National Forest on foot. The woods conceal hiking trails that range from carefully tended nature walks to rugged mountain paths.

A mile and a half past Horsethief Spring is a side road leading north to 90-acre Cedar Lake, a perfect spot for enjoying a picnic and a leisurely walk. The grounds are equipped with a variety of facilities, including campsites and a boat launch, but only boats with less than eight-horsepower motors are permitted to ply the lake. The site is also the starting point for several short nature and hiking trails.

Near the midway point of the byway, the Robert S. Kerr Memorial Arboretum and Nature Center maintains three short interpretive nature trails, each with a different theme: one focuses on soil formation,

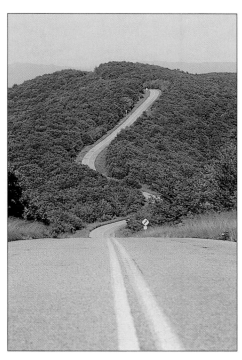

The Talimena Scenic Byway climbs up the Winding Stair Mountain National Recreation Area, above, in the Ouachita National Forest.

another identifies the various plants and trees that grow in the area, and the third explains plant life cycles and communities. The educational center is a peaceful place to spend a few hours.

Just a few miles east of the Oklahoma–Arkansas state line, the road climbs to Queen Wilhelmina State Park, high atop rugged Rich Mountain. The park, which stands out as one of the most scenic areas in Arkansas, is equipped with a lodge, restaurant, store, and camping facilities. A network of hiking trails reaches across the area, and naturalist programs are offered by the park's experienced staff. Before leaving the park visitors invariably stop at the Rich Mountain Lookout for a dramatic perspective on the Ouachita Mountains to the south.

At 2,681 feet, Rich Mountain marks the highest point on the Talimena Scenic Byway. As the road descends the mountain toward the town of Mena, Arkansas, a series of overlooks by the road offers visitors their last glimpses of this forested kingdom.

FOR MORE INFORMATION:

Talimena Scenic Byway, Ouachita National Forest, 100 Reserve St., P.O. Box 1270, Hot Springs, AR 71902; 501-321-5202.

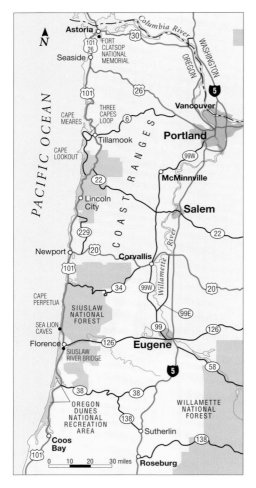

The interplay of land and sea along Highway 101 offers a heady mixture of thick, old-growth forests, misty coastal ranges, and stormy headlands scented by wafts of salty air. Secluded shores are peppered with dark volcanic sea stacks, and lone beacons shine forth from capes shrouded in fog. These natural wonders can be experienced on the 180-mile drive down the Pacific Coast from Astoria, Oregon, to the Oregon Dunes National Recreation Area, just south of Florence.

The town of Astoria sits at the wide mouth of the Columbia River against a backdrop of forested hills. Established in 1811 as a fur-trading post, the maritime town is the oldest permanent settlement west of the Mississippi.

The bays and estuaries of northern Oregon figured prominently in the records of the explorers Meriwether Lewis and William Clark during their 1805–06 expedition in search of a Northwest Passage. At the Fort Clatsop National Memorial, visitors can tour the 125 acres and log stockade where the explorers spent the winter before returning to the east.

Heading south, the highway follows the shoreline through waterfront towns such as Seaside and Cannon Beach, and passes mountains blanketed with Sitka spruce forest. The forest gives way to green pasturelands near the town of Tillamook, where motorists can leave Highway 101 and follow the signs to Three Capes Loop.

The road traces the curve of Tillamook Bay in the direction of Bayocean Spit, a seven-mile tongue of mudflats frequented by sandpipers and pelicans. Cape Meares State Park offers sweeping views of the ocean and glimpses of tufted puffins and pelagic cormorants. Amid the thick forest, a giant Sitka spruce—dubbed the Octopus Tree—stretches its limbs horizontally for 30 feet before reaching skyward.

A short detour on Highway 6 leads to Cape Lookout, which juts from an old spruce, hemlock, and cedar forest. Several trails to the tip offer an excellent vantage point for watching migrating gray whales. At Cape Kiwanda, red and yellow sandstone cliffs bear up against the wrath of the Pacific. Winds lash at the headland, while fierce waves pound against the rocks below. Farther south, Cascade Head's foggy prairies host the Pacific giant salamander, a foot-long amphibian that eats mice.

Fishing nets are piled in the harbor yard at Yaquina Bay in Newport, left. Farther south, at Oregon Dunes National Recreation Area, rhododendrons take root in the dunes, above.

PACIFIC RAIN FOREST

Highway 6 rejoins Highway 101 before Lincoln City then continues past Newport to Cape Perpetua. Near the shoreline lies the largest intact coastal rain forest in the continental United States. Five state parks merge over the next 24 miles, offering uncrowded public beaches populated by harbor seals and thousands of sandpipers.

Near Devil's Elbow State Park stands Heceta Head Lighthouse, which has lit the way for water traffic continuously since 1894. A mile south of the lighthouse, visitors arrive at Sea Lion Caves, where roughly 400 of the rotund mammals live. Visitors can descend in an elevator and watch the 800-pound sea lions as they frolic in the vast cavern. At Florence the highway crosses the elegant Art Deco–style Siuslaw River Bridge. Basalt cliffs stop short of the river, marking the beginning of a 40-mile-long stretch of undulating sands, much of which lies within the 31,500-acre Oregon Dunes National Recreation Area.

FOR MORE INFORMATION:

Oregon Tourism Commission, 775 Summer St. N.E., Salem, OR 97310; 503-986-0000.

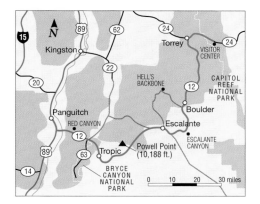

A surreal desertscape unfolds before Utah's Route 12, a 122-mile stretch of highway that links the eerie spires of Bryce Canyon National Park with the massive sandstone domes and twisted passageways of Capitol Reef National Park. En route, the road plunges through a slickrock wilderness, where the ancient geological forces of uplift and erosion have raised, creased, and chiseled varicolored rock strata over 200 million years.

Paved in its entirety only since 1985, the highway begins in the Old West town of Panguitch and heads east toward Red Canyon, onetime hideout of outlaw Butch Cassidy. Cliffs of vermilion limestone are offset by green ponderosa pines as the road climbs toward the turnoff for Bryce Canyon. Heading southeast off Route 12, Route 63 skirts the rim of 35,835-acre Bryce Canyon National Park and its series of huge, U-shaped amphitheaters 1,000 feet deep. Cluttered with weatherworn pillars called hoodoos, the vast alcoves were carved by the waters of several creeks eating away at soft spots in the rock. Iron and magnesium oxides in the limestone have tinted the rock in myriad shades of gold, orange, lavender, and vermilion.

Overlooks along the 37-mile park road display the area's roughly hewn spires, pinnacles, and arches. Hiking trails zigzag below the rim toward fanciful rock formations: one looks like a sentinel and others resemble a sunken ship and a city skyline. Motorists link back up with Route 12 at the northern edge of the park, then descend toward the small towns of Tropic and Cannonville. An overlook about a dozen miles past Tropic affords visitors spectacular views of the terra-cotta cliffs of 10,188-foot Powell Point, a landmark named for a renowned 19th-century surveyor named Maj. John Wesley Powell.

The road glides across the high plains of the Table Cliff Plateau to Escalante, a ranching town settled by Mormons. Nearby 2,100-acre Escalante State Park is scattered with petrified logs and stumps dating back 140 million years to when powerful rivers and volcanic eruptions uprooted the trees. The sunken logs became permeated with mineral-laden water that replaced the logs' organic material and turned the wood to stone. Mineral impurities stained them red, yellow, purple, and brown. Walkers can view the logs by hiking up a hillside covered with piñon pines and junipers along the Petrified Forest Trail.

East of town the Calf Creek Recreation Area provides campsites and views of prehistoric Fremont Indian rock art. Visitors can go on a five-and-a-half-mile trail to misty Calf Creek Falls and take a dip in the shallow waters of the creek.

Farther along, the highway serves as a roadhead for scenic drives throughout the arid, rocky region. Hell's Backbone Road climbs a spine-tingling ridge that overlooks the golden-walled canyons of Box-Death Hollow Wilderness Area. Hole-in-the-Rock Road circles past the arches and hoodoos of Devil's Garden and leads to the site 2,000 feet above the Colorado River where Mormon pioneers blasted a notch through a canyon wall.

Once back on Route 12, motorists continue north to Boulder, where Anasazi State Park preserves an 87-room community occupied by the Ancestral Pueblo from A.D. 1050 to 1200. Visitors can follow a self-guided tour of the stabilized ruins and examine the pottery, ax heads, arrow points, and tools that are on display at the museum. Visitors can learn more about the daily activities of the Ancestral Pueblo by studying a detailed diorama.

The route climbs to the sagebrush-covered summit of 9,200-foot Boulder Mountain, then swoops down to meet Route 24 near Torrey.

LAND OF THE SLEEPING RAINBOW

Travelers can conclude their scenic tour by taking Route 24 east to Capitol Reef National Park. The 100-mile-long reef, which rises from the desert like a stone tidal wave, is part of the Waterpocket Fold, a great wrinkle in the earth's crust. Erosion has shaped the exposed ridgelines into great scallops, colored in pink, salmon, chocolate, and vermilion. Roads and hiking trails ascend the tiered cliffs and canyons, called the Land of the Sleeping Rainbow by the Navajo. Etched on the red rock cliffs are numerous petroglyphs created by the Fremont Indians. The remains of Fruita, an early Mormon pioneer settlement, also can be visited.

FOR MORE INFORMATION:

Utah Travel Council, Council Hall, Salt Lake City, UT 84114; 801-538-1030.

Bryce Canyon's Silent City, below, of eroded limestone skyscrapers, can be viewed from Sunset Point. The park's unusual array of spires and spindles is produced by an average of 200 freeze-thaw cycles a year.

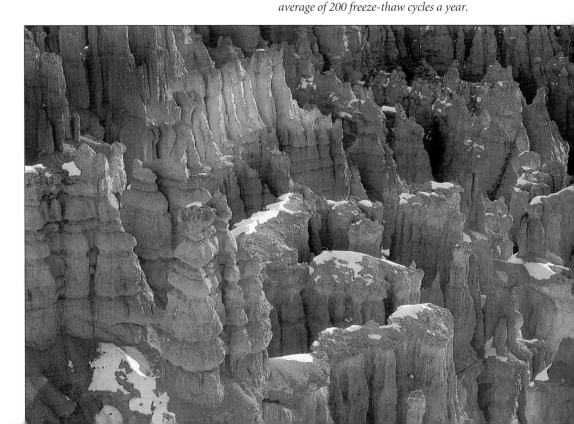

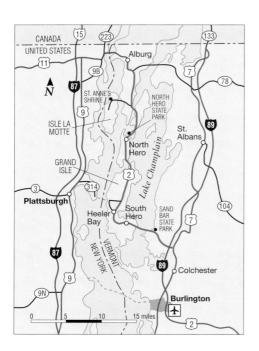

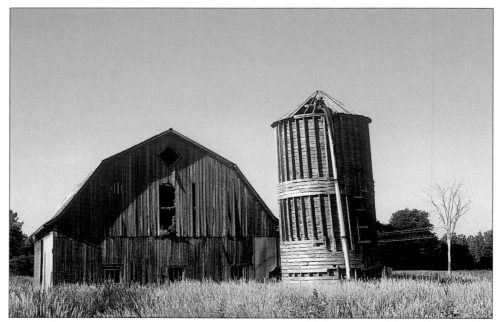

A weathered barn and silo on the Alburg Peninsula, above, remind travelers that the rich land of the Lake Champlain valley has provided a lifeline for generations of Vermont farmers.

The islands of Vermont's Grand Isle County—Grand Isle, North Hero, and Isle La Motte—have attracted vacationers since the 1870's. These early visitors arrived by lake steamers and whiled away the lazy days of summer amid the islands' green pastures and along its sandy beaches. Tourism increased with the advent of the railroad around the turn of the century, and more and more visitors flocked to the area to stay in one of several hotels that sprang up there. Nowadays, travelers get to the islands by taking the ferry from Plattsburgh, New York, to Grand Isle, Vermont, or by driving Route 2, which connects the archipelago to the town of Alburg, a farming community on a peninsula that juts from Quebec into the northern end of Lake Champlain.

RURAL TOUR

Route 2, a two-lane highway, departs from north of Colchester, Vermont, and travels west through well-ordered countryside. Robust silos, verdant cornfields, and clapboard farmhouses—most of them painted white with green trim, and some pale blue or primrose—comfort the eye.

Marshes filled with willowy bulrushes come into view as the highway approaches the Lamoille River. Just before taking the causeway that connects the mainland to South Hero Island, the cedar-rail fences of Sand Bar State Park appear on the right. In the summer families with young children take to its sandy beaches because of the shallow water and the slow, gentle slope of the underwater drop-off. Bicycle paths, volleyball courts, and picnic tables round out

the park's facilities. In winter, when the park is closed, the dark figures of anglers can be seen hunkered down offshore by their fishing lines, seemingly oblivious to the whistling cold.

An 1816 Meeting Hall with a distinctive round-topped steeple announces the hamlet of South Hero, a cluster of buildings at a crossroads. To the west along South Street lie three of the island's orchards. At apple blossom time or apple picking time, travelers immediately grasp why Grand Isle is also known as Apple Island. The road skirts Keeler Bay on its way to the village of Grand Isle, where a lovely old country store marks the center of town. The Hyde Log Cabin, reputedly the oldest log cabin in the nation, was built nearby in 1783 by Jedediah Hyde, a veteran of the American War for Independence. The cabin was moved to this site in 1945.

The highway meanders past hay and cornfields, pastures of grazing Holstein cows, and driveways lined with towering Lombardy poplars. To the southeast soars stern-faced Mount Mansfield, tallest of the northern Green Mountains; to the west rise the imposing Adirondacks.

A drawbridge to North Hero Island across a Lake Champlain passage known as the Gut, leads to Knight Point State Park, which offers picnic grounds, boat rentals, and an attractive beach. The island recently gained fame as the summer home of the Herrmann's Royal Lipizzan Stallions, magnificent white horses trained in Austria that

perform highly disciplined routines. Tickets to their summer shows are in great demand. The hamlet of North Hero is a lakeside resort with old-fashioned inns and cottages. North of town, off Highway 2, lies North Hero State Park, the most remote and perhaps the prettiest of the islands' four state parks. It offers campsites, a small swimming beach, and boat rentals.

The names on mailboxes along Route 2 reveal the French ancestry of their owners. The first European settlement in Vermont was Fort St. Anne on Isle La Motte, which was built by soldiers under French captain Pierre La Motte in 1666. St. Anne's Shrine was constructed on the original site of the fort in 1893 in commemoration of those courageous men. A little white chapel there still celebrates mass on weekends from May to October.

In any season, visitors to the area will enjoy wandering among the cedars, white pines, and oak trees that tower above the shrine's stations of the cross, which are set up near the water's edge. A statue of the French explorer Samuel de Champlain, who discovered the lake that bears his name, stands guard nearby.

FOR MORE INFORMATION:

Lake Champlain Islands Chamber of Commerce, P.O. Box 213, North Hero, VT 05474; 802-372-5683.

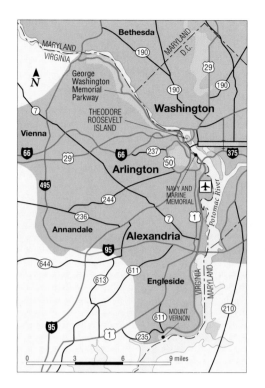

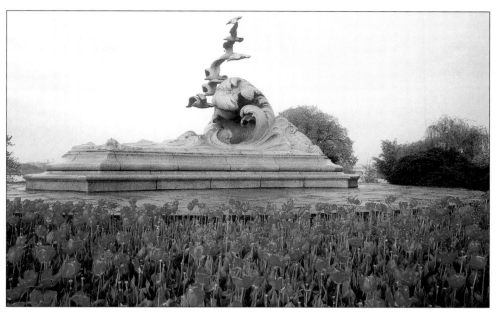

The George Washington Memorial Parkway travels through an area that is rich in natural and man-made landmarks. They include the Navy and Marine Memorial, above, which was designed in 1922 and is dedicated to all Americans who lost their lives at sea.

More than simply a road to the nation's capital, the George Washington Memorial Parkway is a beautifully landscaped band of greenery designed to reflect and preserve the region's natural scenery and history.

The route begins at Mount Vernon—George Washington's plantation home from 1754 to 1799—and skirts the Virginia shoreline of the Potomac River as it winds north to Washington, D.C., and beyond. The scenery along the route alternates between towering hardwood forests, and broad, grassy areas planted with red cedar trees. During the spring the countryside blooms in a glorious profusion of redbuds and dogwoods, and in autumn red maples, oaks, sumacs, and hickories set the hills ablaze with color.

From one end to the other, the parkway gives a fascinating lesson in scenic roadway design. It begins as a narrow, winding, and largely undivided roadway, then incorporates wider traffic lanes, generous curves, and continuous medians as it approaches the National Airport. Steel-and-concrete bridges northwest of Washington allow the parkway to pass over stream valleys along palisades and hardwood forests.

In keeping with the tradition of American parkways, the road is limited to passenger cars and is designed to make the most of the region's natural features. Forests have been selectively cut to provide views of the Potomac. Subtle curves have been added that show off stands of old trees and provide spectacular vistas of the nation's capital.

POTOMAC RIVER ROAD

Like the parkway itself, the character of the Potomac River changes dramatically as it cuts through the Virginia country-side. Above Great Falls the river is wide, calm, and shallow. On its way to Theodore Roosevelt Island, the waterway descends about 90 feet, flowing through a series of narrow channels bordered by steep cliffs, then moving on to a stretch of rapids and low falls. At Great Falls, the Potomac flows over a steep, jagged rock wall before rushing furiously through a narrow gorge, creating one of the most striking sights along the river.

As it travels past historic landmarks, recreational areas, and beautiful natural scenery, the parkway provides motorists with a multifaceted view of Virginia and the approach to Washington.

FOR MORE INFORMATION:

George Washington Memorial Parkway, Turkey Run Park, McLean, VA 22101; 703-285-2598.

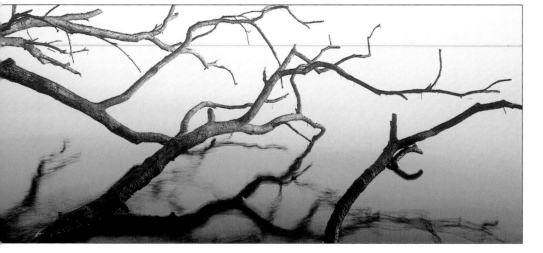

The parkway protects sections of the Potomac River, left, and its watershed. As a wildlife refuge, it is a sanctuary for white-tailed deer, raccoons, opossums, wild turkeys, and red foxes, as well as many nesting songbirds.

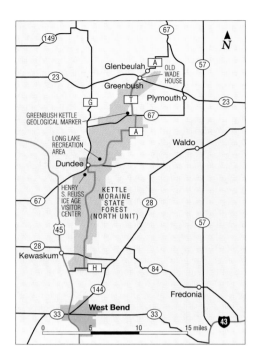

In the fall, when the maples, sumacs, and basswoods of the Kettle Moraine State Forest glow in a firestorm of color and the glassy lakes reflect a crisp blue sky, it is difficult to imagine a time tens of thousands of years ago when heavy masses of ice sheets and enormous glaciers fashioned this terrain. But the ice-age legacy haunts this landscape, and motorists who travel on the northern portion of Kettle Moraine Drive in southeastern Wisconsin pick up the subtle yet indelible signs of ancient geological history.

The 33 miles of this section of the Kettle Moraine Drive link the town of Glenbeulah with County Highway H. The drive, which is made up of several state and county highways and town roads, is shown with green, acorn-shaped signs. It traverses the north unit of Kettle Morraine State Forest, 30,000 acres of forests, glacial formations, and prairieland. The National Ice Age Trail goes through the forest as do five other loop trails used by hikers, bicyclists, and skiers.

The first leg of the drive follows Highway A (Kettle Moraine Drive) through a region of farmland from the town of Glenbeulah to Greenbush. An inn called the Old Wade House stands at the junction of Highway A and Highway T. Built in 1851 to cater to stagecoach travelers, the building is now open for public tours of the taproom and the ballroom. Before leaving Greenbush, visitors often stop at the Wesley W. Jung Carriage Museum. Among the more than 100 antique horse-drawn vehicles on display here are fire-engine pumpers, public omnibuses, a 10-passenger sleigh, and a circus calliope.

Outside Greenbush, the road climbs onto a ridge of land called the Green Bay Terminal Moraine. More than 20,000 years ago, two colossal sheets of ice—called the Green Bay Lobe and the Lake Michigan Lobe—collided in this region. On their journey here, the two ice sheets swept up rocky material ranging in size from tiny grains to boulders. As the lobes melted, they deposited the jumble of debris in moraines, or ridges, that reached heights of 300 feet. The Green Bay Terminal Moraine is a steep ridge marking the farthest advance of the Green Bay Lobe before it retreated.

About three miles south of Greenbush lies the Greenbush Kettle Geological Marker, a large-scale depression in the ground where visitors can park their cars and explore the area on foot. Such depressions, called kettle holes, were formed when glacial debris was laid atop a melting ice block. As the block melts, the sediment sinks into the depression. Although some kettle holes contain ponds or marshes, this particular one is empty.

GLACIAL OUTWASH

The drive continues east on Highway 67 and south on Highway A into some of Wisconsin's richest farmlands, which rest on a plain of sand and gravel deposited by glacial meltwater. Soon the road climbs up the steep wooded hills of the Lake Michigan Terminal Moraine, left by the farthest westward advance of the Lake Michigan Lobe. For a panoramic view of the region, visitors can drive to the Parnell Tower, a 60-foot-high observation post. When the weather is clear, the view from this vantage point extends at least 25 miles.

The Long Lake Recreation Area, located several miles north of Dundee, is a truly enchanting park where swimmers and canoeists take to the water, while hikers follow various trails that wind through the tranquil woods.

Just east of Dundee, on the north side of Kettle Moraine Drive, rises Dundee Mountain, a massive conical hill. It is composed of water-rounded sand and cobbles left by streams that flowed down through cracks in the ice during the ice age. The Dundee Kame is considered one of the finest examples of this geographic formation in the world. The Henry S. Reuss Ice Age Visitor Center, at the intersection of Highway 67 and County Route G, is an invaluable resource on the region's geographic history. A 20-minute film and exhibits explain how the ice age glaciers shaped the magnificent contours of Wisconsin's landscape.

FOR MORE INFORMATION:
Wisconsin Department of Tourism, P.O. Box 7976, Madison, WI 53707; 608-266-2345.

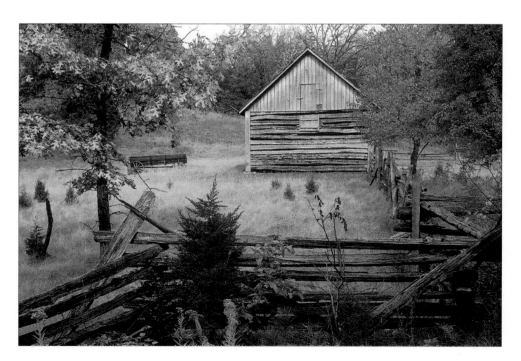

South of County Road H on the Kettle Moraine Scenic Drive lies Old World Wisconsin, left, an outdoor museum featuring historic farmhouses, shops, and barns from all around the state.

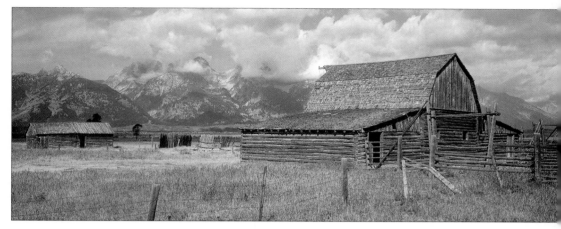

Many ranches in Wyoming, including one at Jackson Hole in Grand Teton National Park, above, were unable to survive because of the region's harsh winters and rocky soil. Today many serve as dude ranches for tourists. As one old-timer puts it: "Dudes winter better than cattle."

Twisting and turning, climbing and dipping, Wyoming's Centennial Scenic Byway is a roller-coaster ride on Highway 287/26 and Highway 189/191 through a landscape that epitomizes the American West. The 162-mile journey from Dubois to Pinedale can take most of a day to drive because travelers find themselves stopping again and again to absorb one outstanding view after another of densely forested mountain slopes, deep valleys, and forsaken badlands.

The byway leaves Dubois and cuts a course through the arid, pastel-colored badlands and the eastern flank of the Wind River Range, following the headwaters of the Wind River into the cool Shoshone National Forest. Just inside the boundary of the national forest, visitors will find a monument to tie-hackers, the hardy lumberjacks who, until the 1930's, worked year-round cutting down trees for ties in the ever-expanding network of railroads.

CROSSING THE DIVIDE

The road climbs through a forest of spruce, fir, and soaring lodgepole pine inhabited by deer, elk, moose, and black bears. The formidable Breccia Cliffs dominate the horizon to the north, and farther along appear the flat-topped Pinnacle Buttes, landforms made up of layers of volcanic rock and ash.

The road continues its ascent until it reaches 9,544 feet and crosses Togwotee Pass on the Continental Divide. Then the road descends to the floodplain of Buffalo Valley and the Grand Teton National Park. On the way down, travelers rarely pass up Teton Range Overlook, which offers an awe-inspiring view of the granite peak lineup: Nez Perce, Middle Teton, Mount Owen, Teewinot Mountain, and—soaring shoulders above the rest—13,770-foot Grand Teton. The Tetons are magnificent: their peaks break through the flat valley floor like spears of glittering glass, their aspect changing with each season.

Grand Teton National Park celebrates the grandeur of mountain and river. At the Snake River Overlook, situated above a wide bend in the river, bald eagles and ospreys are sometimes seen soaring high above on the air currents. In summer the flatlands become a tangle of wildflowers, and in autumn the land is painted with the yellow and gold of cottonwood and aspen. Winter brings its silver-and-white beauty.

Just beyond Grand Teton National Park the byway turns south onto Highway 189/191 and edges along the Snake River and past Jackson Hole. Nearby is the National Elk Refuge, an area of 37 square miles that attracts as many as 10,000 elk in winter. From mid-December to late March, horse-drawn sleighs take visitors out for views of the herds silhouetted against the radiant white mountainsides.

After passing through the lively town of Jackson, the route follows the Snake River to Hoback Junction, where the waters of the Snake and Hoback rivers rush into the Grand Canyon of the Snake River. The highway descends into Hoback Canyon, within the winter range for moose, elk, deer, and bighorn sheep. A short detour down Granite Creek Road, 11 miles south of Hoback Junction, brings travelers to a pool, built in 1933, that is fed by hot springs and is open during the summer.

Southeast of the town of Bondurant, the road swoops out of the mountains and into the sagebrush flatlands of the Green River valley. The byway comes to an end in Pinedale, at the foot of the snow-crusted peaks of the Wind River Range. The range, including 13,804-foot Gannett Peak, can be seen from more than 100 miles away.

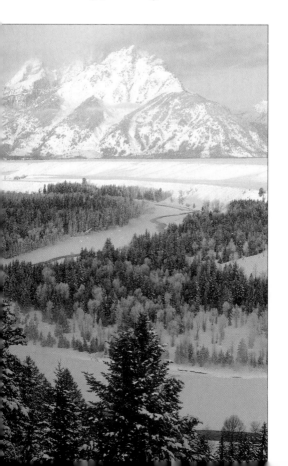

From Snake River Overlook travelers can watch the sun light up the peaks of the Grand Tetons at dawn, left.

FOR MORE INFORMATION:

Wyoming Division of Tourism, I-25 at College Dr., Cheyenne, WY 82002-0660; 307-777-7777.

INDEX

PICTURE CREDITS

Cover photograph by Ian Adams
2 Carr Clifton
5 Tom Till Photography

ROADSIDE VERMONT
8, 9 David Muench
10 (upper right) Fred Hirschmann
10 (lower left) William H. Johnson
12, 13 Ric Ergenbright Photography
13 (lower right) George Wuerthner
14 (upper right) William H. Johnson
14 (lower left) George Wuerthner
15 Michael J. Pettypool/Dave G. Houser
16 (upper right) William H. Johnson
16 (lower left) Fred Hirschmann
17 David Muench

SKYLINE DRIVE
18, 19 David Muench
20 (upper left) David Muench
20 (lower right) Terry Donnelly
22 (right) Fred Hirschmann
22 (left) William B. Folsom
23 (upper) William B. Folsom
23 (lower) Jeff Gnass Photography
24 (both) Terry Donnelly
25 Tim Wright
26 (upper) William B. Folsom
26 (lower) Carr Clifton
27 (upper) David Muench
27 (lower) William B. Folsom

COASTAL ROUTE
28, 29 David Muench
30 Lee Snider/Photo Images
32 (upper) John Elk III
32 (lower) Zandria Muench Beraldo
33 Lee Snider/Photo Images
34 (left) Lee Snider/Photo Images
34 (right) Jonathan Wallen
35 Robert Clark/TRANSPARENCIES, Inc.
36 (upper) Lawrence Dolan/
 TRANSPARENCIES, Inc.
36 (lower) Lee Snider/Photo Images
37 J. Faircloth/TRANSPARENCIES, Inc.

NATCHEZ TRACE PARKWAY
38, 39 Laurence Parent
40 (upper right) Jonathan Wallen
40 (lower left) Laurence Parent
42 (upper) Laurence Parent
42 (lower) Lee Foster
43 (upper right) Jack Olson
43 (lower left) Laurence Parent
44 Jeff Gnass Photography
45 (upper) Dave G. Houser

45 (lower) John Elk III
46 (upper left) Balthazar Korab
46 (lower right) Jack Olson
47 Dave G. Houser
48 Balthazar Korab
49 (upper) John Elk III
49 (lower) Larry Ulrich Photography

THE GREAT PLATTE RIVER ROAD
50, 51 Chuck Haney
52 (upper left) Terry Donnelly
52 (lower right) Scott T. Smith
54 (left) Deneve Feigh Bunde/
 Unicorn Stock Photos
54 (lower right) Dave G. Houser
54, 55 (upper right) Scott T. Smith
55 (lower right) Cheryl R. Richter
56 (upper) Cheryl R. Richter
56 (lower) Chuck Haney
57 (upper right) Dave G. Houser
57 (lower left) Chuck Haney

THE BEARTOOTH HIGHWAY
58, 59 Laurence Parent
60 Jon Gnass
61 John Elk III
62 Larry Ulrich Photography
63 (upper right) Willard Clay
63 (lower left) Michael S. Crummett
64 (upper) Michael H. Francis
64 (lower) Willard Clay
65 John Elk III
66 (upper right) Laurence Parent
66 (lower left) Jack Olson
67 Jon Gnass

SAWTOOTH DRIVE
68, 69 Carr Clifton
70 Steve Bly/Dave G. Houser
72 (upper right) Terry Donnelly
72 (lowerleft) Jeff Gnass Photograph
73 (upper) Dave G. Houser
73 (lower) David Muench
74 (left) Fred Hirschmann
74 (right) Jeff Gnass Photograph
75 (upper) Steve Bly/Dave G. Houser
75 (lower) Jon Gnass
76 (right) Dave G. Houser
76 (left) John Eastcott/Yva Momatuik/
 Woodfin Camp & Associates
77 Jeff Gnass Photography
78 (upper) Terry Donnelly
78 (lower) John Gottberg/Dave G. Houser
79 (both) David Muench

THE SUNSET COAST
80, 81 Carr Clifton
82 (upper left) Wolfgang Kaehler
82 (lower right) Bob Miller
84 (upper) Carr Clifton
84 (lower) Tim Thompson
85 (upper) Tim Thompson
85 (lower) John Elk III
86 (upper) Frank S. Balthis
86 (lower) Bob Miller
87 (upper left) Frank S. Balthis
87 (lower right) Tim Thompson
88 (upper left) Frank S. Balthis
88 (lower right) David Muench
89 Frank S. Balthis
90 David Muench
91 (upper) Frank S. Balthis
91 (lower) John Elk III

ROAD TO THE CRATER
92, 93 David Muench
94 (upper left) John Elk III
94 (lower right) Rita Ariyoshi
96 (both) Rita Ariyoshi
97 (upper) Rita Ariyoshi
97 (lower) Jim Cazel/Photo Resource Hawaii
98 (left) Rita Ariyoshi
98 (lower right) Rita Ariyoshi
98, 99 (upper right) Jim Cazel/Photo
 Resource Hawaii
99 (lower right) Rita Ariyoshi
100 (upper) Jim Cazel/Photo
 Resource Hawaii
100 (lower) Rita Ariyoshi
101 James Ariyoshi
102 (upper) Rita Ariyoshi
102 (lower) Jack Jeffrey/Photo
 Resource Hawaii
103 (upper) Rita Ariyoshi
103 (lower) Heather Titus/Photo
 Resource Hawaii

GEORGE PARKS HIGHWAY
104, 105 Gene Jansen/Ken Graham Agency
106 (left) Gerry Ellis Nature Photography
106 (right) Wolfgang Kaehler
108 (upper) Dorothy Keeler/Ken
 Graham Agency
108 (lower left) Dave G. Houser
108 (lower right) Fred Hirschmann
109 Ken Graham Photography
110 (left) Lee Foster
110 (right) Kim Heacox Photography
111 (upper) Fred Hirschmann
111 (lower) Paul Souders/Ken
 Graham Agency

112, 113 (upper right) C. Mauzy/First Light
112 (lower left) Fred Hirschmann
113 (lower right) Randi Hirschmann

GAZETTEER
114 Ric Ergenbright Photography
115 (upper) James Valentine
115 (lower) Images International/Bud Nielsen
116 Scott T. Smith
117 (upper) Laurence Parent
117 (lower) George H.H. Huey
118 (both) Larry Ulrich Photography
119 Terry Donnelly
120 John Elk III
121 (upper right) Ric Ergenbright
 Photography
121 (lower left) Laurence Parent
122 Lee Snider/Photo Images
123 (left) Lee Foster
123 (right) Dave G. Houser
124 (upper) Tom Till Photography
124 (lower) Larry Ulrich Photography
125 Balthazar Korab
126 James P. Rowan
127 (upper right) Philip Gould
127 (lower left) Laurence Parent
128 Ric Ergenbright Photography
129 (upper) Lee Snider/Photo Images
129 (lower) Jonathan Wallen
130 Terry Donnelly
131 (both) Ric Ergenbright Photography
132 (upper) John Elk III
132 (lower) Scott T. Smith
133 Jonathan Wallen
134 Ian Adams
135 (right) John Elk III
135 (left) Laurence Parent
136 (right) Gerry Ellis Nature Photography
136 (left) Terry Donnelly
137 George H.H. Huey
138 George Wuerthner
139 (upper) Tom Till Photography
139 (lower) Carr Clifton
140 Terry Donnelly
141 (upper right) Ric Ergenbright
 Photography
141 (lower left) Terry Donnelly

Back cover photograph by Jon Gnass

ACKNOWLEDGMENTS

Cartography: Dimension DPR Inc.; map resource base courtesy of the USGS; shaded relief courtesy of the USGS and Mountain High Maps®
Copyright © 1993 Digital Wisdom, Inc.

The editors would also like to thank the following: Lorraine Doré, Pascale Hueber, and Valery Pigeon-Dumas.